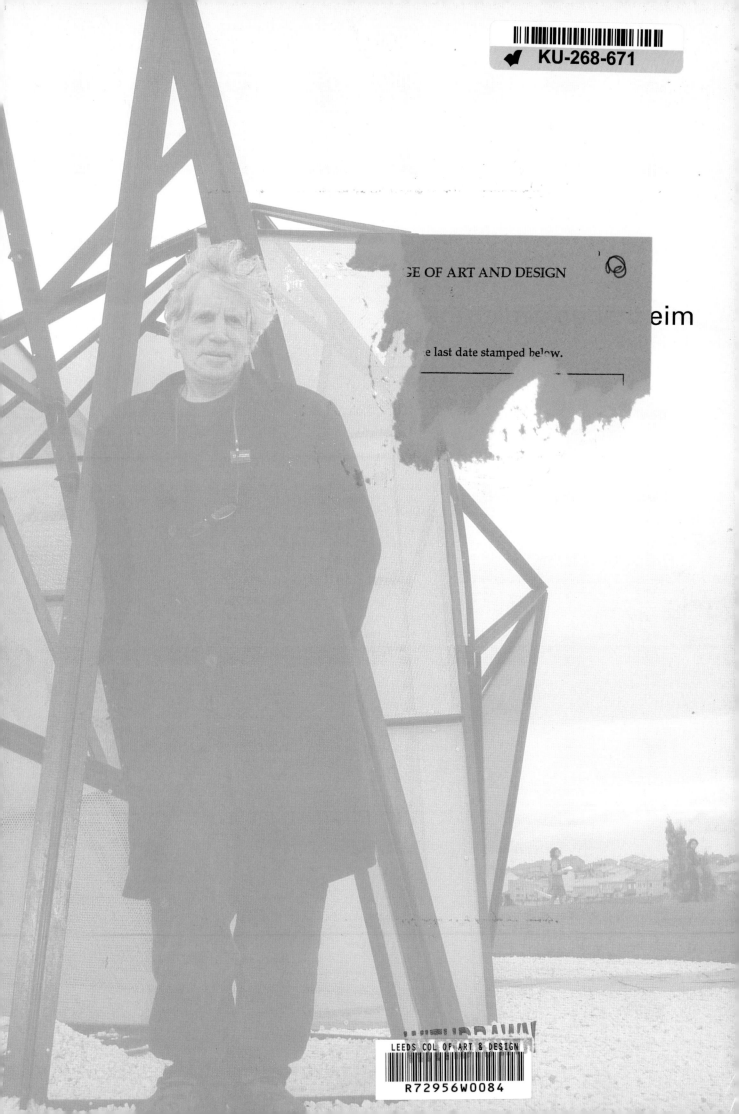

dennis oppenheim

short circuit / cortocircuito

edited by/a cura di
raffaele bedarida
ruggero montrasio

SilvanaEditoriale | Montrasio Arte

Cover/In copertina
Parallel stress 1970

Silvana Editoriale

Progetto e realizzazione / Produced by
Arti Grafiche Amilcare Pizzi Spa

Direzione editoriale / Direction
Dario Cimorelli

Coordinamento editoriale / Editorial Coordination
Anna Albano

Art Director
Giacomo Merli

Redazione lingua italiana / Italian Copy Editor
Emanuela Rossi

Impaginazione / Layout
Paola Forini

Coordinamento organizzativo / Production Coordinator
Michela Bramati

Segreteria di redazione / Editorial Assistant
Sabrina Galasso

Ufficio iconografico / Iconographic office
Alice Jotti

Ufficio stampa / Press office
Lidia Masolini press@silvanaeditoriale.it

Edited by/Mostra a cura di
Raffaele Bedarida
Ruggero Montrasio

Text by/Testo di
Raffaele Bedarida

Catalogue by/Catalogo a cura di
Francesca Montrasio
Letizia Villa

Organizing coordination/Coordinamento organizzativo
Gian Luca Bianco
(Montrasio Arte, Monza-Milano)

Comunication/Comunicazione
CLP Relazioni Pubbliche, Milano

Press Office/Ufficio Stampa
Manuela Petrulli e Carlo Ghielmetti
(CLP, Relazioni Pubbliche Milano)

Thanks to/Grazie a
Dennis Oppenheim, Amy Plumb,
Raffaele Bedarida, Gian Luca Bianco,
Michela Bramati, Luciano Carugo, Alberto Crespi,
Paola Forini, Carlo Ghielmetti, Mario Mauroner,
Francesco Mandressi, Luca Melloni,
Giacomo Merli, Francesca Montrasio,
Mario Moretto, Manuela Petrulli, Letizia Villa,
Nicola Villa, Joy Jayasiri Gunesekere

montrasio arte

via Carlo Alberto 4, 20052 Monza
tel. +39 039 321770 / fax +39 039 2301879
via Brera 5, 20121 Milano
tel. +39 02 878448 / +39 02 875522
www.montrasioarte.com
montrasio@montrasioarte.com

Contents / Sommario

9 Short Circuit: the early Oppenheim and today's public
19 Cortocircuito: gli esordi di Oppenheim e il pubblico odierno
 Raffaele Bedarida

29 Works/Opere

75 Appendix/Apparati
 Amy Plumb

77 List of works/elenco opere

78 Biography/Biografia

79 Solo exhibitions/Mostre personali

82 Group exhibitions/Mostre collettive

90 Selected Public Collections/Collezioni pubbliche (selezione)

92 Books and Catalogues/Monografie e cataloghi

99 Major articles/Principali recensioni

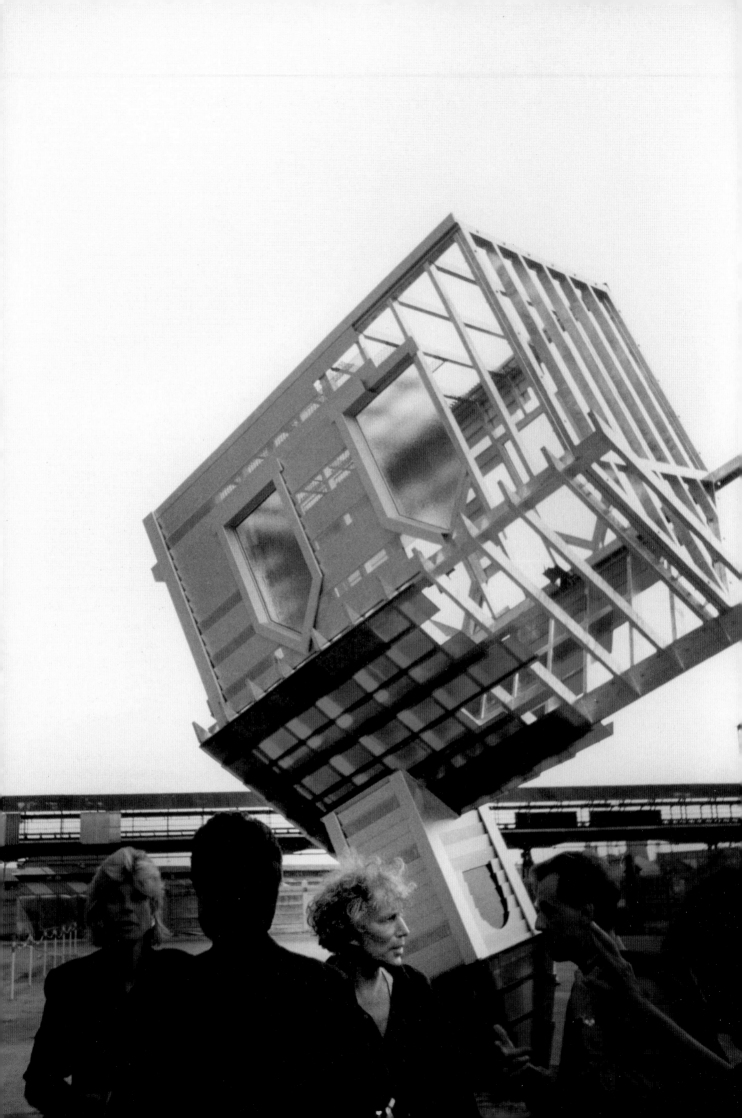

Short Circuit:
the early Oppenheim and today's public

Raffaele Bedarida

On the left, Dennis Oppenheim at the Biennale of Venice, Marghera, 1997.

Although the works on show at Montrasio Arte cover a great deal of the artistic development of Dennis Oppenheim in the last forty years and he is still in full career, I do not here intend to give a historical-critical account of it, since this has already been done, in detail and from diverse points of view, above all by Thomas McEvilley in the catalogue of the exhibition at P.S.1 in New York in 1991,[1] and by Germano Celant in the monograph published in Italian and English editions in 1997 and 2001 respectively.[2] On the contrary, the exhibition in Milan and this text of mine focus mainly on the period of the artist's beginnings, that is, in the late 1960s and early 1970s of the twentieth century. My intention is to tackle a question that is at one and the same time crucial and paradoxical. For example: let us take a theoretical Visitor X, who one day in the spring of 2007 enters the gallery from Via Brera and sees, for example, *Parallel Stress* (Fig. 1). He probably realizes that he has before him a key work, not only in Oppenheim's artistic career but in the history of art in the second half of the twentieth century. The reason for its importance can be found in any manual: *Parallel Stress* uses the body as the physical meter to measure and explore the external world, symbolically marking the shift from the exploration of the landscape to that of one's own body, from Earth Art to Body Art. In concrete fact, however, what Visitor X sees is two photographic images accompanied by an explanatory text. The first photograph shows what we discover to be the artist who, face turned downwards, is supporting himself suspended between two walls, with his body arched to an extreme. The context is the urban pollution at the foot of one of the piers of a bridge in the US, which we discover to be the Manhattan Bridge. The second photo shows the same artist in a similar position, but now he is not suspended over the void, but lying on his back between two hillocks which we are told are to be found on Long Island. The arched body is photographed in such a way as to correspond exactly to the line between earth and sky.

We are told in the text that this is the photographic record of a double operation carried out in 1970, that of the first photograph lasting ten minutes, that of the second an hour. The text explains that the photograph was taken at the moment the body was arched to the fullest extent, immediately before collapse. The body becomes an authentic measuring instrument of tension and, positioned as it is in two different places, provokes a sense of mirror-image between two otherwise unconnected geographical sites. We do not know who took the photographs[3] (which is unusual for the United States, where particular attention is always paid to the authorship of images) or if there was an unseen public outside the frame. But even if someone had been present on both occasions, in Manhattan and on Long Island, this would in any case not have been the

Fig. 1 Dennis Oppenheim, Parallel Stress, 1970. Activity. Pier between Brooklyn and Manhattan bridges and an abandoned sump in Long Island, NY. Masonry blocks, earth. Duration of stress position: 10 minutes; position in slump: 1 hour. The artist tests the capability of his body to suspend itself between two masonry walls. The stress is recorded by the position of his body as it arcs. This arc is then duplicated in abandoned sump, where the artist assumes the parallel arc position.

main means of communication of the event.

The inevitable analogy is with the famous *Leap into the Void* (1960) by Yves Klein (Fig. 2), which is considered the prototype of what Rosalind Krauss has called the "expanded field"[4] of sculpture, in which the photograph becomes a document, a certificate of the operation that has taken place, but is also the authentic incarnation of the conceptual event.[5] All the same, unlike Oppenheim's work, in this case the author of the photograph was a well known professional (Harry Shunk) and the construction of the image was studied in form and manifestly constructed, to the point of revealing successive episodes of photo-montage. In addition to that, Klein's photograph was not intended for show in a gallery, but for publication in a phony edition of the *Dimanche* newspaper.

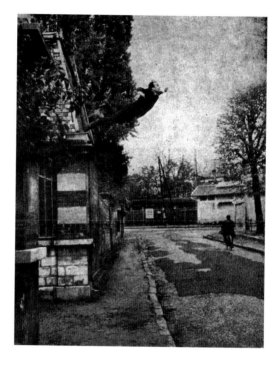

Fig. 2 Yves Klein, photograph by Harry Shunk. Fontenay - aux - Roses, Paris.

As Douglas Fogle has written,[6] there was a break with the use of photography with respect to the formalist concept of the "decisive moment" theorized by Henri Cartier-Bresson in 1932 as the essential specific feature of photography, and still dominant in the mid-1970s, for Oppenheim had taken a step further.

Lawrence Alloway, as early as 1970, noticed the peculiarity of the use our artist made of photography: from the sequence of the shots in various phases of the action to the poor definition and quality of the images; from the doubt about the authorship of the photo to the juxtaposition of

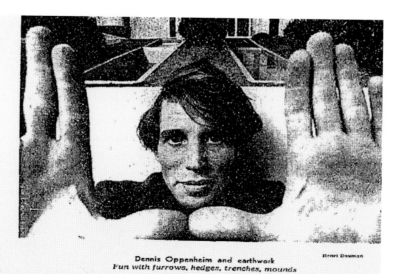

An Artful Summer

By GRACE GLUECK

SUMMER is icumen in
And galleries are
de-camping
The switched-on local
scene grows dim
While artists go East
Hamp-ing.
But, stay-at-homes, do not
despair
The city won't be artless
Our grooviest museums will
air
Bright shows displayed with
smartness.
There's minimal and art with

Dennis Oppenheim and earthwork
Fun with furrows, hedges, trenches, mounds

Henri Dauman

Fig. 3 "New York Times", solo exhibition of Dennis Oppenheim at John Gibson Gallery. Grace Glueck, An artful summer, "New York Times", 19 may 1968, sec. D., p. 35.

the latter to explanatory texts and geographical maps. All this leads us to consider the actual photograph as secondary to the event which occurred some place in the external world, despite the fact that it was through the photograph that this event reached the public, not through direct experience.[7] Alanna Heiss has in this regard pointed out the difference with respect to the complete control which Christo has always maintained over the images portraying his interventions, because in his work the very intervention upon the city or the landscape is central, as a great event addressed to the public, but central also is the authorship of the documentation itself.[8]

Returning to the example of *Parallel Stress*, the question is therefore: what, in the eyes of Visitor X, are this work and the event to which it bears witness? And in what respect does his experience when faced with this work differ from that of a New York visitor in 1970? (The case of the photographic documentation is simply a particularly significant example of an analogous conceptual use equally applicable to our artist's *maquettes*, video and drawings.)

When the twenty-nine year-old Oppenheim had his first one-man show at the John Gibson Gallery in New York in May 1968 (Fig. 3) he showed photographs, drawings and models of real or potential works created or to be created in various parts of the external world. The models were called "Ground Systems" (Fig. 4), many of which comprised, in part, live plants and water vessels. On the walls were project drawings corresponding to the various models. The press release stressed the ephemeral aspect of the young artist's work: "Dennis Oppenheim's sculpture is Alive and Growing at John Gibson." Then followed a list of the materials used: "Furrows, hedges, trench-

es, mounds, water, earth, grass."[9] Critics have concentrated chiefly on the external setting and the territorial dimension of these works as being critical of the gallery as marketplace[10] and of the most firmly entrenched conventions of the institutional spaces of art.[11] Grace Glueck in the *New York Times* (and therefore addressing the general public) started her review by stressing the impossibility of collecting the works on view: "There's a reason why collectors don't flock to acquire Dennis Oppenheim's landscapes. They're real. ... 'It stems from a need to get art out of the galleries', says Oppenheim. ... 'A lot of sculptors today are concerned with art outside of galleries, but much of what they do is simply a blow-up of gallery-scale work.'"[12] Another aspect stressed in the pronouncements of the artist himself was the contrast with respect to the Minimalist theories then dominant: "The minimalists' urge is to become more objectless — to arrive at a presence without making an object. Rather than isolate a form, I prefer to tie in with forms that already exist, as in a huge piece of landscape."[13]

Also on show were a number of *Sitemarkers* (Fig. 5), produced the previous year.[14] These are "bits of aluminum that mark photographs and descriptions of particular areas of landscape or objects: in a field, a stretch of turnpike, a building."[15] In the *National Observer* Douglas Davis picked on Dadaism as the source of this type of approach of making art as the attribution of a new meaning to something already existing in the world, a sort of environmental ready-made, rather than as the material and craftsmanly construction of objects conceived as art.[16] The artist commented: "I saw them [these places] as sculpture and they were as good as anything I could do. I didn't feel the need to create them. It was an exhaustion with the manual involvement of making art. If people wanted to buy the

Fig. 5 Dennis Oppenheim, Sitemarker n. 8, Port Jervis, 1967, Alluminium: 5'x3'. Document: black and white photography and text, 20x24 inc.

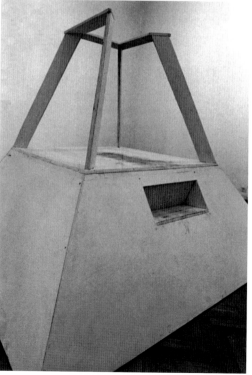

Fig. 6 Dennis Oppenheim, Viewing station # 1, 1967. Wood, 15'x15'x15'.

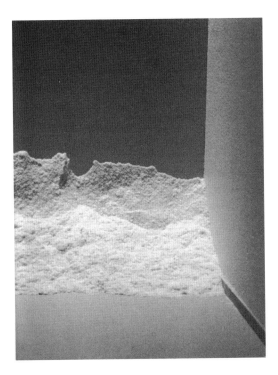

Fig. 7 Dennis Oppenheim, Gallery decomposition, 1968. Scale model: wood and lime. 18'x24'x30'.

Fig. 8 Dennis Oppenheim, Identation - Removal, 1968. Color photography and collage, each 3'x5'.

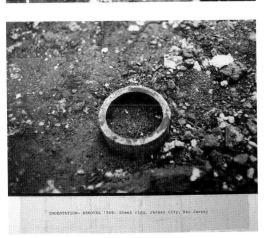

INDENTATION- REMOVAL 1968. Steel ring. Jersey City, New Jersey

site markers as sculpture, why fine."[17] A number of key features of Oppenheim's future as an artist were already contained in this first show. In the first place, the artist expressed doubts about the exhibition space and the act of looking at the work of art, shedding doubt on what a work of art is, where it is to be found and how to look at it and grasp it intellectually. Secondly, he put forward a criticism of the formalist tradition of Modernism and the cumbersome critical legacy of Clement Greenberg, who saw the only possibility of survival of the work of art in the contemporary world in a self-critique of the specificity of the medium itself in a Kantian sense. In Greenberg's vision of things, experience of the work of art has to be absolute, almost religious, free from any contact with the world and consequently experienced in a gallery or museum seen as a neutral place outside space and time. Hence the "canonization" during the 1970s of the White Cube as the ideal place for the enjoyment of art. In opposition to this Oppenheim presented in a gallery a work which pointed to a reality existing outside the gallery itself, a link with the real world, with the earth. Germano Celant has associated this type of protest with the generational rebellion of 1968 in a parallel with the Italian movement of Arte Povera.[18] As McEvilley insisted, along with many other artists in the 1960s, Oppenheim had recourse to Duchamp in order to overcome the new romantic-modernist academicism inherited from the previous decade. It was in this sense that his pseudo-scientific language was to be understood. Finally there emerged from this exhibition the conscious dialectical elimination of reflection on the object and the primary structures of Minimalism, in a new and double direction: on the one hand the dissolution of the object-artefact, and at the same time the need for a new contact

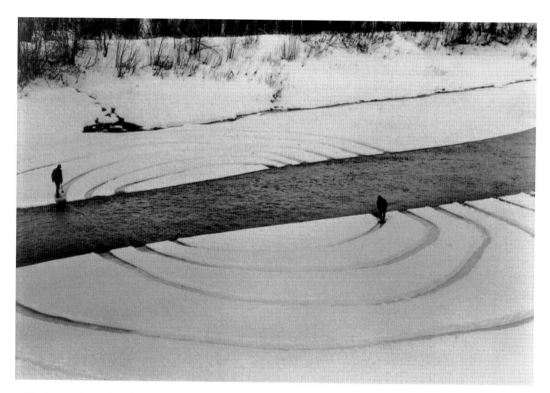

Fig. 9 Dennis Oppenheim, Annual rings, 1968. Tyhe schema of lines depicting the annual growth of a tree is mapped as pathways shoveled out of snoww, and is bisected by the river that forms the United States and Canadian boundary line. A collage of scales and a contrast of durable and transient materials (wood and snow) are used to the intertwine and root together familiar concepts of tree rings, time zones, and geopolitical boundaries.

with the real world, dirty and ever-changing as it is. Significant with regard to this new way of feeling was the release in that same year of 1968 of Stanley Kubrick's film *2001: Space Odyssey*, in which it was the contrast of the smooth elemental prism (which cannot but recall the aesthetic of a Donald Judd) on the bare earth that symbolized the tendency towards or the rift between man, world and knowledge. As regards the anti-commercial dispute, Oppenheim obviously insinuated a trenchant doubt about the system of indiscriminate production and sale of art objects by himself creating not objects, and not non-objects (in the sense used by Donald Judd), but rather products suggestive of something that eluded any notion of merchandise. But it would be naïve and on the verge of intellectual dishonesty to think of these works as a rejection of the market. All the more so because, as pointed out by Suzaan Boettger, this very exhibition was held on commercial premises (however unusual), and its success led within a few months to the young artist's exhibiting at the Dwan, a gallery on 57th Street in Manhattan, which is to say the very hub of the world art market.

Oppenheim's success was in fact immediate. In that same May of 1968, at the Green Gallery in San Francisco, he exhibited photographs and models of structural elements germinating from the soil with the relative maps to show their locations. That summer he was interviewed by Lucy Lippard for *Newsweek*, in the famous article "The New Art"[20] which sparked off the debate on the "dematerialization" of the object in art. That summer he succeeded in producing some of the most important of his *Earthworks*, including *Salt Flat* (see below). In October he took part in the historic collective exhibition *Earth Works* at the Dwan Gallery, along with some of the most important former Minimalist and Pop artists, who had recently gone over to the new field of research

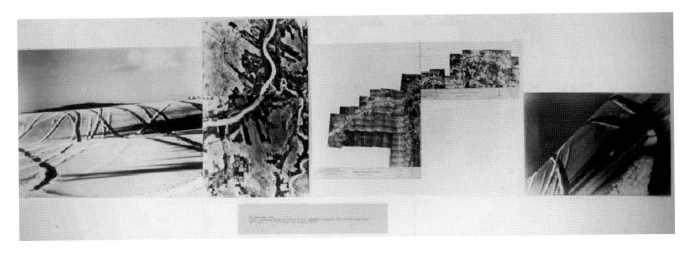

Fig. 10 Dennis Oppeneheim, One hour run, 1968. St. Francis Maine. 1'x3'x6' miles, 1 hour.

Fig. 11 Dennis Oppenheim, Salt flat, 1968. New York City. Baker's salt. 50'x100'. One thousand pounds of baker's salt are spread in a rectangle on an asphalt - covered parking lot. Two additional formations of identical dimensions are proposed: one made of one foot by one foot lick blocks to be laid on the ocean floor off the Bahama Coast; the second to be excaveted to a depth of one foot in the Salt Lake Desert, Utah.

Fig. 12 Dennis Oppenheim, Reading position for second degree burn, 1970. Jones beach, New York. Skin, book, solar energy. Duration of exposure: 5 hours.

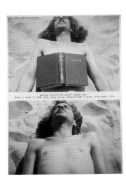

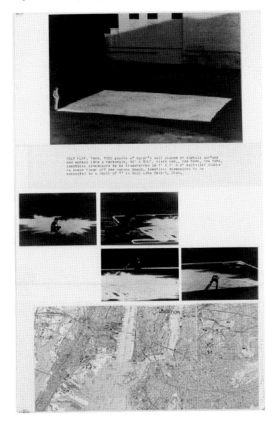

on the Earth. These included Robert Morris and Carl Andre, Claes Oldenburg and Robert Smithson. Oppenheim was the only one to have actually started out as an Earth Artist. As early as January 1969 Oppenheim, in a second one-man show at the John Gibson Gallery, exhibited some of his most successful works, created on the US-Canadian border. These included *Annual Rings*, *Time Pocket* and *One Hour Run* (see below).

Starting from this nodal moment, by means of a number of examples typifying the complex phenomenological range of the artist's work during these years, it is possible to obtain a brief outline of the directions his research has taken from the beginnings and leading up to Body Art.

In 1967, as we have seen, he created the series *Sitemarkers*. Dating from the same year are the *Viewing Stations* (Fig. 6), which are platforms raised either in a gallery or in the open air, onto which the visitor is invited to step. This causes a reversal of the relationship between the observer and the art object, since the work is no longer what one is looking at but the place from which to look. Also a critical judgement on the conventions of artistic enjoyment are the *Decompositions* (Fig. 7), the work of 1968. These are models of exhibition spaces which reveal the material of which they are made (lime without water) — in fact mere heaps of white powder which give rise to an image of disintegration, a desecrating portrait of the White Cube. Dating from 1968–69 we find the *Indentations–Removals* (Fig. 8). These are discarded objects found in dirty and abandoned places, which are then removed, leaving on the ground the mark of where they are missing, a striking negation of the object. As McEvilley has suggested, the period 1968–70 can be considered the period of "pure" Earth Art.[21]

I will now proceed to describe three key works. In *Annual Rings* (1968, Fig. 9), the artist has made paths in the snow which reproduce on a vast scale the annual growth rings of a tree. These concentric rings are made in such a way as to straddle the river marking the border between the United States and Canada and also the line between two time zones. We therefore have a superimposition of the perceived and the formal notions of time, natural, artificial and mental signs, and geographical and political locations. During the same period and also there on the border Oppenheim also made *One Hour Run* (Fig. 10), which traces one hour's nonstop run on a snowmobile. Time is translated into a physically visible and geographically identifiable sign, but in snow, the ephemeral material par excellence. In *Salt Flat* (1968, Fig. 11) the artist has sprinkled as much coarse salt as he could buy with the money he had in his pocket onto a rectangular area in an asphalted car park in Manhat-

tan. Part and parcel of the project is the subsequent creation of a rectangle of the same size on the ocean bottom of the Bahamas Coast, and another identical rectangle dug into the Salt Lake Desert in Utah. Here the concept of a natural element and the notions of positive and negative are eliminated by the incongruent equivalence between irreconcilable locations and levels. In Oppenheim's Body Art works in the years 1970–74, the body progressively ceases to be the parameter and yardstick for measuring the world, and becomes the central place and object itself. The celebrated *Reading Position for Second Degree Burn* (1970, Fig. 12) has been described by the artist himself as follows: "The piece incorporates an inversion or reversal of energy expenditure. The body is placed in the position of recipient … an exposed plane, a captive surface. The piece has its roots in a notion of color change. Painters have always artificially instigated color activity. I allow myself to be painted — my skin becomes pigment. I can regulate its intensity through control of the exposure time. Not only do the skin tones change, but change registers on a sensory level as well. I feel the act of becoming red."[22]

The *Genetic Works* of 1971 come within the context of Body Art. Among the most intense is *Transfer Drawing* (Fig. 13), which Oppenheim describes as follows: "As I run a marker along Erik's back, he attempts to duplicate my movement on the wall. My activity stimulates a kinetic response from his memory system. I am ... drawing through him. Because Erik is my offspring, and we share similar biological ingredients, his back … can be seen as an immature version of my own … In a sense, I make contact with a past state. When the roles are reversed, and Erik draws on his father's mature back, he makes contact, in a sense, with his future state."[23]

What we have here is an operation carried out on several levels simultaneously, and consisting of baffling fragments and transitions, in clean contrast to the principles of continuity and coherence in a Modernist sense. It is a "strategy" which corresponds to the continual transference of sense between inharmonious systems which create a short circuit between the level of perception and that of understanding. As Oppenheim has said of his work: "It's not mental, not visual, but somewhere in between."[24] And it is at the very moment when the circuit breaks that Oppenheim is able to spark off in the visitor a critical dimension which opens up a network of relations with the outside world, and thereby forces him to reflect upon the manner and location of his own way of looking.

Returning to the present day, time has charged these objects and images with a potent iconic significance, and surrounded those actions with an almost mythological aura, rendering the experience of today's visitor very different from that of the New Yorker of 1970 when confronted with the same objects. What is lacking is a

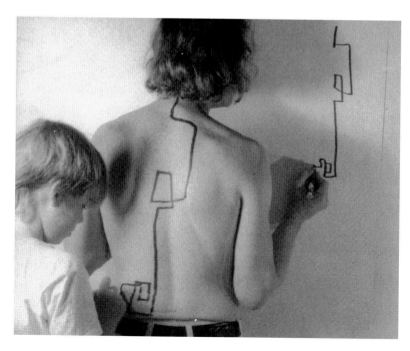

Fig. 13 Dennis Oppenheim, Two stage transfer drawing (Advancing to a future state). Erik to Dennis Oppenheim, 1971. Boise, Idaho. Felt - tip markers, wall, human backs.

further link in the circuit, that contact with the fact as perceived as a real moment in the real world. A new short circuit has been created, with respect to collective history and memory, forcing the observer into a new and complex reflection upon the here and now of the position from which he is observing.

New York, March 2007

[1] Thomas McEvilley, "The rightness of wrongness: Modernism and its alter-ego in the work of Dennis Oppenheim", in Alanna Heiss, *Dennis Oppenheim: Selected Works, 1967–90. And the ming grew finger*, exhibition catalogue, P.S.1 Museum, New York, 8 December 1991 – 2 February 1992, Institute for Contemporary Art, P.S.1 Museum in association with Harry N. Abrams, New York 1992, pp. 7–76.

[2] Germano Celant, *Dennis Oppenheim*, Charta, Milan 1997; Germano Celant, *Dennis Oppenheim: explorations*, Charta, Milan 2001.

[3] In fact, depending on the publication, two different versions of the first photograph were reproduced, taken from two different angles. The one reproduced here is attributed to Robert K. McElory. The mention of the author is in any case something rare, and the small importance of establishing an official image is further confirmed by the existence of two versions of the same work.

[4] Rosalind Krauss, "Sculpture in the Expanded Field", in *October*, 8 (Spring 1979), pp. 30–44.

[5] Douglas Fogle, "The Last Picture Show", in *The Last Picture Show: Artists Using Photography, 1960–1962*, exhibition catalogue, ed. by D. Fogle, Walker Art Center, Minneapolis, Minnesota, 11 October 2003 – 4 January 2004, Walker Art Center, Minneapolis 2003, pp. 9–19.

[6] "Neither simply performance nor document and far from an aesthetic embodiment of modernist photography's hermetic concern with its own limits and conditions of possibility, this work disrupted the standard circuits of the reception of both photography as art and the traditional object of sculpture by surreptitiously inserting itself into the flow of consumer print culture." Fogle 2003, p. 10.

[7] Lawrence Alloway, *Artists and Photographs*, Multiples Inc., New York 1970.

[8] Heiss 1992, p. 145.

[9] For a careful reconstruction of the show cf. Suzaan Boettger, *Earthworks: Art and Landscape of the Sixties*, University of California Press, Berkeley, Los Angeles & London 2002, pp. 120–23.

[10] Grace Glueck, "An artful summer", in *New York Times*, 19 May 1968, Section D, p. 35.

[11] Douglas Davis, "Dada loses its shock effect, and the crowds flock around", in *National Observer*, 7, no. 3 (Summer 1968), p. 17.

[12] Glueck 1968, p. 35.

[13] Ibid.

[14] Worth noting is the analogy with the conceptually identical work by Renato Mambor, E*videnziatore*, dating from the same year of 1968.

[15] Glueck 1968, p. 35.

[16] Davis 1968, p. 17.

[17] Glueck 1968, p. 35.

[18] Celant 1997, pp. 10–11.

[19] Boettger 2002, pp. 123–24.

[20] "The New Art. It's Way, Way Out", in *Newsweek*, 29 July 1968, pp. 56–63.

[21] McEvilley 1992, op. cit., pp. 16-20.

[22] Dennis Oppenheim, caption for *Reading Position...*, in Heiss 1992, p. 62.

[23] Dennis Oppenheim, caption for *Transfer Drawing...*, in Heiss 1992, p. 72.

[24] Dennis Oppenheim interviewed by Alanna Heiss, in Heiss 1992, p. 137.

Cortocircuito:
gli esordi di Oppenheim e il pubblico odierno

Raffaele Bedarida

Sebbene le opere esposte presso Montrasio Arte coprano buona parte del percorso artistico di Dennis Oppenheim svoltosi nell'arco degli ultimi quarant'anni e in pieno divenire, eviterò in questa sede di ripeterne la narrazione storico-critica, in quanto questo è già stato fatto, con minuzia e da differenti punti di vista: soprattutto da Thomas McEvilley nel catalogo della mostra tenutasi al P.S.1 di New York nel 1991[1], e da Germano Celant nella monografia pubblicata nella doppia edizione in italiano e in inglese rispettivamente nel 1997 e nel 2001[2]. Piuttosto, l'attenzione della mostra milanese e di questo mio testo si focalizza principalmente sul periodo degli esordi dell'artista, tra lo scorcio degli anni sessanta e gli inizi dei settanta del Novecento. L'intento è quello di affrontare una questione allo stesso tempo cruciale e paradossale. Ovvero: prendiamo in considerazione un generico visitatore X, che in una giornata di primavera del 2007, da via Brera entra in galleria e vede, per esempio, *Parallel Stress* (Fig. 1). Probabilmente sa di avere di fronte un'opera chiave non solo nel percorso artistico di Oppenheim, ma nella storia dell'arte della seconda metà del Novecento. Il motivo della sua importanza può essere rintracciato su ogni manuale: *Parallel Stress* fa del corpo il metro fisico per misurare e sondare il mondo esterno, segnando simbolicamente il passaggio dall'indagine sul paesaggio a quella sul proprio corpo, dalla Earth Art alla Body Art. In pratica, però, il visitatore X ha di fronte a sé due immagini fotografiche accompagnate da un testo esplicativo: la prima fotografia mostra quello che si apprende essere l'artista che, faccia rivolta verso il basso, si tiene sospeso tra due muri, inarcando estremamente il proprio corpo. Il contesto è il degrado urbano ai piedi di un pilone di un ponte americano che si apprende essere il Manhattan Bridge; la seconda fotografia mostra lo stesso artista in una posizione analoga. Ora non è sospeso nel vuoto, bensì è sdraiato supino tra due dossi che apprendiamo trovarsi a Long Island. Il corpo inarcato è fotografato in modo tale da trovarsi esattamente sulla linea tra cielo e terra. Il testo ci informa che si tratta della documentazione fotografica di una doppia operazione avvenuta nel 1970, durata dieci minuti quella raffigurata nella prima fotografia, un'ora la seconda. Il testo spiega anche che la fotografia è stata scattata al punto massimo di inarcamento, subito prima del collasso. Il corpo diventa vero e proprio strumento di misura di tensione, e, collocato in due luoghi diversi, innesca un senso di specularità tra due siti geografici altrimenti scollegati. Non sappiamo né chi abbia scattato la fotografia[3] (fatto tanto più anomalo nel contesto statunitense, dove particolare attenzione è sempre dedicata alla paternità delle immagini) né se, fuori dall'inquadratura, ci fosse un pubblico. Anche se qualcuno era presente a entrambe le operazioni, di Manhattan e Long Island, non sarebbe comunque

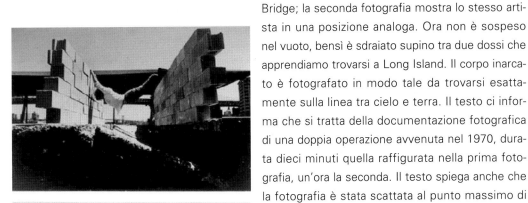

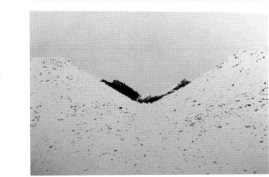

Fig. 1 Dennis Oppenheim, *Parallel stress*, 1970. Operazione. Molo tra i ponti di Brooklyn e Manhattan, e discarica abbandonata a Long Island, New York. Mattoni, terra. Durata in posizione di tensione: 10 minuti; posizione tra i dossi: 1 ora.

stato questo il principale veicolo comunicativo del fatto. Il paragone obbligato è con il celebre *Salto nel vuoto* (1960) di Yves Klein (Fig. 2), considerato il capostipite di quello che Rosalind Krauss ha chiamato "expanded field"[4] (territorio espanso) della scultura, in cui la fotografia diveniva documento, certificato di avvenuta operazione, ma anche vera e propria incarnazione dell'evento concettuale[5]. Tuttavia, a differenza dell'opera di Oppenheim, in questo caso l'autore dello scatto era un professionista accreditato (Harry Shunk) e la costruzione dell'immagine, formalmente studiata e visibilmente costruita, riportava addirittura successivi interventi di foto-montaggio. Inoltre la fotografia di Klein non era pensata per essere esposta in galleria, bensì diffusa attraverso un'edizione fasulla del quotidiano *Dimanche.* Come ha scritto Douglas Fogle, la rottura nell'utilizzo del mezzo fotografico avve-

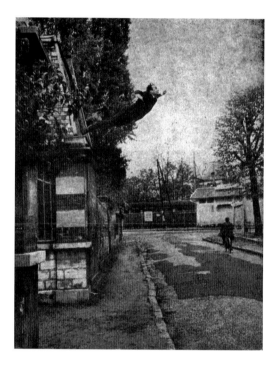

Fig. 2 Yves Klein, *Salto nel vuoto*, 1960, evento concettuale. Fotografia scattata da Harry Shunk. Ritrae Yves Klein nell'atto di cadere da un cornicione nella periferia di Parigi, Fontenay-aux-Roses.

niva rispetto al concetto formalista del "momento decisivo" teorizzato da Henri Cartier-Bresson nel 1932 come caratteristica essenziale della specificità fotografica, e ancora dominante alla metà degli anni sessanta, per esempio nell'influente dipartimento di fotografia del MoMA sotto la direzione di John Szarkowski: "Non semplicemente performance né documento, ma ancor più lontana dalla concretizzazione estetica dell'interesse modernista della fotografia per i propri limiti e condizioni potenziali, quest'opera ha infranto il circuito standard della ricezione sia della fotografia

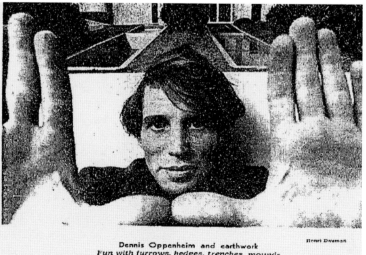

Fig. 3 Immagine tratta dalla recensione apparsa sul "New York Times" della prima mostra personale di Dennis Oppenheim presso la galleria John Gibson: Grace Glueck, *An artful summer*, in "New York Times", 19 maggio 1968, sec. D, p. 35.

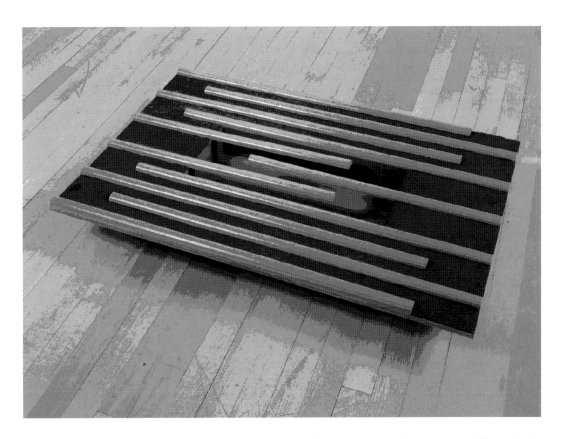

come arte, sia dell'oggetto tradizionale della scultura, infiltrandosi surrettiziamente nel flusso della cultura della stampa di consumo"[6].

Oppenheim ha compiuto un passo ulteriore. Lawrence Alloway, già nel 1970, notava tempestivamente la peculiarità dell'utilizzo che il nostro artista ha fatto del mezzo fotografico: dalla sequenzialità degli scatti in fasi differenti delle azioni alla scarsa definizione e qualità delle immagini; dalla casualità dell'autore dello scatto alla giustapposizione della fotografia a scritte esplicative e carte geografiche. Tutto ciò spinge a considerare secondario l'oggetto fotografico rispetto al fatto avvenuto in un luogo del mondo esterno, nonostante fosse comunque tramite la documentazione fotografica che questo fatto raggiungeva il pubblico, e non per esperienza diretta[7]. La Heiss ha notato in proposito la differenza rispetto al controllo assoluto che Christo ha sempre avuto delle immagini che ritraggono i suoi interventi, corrispondente a una diversa centralità che nella sua opera ha da una parte l'intervento stesso sulla città e sul paesaggio come grande evento rivolto al pubblico, ma anche l'autorialità della documentazione stessa[8].

Tornando all'esempio di *Parallel Stress*, la domanda dunque è: cosa sono, agli occhi del visitatore X, quest'opera e il fatto che essa testimonia? E in che cosa la sua esperienza di fronte a quest'opera è cambiata rispetto a quella di un visitatore newyorchese del 1970? (il caso della documentazione fotografica è semplicemente un esempio particolarmente significativo di un analogo utilizzo concettuale applicabile anche a *maquettes*, video e disegni del nostro artista).

Quando il ventinovenne Oppenheim esordì con la prima mostra personale a New York presso la

John Gibson Gallery nel maggio del 1968 (Fig. 3), esponeva fotografie, disegni e modelli di opere reali o potenziali, realizzate o da realizzarsi in luoghi diversi del mondo esterno. I modelli erano intitolati "Ground Systems" (Fig. 4), e molti di essi si componevano, tra l'altro, di piante vive e contenitori d'acqua. Alle pareti erano disegni progettuali corrispondenti ai vari modelli. Il comunicato stampa sottolineava l'aspetto effimero delle opere del giovane artista: "La scultura di Dennis Oppenheim è Viva e in Crescita da John Gibson"; di seguito erano indicati i materiali utilizzati: "solchi, siepi, canali, terrapieni, acqua, terra, erba"[9]. I critici hanno concentrato la loro attenzione principalmente sulla collocazione esterna e la dimensione territoriale di queste opere come critica alla galleria in quanto mercato[10] e alle più assodate convenzioni degli spazi istituzionali dell'arte[11]. Grace Glueck sul "New York Times" (dunque rivolgendosi a non addetti ai lavori) apriva la recensione sottolineando l'impossibilità di collezionare le opere in mostra: "C'è un motivo se i collezionisti non comprano i paesaggi di Dennis Oppenheim: perché sono reali […] '[questo] deriva da un bisogno di uscire dalle gallerie', dice Oppenheim […] 'Molti scultori oggi sono interessati all'arte fuori dalle gallerie, ma gran parte di quel che fanno è semplicemente un ingrandimento di opere da galleria'"[12].

Altro aspetto che emergeva dalle dichiarazioni dell'artista era il contrasto rispetto alle istanze minimaliste allora dominanti: "I minimalisti sentono il bisogno di annullare l'oggetto, di arrivare a una presenza senza costruire un oggetto. Piuttosto che isolare una forma, io invece preferisco creare un legame con forme già esistenti, come in un grande tratto di paesaggio"[13].

In mostra erano anche alcuni *Sitemarkers* (Fig. 5), realizzati nell'anno precedente[14]. Ovvero: "pezzi in alluminio che segnalano fotografie e descrizioni di particolari aree del paesaggio o

Fig. 5 Dennis Oppenheim, *Sitemarker n.8*, Port Jervis, 1967, Alluminio inciso: 102x150x270 cm, Documento: fotografia in bianco e nero e testo, 50x60 cm.

Fig. 6 Dennis Oppenheim, *Viewing station # 1*, 1967.Costruzione in legno. 450x450x450 cm.

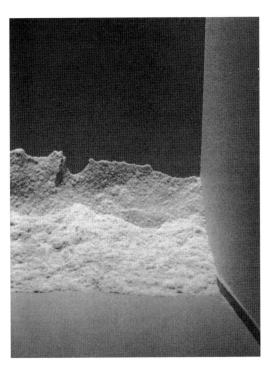

Fig. 7 Dennis Oppenheim,
Gallery decomposition, 1968.
Modello in scala: legno,
cemento, calce. 45x60x75
cm.

Fig. 8 Dennis Oppenheim,
Indentation-Removal, 1968.
Fotografia a colori e collage,
104x152 cm ognuno.

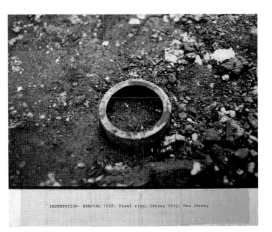

INDENTATION- REMOVAL 1968. Steel ring, Jersey City, New Jersey

oggetti: un campo, un tratto di autostrada, un palazzo"[15]. Douglas Davis sul "National Observer" indicava nel Dadaismo la fonte ispiratrice per questo tipo di approccio al fare arte come attribuzione di nuovo significato a qualcosa di già esistente nel mondo, sorta di *ready-made* ambientale, piuttosto che come costruzione materiale e artigianale di oggetti concepiti come arte[16]. L'artista commentava: "Ho individuato [questi luoghi] come scultura, e vanno altrettanto bene che qualsiasi cosa avessi potuto fare io. Non ho sentito il bisogno di crearli. È avvenuto un esaurimento della necessità di intervento manuale nel fare arte. Se la gente volesse comprare i Site Markers come scultura, perché no"[17]. Alcuni punti chiave della futura ricerca di Oppenheim erano già in questa mostra. Infatti, prima di tutto l'artista proponeva una riflessione problematica sullo spazio espositivo e sull'atto di guardare l'opera d'arte, mettendo in dubbio qual è e dove si trova l'opera, come guardarla e afferrarla intellettualmente. In secondo luogo avanzava una critica alla tradizione formalista del Modernismo e all'ingombrante retaggio critico di Clement Greenberg, che vedeva l'unica possibilità di sopravvivenza per l'opera d'arte nel mondo contemporaneo in un'autocritica sulla specificità del mezzo stesso in senso kantiano. Nella visione di Greenberg, l'esperienza dell'opera d'arte doveva essere assoluta, quasi religiosa, avulsa da ogni contatto con il mondo, vissuta di conseguenza nella galleria o nel museo intesi come luogo neutro fuori dal tempo e dallo spazio. Da qui la canonizzazione negli anni sessanta del *white cube* come luogo ideale della fruizione dell'arte. A questo Oppenheim opponeva la presentazione in galleria di un'opera che era indice di una realtà esistente fuori dalla galleria stessa, legame con il mondo reale, con la terra. Germano Celant ha collegato questo tipo di protesta alla ribellione generazionale del Ses-

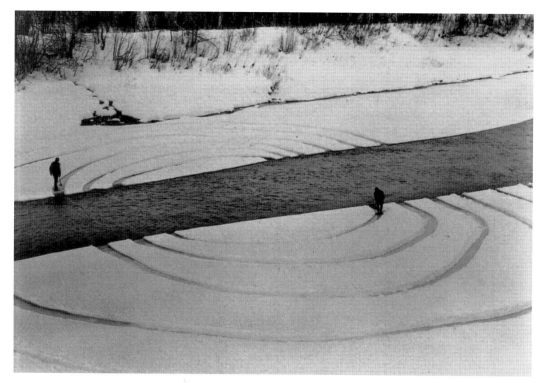

Fig. 9 Dennis Oppenheim, *Annual rings*, 1968. Sul confine tra Stati Uniti e Canada a Fort Kent nel Maine, e Clair nel Brunswick. Ora: USA 1.30 PM, Canada 2.30 PM. Ascia, pala, ghiaccio, neve, 45x60 mt.

santotto in un parallelo con l'italiana Arte povera[18]. Come ha insistito McEvilley, Oppenheim, insieme a moltissimi altri artisti negli anni sessanta, è ricorso a Duchamp per superare la nuova accademia romantico-modernista ereditata dal decennio precedente. In questo senso erano da intendere il metodo e linguaggio di tipo pseudo-scientifico. Dalla mostra emergeva infine il consapevole superamento dialettico della riflessione sull'oggetto e sulle strutture primarie del Minimalismo, in una nuova, doppia direzione: da una parte la dissoluzione dell'oggetto-manufatto, e allo stesso tempo la necessità di un nuovo contatto con il mondo vero, sporco e sempre mutevole. Significativa di questa nuova sensibilità l'uscita nello stesso 1968 del film *2001: Odissea nello spazio* di Stanely Kubrick, in cui era proprio il contrasto del prisma liscio ed elementare (che non può non ricordare l'estetica di un Donald Judd) sulla nuda terra a incarnare *il tendere a* o il divario tra uomo, mondo e conoscenza. Per quanto riguarda la polemica anti-commerciale, evidentemente Oppenheim insinuava un dubbio penetrante nel sistema dato di acritica produzione e vendita di oggetti d'arte, attraverso la creazione non di oggetti, né di non-oggetti (nel senso usato da Donald Judd), bensì di prodotti indiziali di qualcosa che sfuggiva alla nozione di merce. Ma sarebbe ingenuo e al limite della disonestà intellettuale considerare queste opere come rifiuto del mercato. Tanto più che, come ha notato Suzaan Boettger, questa stessa mostra avveniva di fatto in uno spazio commerciale (per quanto anomalo), il cui successo ha condotto in pochi mesi il giovane artista a esporre da Dwan, una galleria collocata sulla 57th Street di Manhattan, ovvero nel fulcro del mercato dell'arte mondiale[19].

Il successo di Oppenheim infatti è stato immediato. Nello stesso maggio 1968 esponeva alla Green Gallery di San Francisco fotografie e modelli di elementi strutturali germinanti dal terreno con le relative mappe geografiche che ne mostravano la collocazione; quell'estate veniva intervistato da

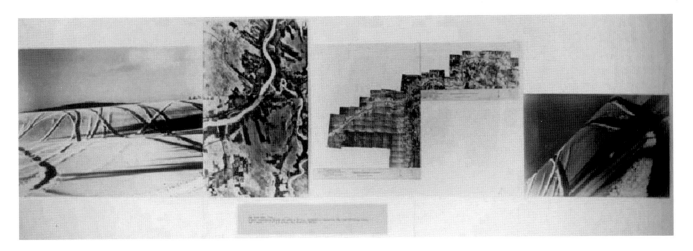

Fig. 10 Dennis Oppenheim, *One hour run*, 1968. St. Francis nel Maine. Gatto delle nevi da 10 horsepower. 1.6x4.8x9.6 km. Durata: 1 ora.

Lucy Lippard per il settimanale "Newsweek", nel famoso articolo *The New Art*[20] che avrebbe avviato il dibattito sulla "dematerializzazione" dell'oggetto d'arte. Durante quell'estate ha potuto eseguire alcuni dei suoi più importanti *Earthworks*, tra i quali *Salt Flat* (vedi più avanti); nell'ottobre, si è visto, ha partecipato alla storica mostra collettiva "Earth Works" presso la Dwan Gallery con alcuni dei più importanti tra gli ex minimalisti e "Pop Artists", recentemente passati al nuovo ambito di ricerca sulla Terra: da Robert Morris a Carl Andre, Claes Oldenburg e Robert Smithson. Oppenheim era l'unico a esordire come "Earth Artist". Già nel gennaio del 1969 Oppenheim esponeva in una seconda personale da John Gibson alcune delle sue opere più efficaci, realizzate sul confine tra Stati Uniti e Canada: *Annual Rings*, *Time Pocket* e *One Hour Run* (vedi più avanti).

Da questo momento nodale, attraverso una ricostruzione schematica ed esemplificativa del complesso ventaglio fenomenologico in cui l'artista lavorava in questi anni, si può sommariamente disegnare il complesso intrecciarsi di percorsi di ricerca dagli esordi alla Body Art.

Nel 1967, s'è visto, realizza la serie dei *Sitemarkers* (Segnaluoghi). Dello stesso anno sono le *Viewing Stations* (Postazioni per guardare, Fig. 6), ovvero pedane da collocarsi in galleria o all'aperto, sulle quali il visitatore è invitato a salire. Viene così ribaltato il rapporto tra osservatore e oggetto d'arte, dal momento che l'opera non è più ciò che si guarda ma il luogo da cui guardare. Una riflessione critica sulle convenzioni della fruizione artistica sono anche le *Decompositions* (Decomposizioni, Fig. 7), realizzate nel 1968. Sono modelli di spazi espositivi che mostrano la propria composizione materiale (calce senza acqua), ovvero cumuli di polvere bianca, dando vita a un'immagine di disfacimento, ritratto dissacrante del *white cube*. Del biennnio 1968-1969 sono le *Indentations – Removals* (Impressioni – Rimozioni, Fig. 8): oggetti di scarto individuati in luoghi abbandonati e sporchi venivano rimossi lasciando sul terreno il segno della loro assenza, eclatante negazione dell'oggetto. Ogni operazione è documentata da due fotografie prima e dopo la rimozione.

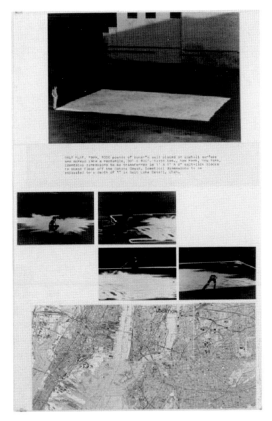

Fig. 11 Dennis Oppenheim, *Salt flat*, 1968. Fotografie a colori e fotografie in bianco e nero, mappa topografica, 152 x 102 cm.

Fig. 12 Dennis Oppenheim, *Reading position for second degree burn*, 1970. Jones Beach, New York. Pelle, libro, energia solare. Durata di esposizione: 5 ore.

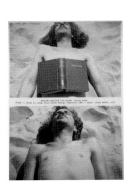

Come ha suggerito McEvilley, si può considerare fase "pura" della Earth Art il periodo tra il 1968 e il 1970[21]. Ne descrivo qui tre opere chiave. *Annual Rings* (1968, Fig. 9): l'artista ha segnato sulla neve dei sentieri che disegnano una mappa macroscopica degli anelli di crescita annuale di un albero. Gli anelli concentrici sono realizzati a cavallo del fiume che costituisce la linea di confine tra Stati Uniti e Canada e la linea temporale del passaggio di fuso orario. Si tratta dunque della sovrapposizione di nozioni di tempo vissuto e convenzionale, segni naturali, artificiali e mentali, luoghi geografici e politici. Nello stesso perio-

do e sempre lungo quel confine Oppenheim realizza *One Hour Run* (Percorso di un'ora, Fig. 10), ovvero il tracciato sulla neve segnato da un'ora di guida ininterrotta su un gatto delle nevi. Il tempo è tradotto in tracciato fisico localizzabile geograficamente, ma sulla neve: materiale effimero per eccellenza. In *Salt Flat* (Superficie di sale, 1968, Fig. 11), l'artista sparge la quantità di sale grosso che si è potuto permettere di comprare con i soldi che aveva in tasca su un'area rettangolare di un parcheggio asfaltato nel centro di Manhattan. Parte del progetto è la successiva realizzazione di un rettangolo delle stesse dimensioni sul suolo sottomarino a largo della Bahama Coast, e uno scavato nel Salt Lake Desert, nello Utah. Saltano qui il concetto di elemento naturale, le nozioni di positivo e negativo, tramite l'incongruente equivalenza tra luoghi e livelli inconciliabili. Da parametro e strumento materiale di misurazione del mondo, il corpo progressivamente diviene luogo e oggetto centrale della ricerca di Oppenheim, nell'ambito della Body Art, tra 1970 e 1974. La celebre *Reading Position for Second Degree Burn* (Posizione di lettura per un'ustione di secondo grado, 1970, Fig. 12), è stata descritta dallo stesso artista: "Il pezzo vede un'inversione o capovolgimento di impiego d'energia. Il corpo è messo nella posizione di recipiente [...] un piano esposto, una superficie coatta. Il pezzo ha le sue origini nella nozione di cambiamento di colore. I pittori hanno sempre portato avanti artificialmente un'attività basata sul colore. Io rendo me stesso dipingibile – la mia pelle diventa pigmento. Posso regolare la sua intensità attraverso il controllo del tempo di esposizione. Non solo cambia il tono di colore della pelle, ma il cambiamento si registra anche a livello sensoriale. Io percepisco l'atto di divenire rosso"[22].

Sotto-ambito della Body Art, di rapporto del corpo con una mappatura di tipo genetico, sono i *Genetic Works* del 1971. Tra i più intensi è *Transfer Drawing* (Fig. 13), che Oppenheim ha così decritto: "Mentre io faccio scorrere un pennarello sulla schiena di Erik, egli cerca di riprodurre il mio movimento sul muro. La mia attività stimola una risposta cinetica dal suo sistema mnemonico. Io sto [...] disegnando attraverso di lui. Dal momento che Erik è mio figlio, e noi condividiamo ingredienti genetici analoghi, la sua schiena può essere vista come una versione immatura della mia stessa schiena [...] In un certo senso, creo un contatto con uno stadio passato. Quando i ruoli vengono invertiti, ed Erik disegna sulla schiena matura di suo padre, in un certo senso crea un contatto con il suo futuro"[23].

Si tratta di un metodo operativo portato avanti simultaneamente su più livelli, e fatto di scarti e passaggi spiazzanti, in netto contrasto con i principi di continuità e coerenza in senso modernista. È una "strategia" che corrisponde al continuo trasferimento di senso tra sistemi disomogenei che creano un cortocircuito tra il livello del percepire e quello del comprendere. Come ha affermato lo stesso Oppenheim, il suo lavoro

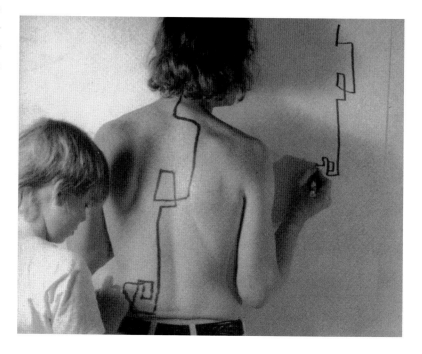

Fig. 13 *Two stage transfer drawing (Advancing to a future state). Erik to Dennis Oppenheim*, 1971. Boise, Idahio. Pennarello dalla punta di feltro, muro, schiena umana.

"non è mentale né visivo, ma sta da qualche parte nel mezzo"[24]. Ed è proprio nel momento in cui il circuito salta che Oppeheim è in grado di innescare nel visitatore una dimensione critica che, aprendo una rete a sua volta aperta di relazioni con il mondo esterno, lo riconduce a una problematizzazione del modo e del luogo del proprio guardare.

Tornando a oggi, il tempo ha caricato questi oggetti e queste immagini di un forte valore iconico, e ha avvolto quelle azioni di un'aura quasi mitologica, rendendo l'esperienza dell'odierno visitatore certamente differente da quella di un visitatore newyorchese nel 1970, di fronte agli stessi oggetti: è venuto meno un ulteriore nesso all'interno del circuito, il contatto con il fatto percepito come momento reale del mondo reale. Un nuovo cortocircuito si è creato rispetto alla storia e alla memoria collettiva, costringendo chi guarda a una rinnovata, problematica riflessione sul qui e ora della posizione da cui osserva.

New York, marzo 2007

[1] Thomas McEvilley, "The rightness of wrongness: Modernism and its alter-ego in the work of Dennis Oppenheim", in Alanna Heiss, *Dennis Oppenheim: selected works, 1967–90. And the ming grew finger*, catalogo della mostra, New York, P.S.1 Museum, 8 dicembre 1991 – 2 febbraio 1992, Institute for Contemporary Art, P.S.1 Museum, in association with Harry N. Abrams, New York 1992, pp. 7-76.

[2] Germano Celant, *Dennis Oppenheim*, Charta, Milano 1997; Germano Celant, *Dennis Oppenheim: explorations*, Charta, Milano 2001.

[3] In realtà, a seconda della pubblicazione, vengono riprodotte due diverse versioni della prima fotografia (presa da due angolature diverse). L'immagine qui riprodotta è attribuita a Robert K. McElory. La citazione dell'autore è comunque un fatto raro e la scarsa importanza di stabilire un'immagine ufficiale è ulteriormente confermata dalla presenza di più versioni della stessa opera.

[4] Rosalind Krauss, *Sculpture in the Expanded Field*, in "October", a. 8 (primavera 1979), pp. 30-44.

[5] Duoglas Fogle, "The Last Picture Show", in *The Last Picture Show: Artists Using Photography, 1960–1982*, catalogo della mostra, a cura di Douglas Fogle, Walker Art Center, Minneapolis, Minnesota, 11 ottobre 2003 – 4 gennaio 2004, Walker Art Center, Minneapolis 2003, pp. 9-19.

[6] Fogle 2003, p. 10. Questa e le successive traduzioni dall'inglese sono dell'autore.

[7] Lawrence Alloway, *Artists and Photographs*, Multiples Inc., New York 1970.

[8] Heiss 1992, p. 145.

[9] Per un'attenta ricostruzione della mostra cfr. Suzaan Boettger, *Earthworks: Art and Landscape of the Sixties*, University of California Press, Berkeley, Los Angeles, London 2002, pp. 120-123.

[10] Grace Glueck, *An artful summer*, in "New York Times", 19 maggio 1968, sec. D, p. 35.

[11] Douglas Davis, *Dada loses its shock effect, and the crowds flock around*, in "National Observer", a. 7, n. 3, estate 1968, p. 17.

[12] Glueck 1968, p. 35.

[13] *Ibid.*

[14] Degna di nota l'analogia con l'opera concettualmente identica, "Evidenziatore", realizzata nello stesso 1967 da Renato Mambor.

[15] Glueck 1968, p. 35.

[16] Davis 1968, p. 17.

[17] Glueck 1968, p.35.

[18] Celant 1997, pp. 10-11.

[19] Boettger 2002 pp. 123-124.

[20] *The New Art. It's Way, Way Out*, in "Newsweek", 29 luglio 1968, pp. 56-63.

[21] McEvilley 1992, pp. 16-20.

[22] Dennis Oppenheim, didascalia per *Reading Position...*, in Heiss 1992, p. 62.

[23] Dennis Oppenheim, didascalia per *Transfer Drawing...*, in Heiss 1992, p. 72.

[24] Dennis Oppenheim intervistato da Alanna Heiss, in Heiss 1992, p. 137.

works / opere

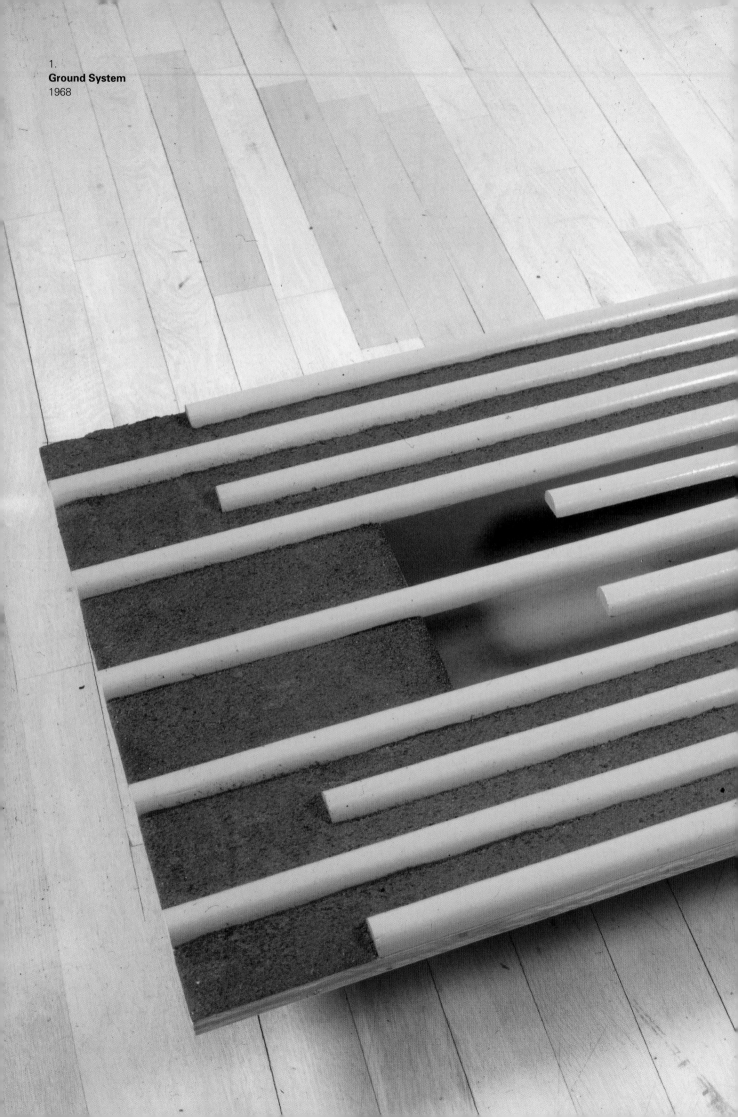

1.
Ground System
1968

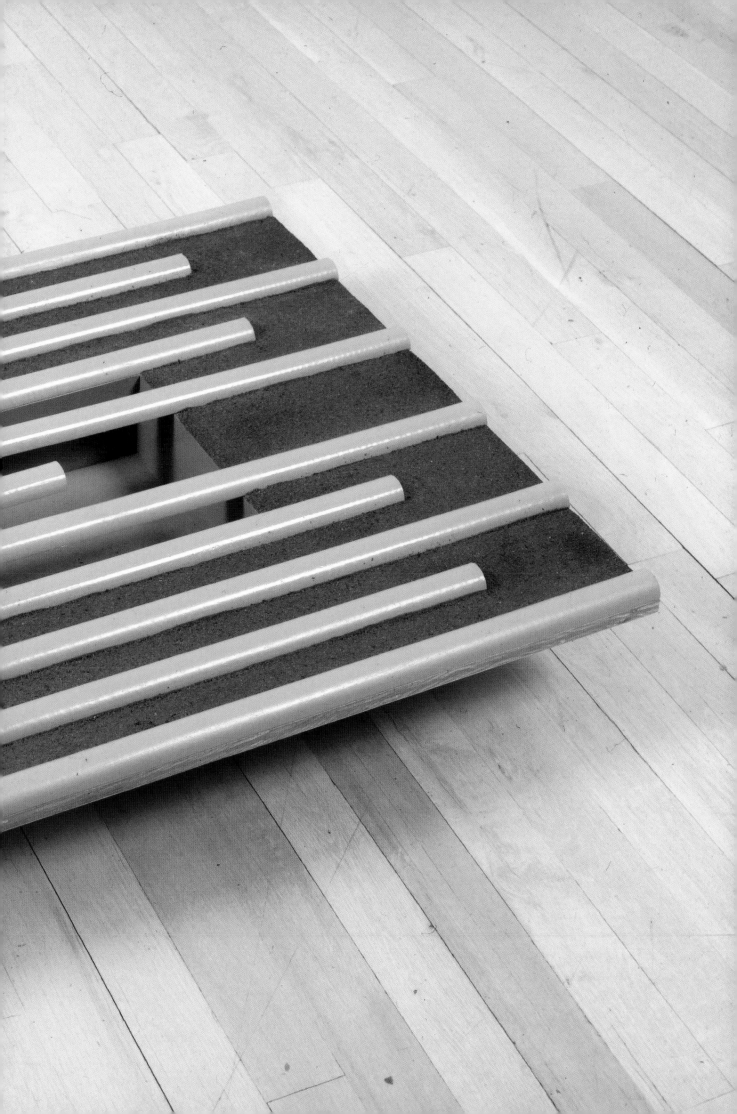

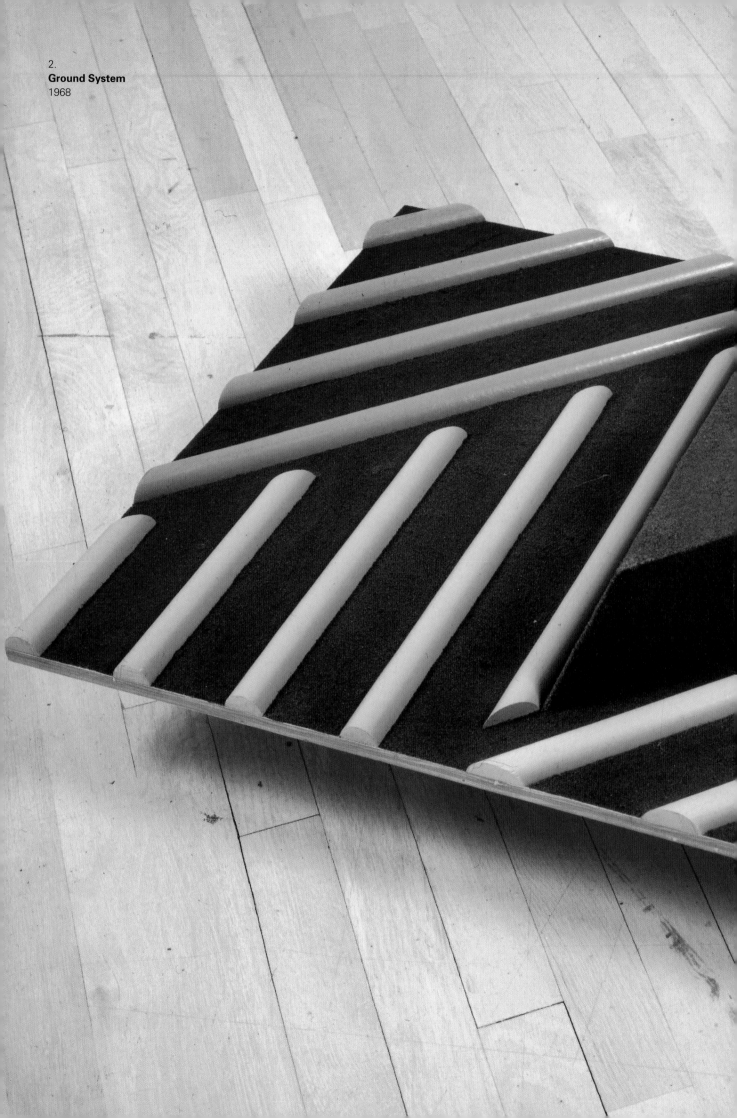

2.
Ground System
1968

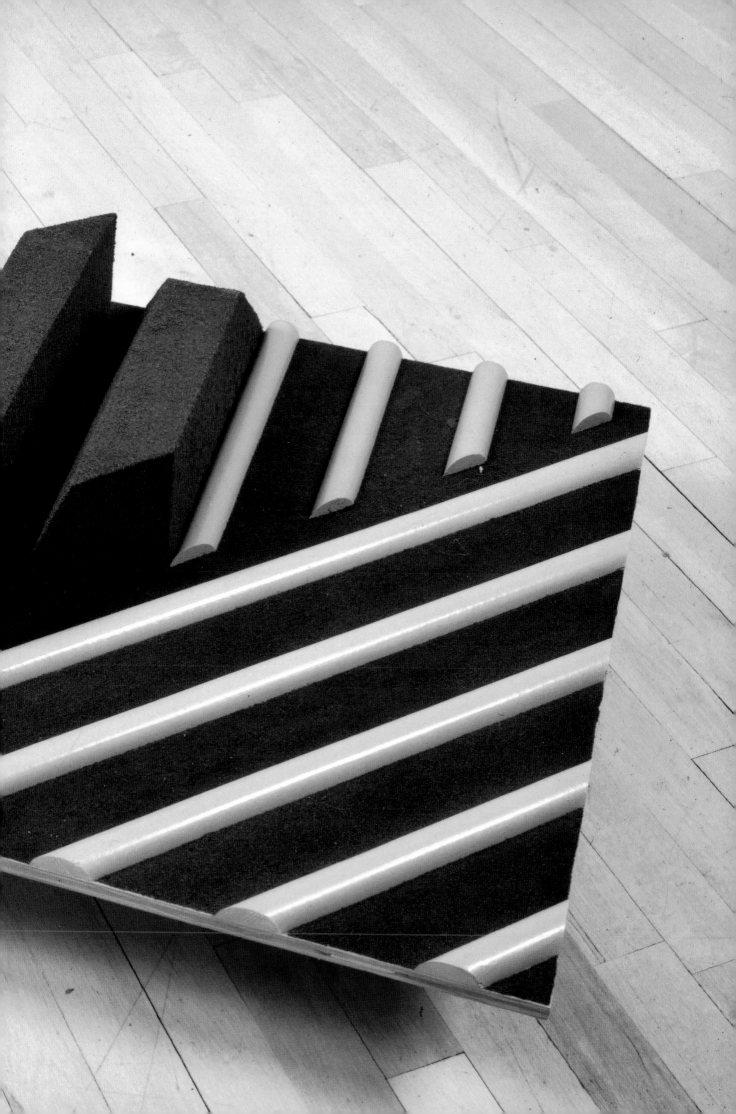

3.
Time Line
1968

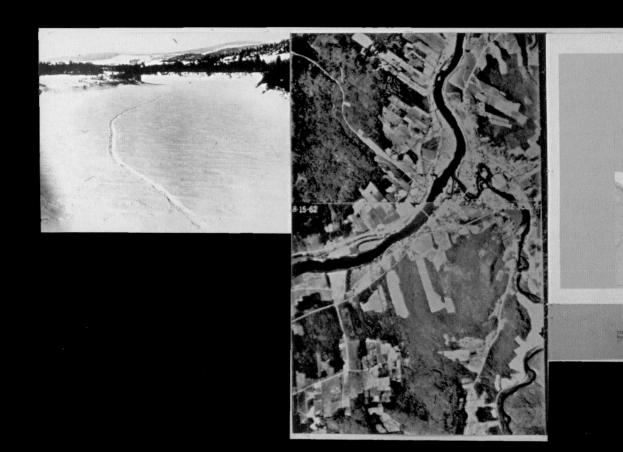

Directed Seeding. Reduced route
configuration from Finsterwolde
to Nieuwe Schans plotted on a
154 x 267 meter field and used
to dictate seeding pattern for
common wheat. (April 1969)

Canceled Crop. The cultivated
media from the two diagonal [illegible]
is isolated from further proc[illegible]
ing. This raw material is to [illegible]
packed in 25 pound bags.(Sept.

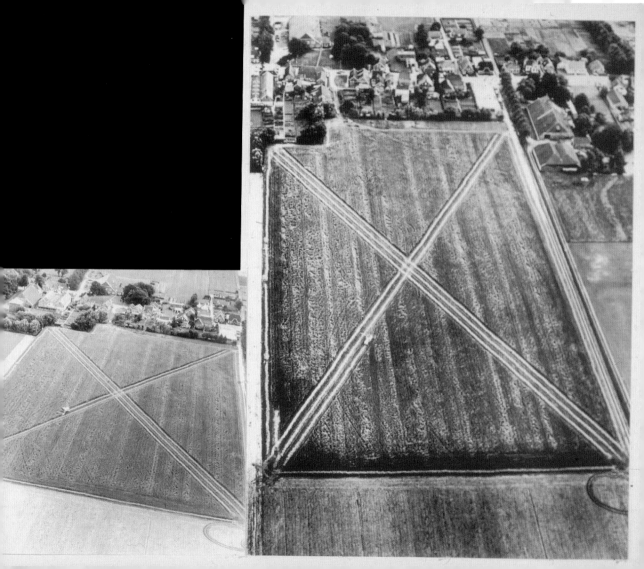

5.
Branded Mountain
1969

6.
Parallel Stress
1970

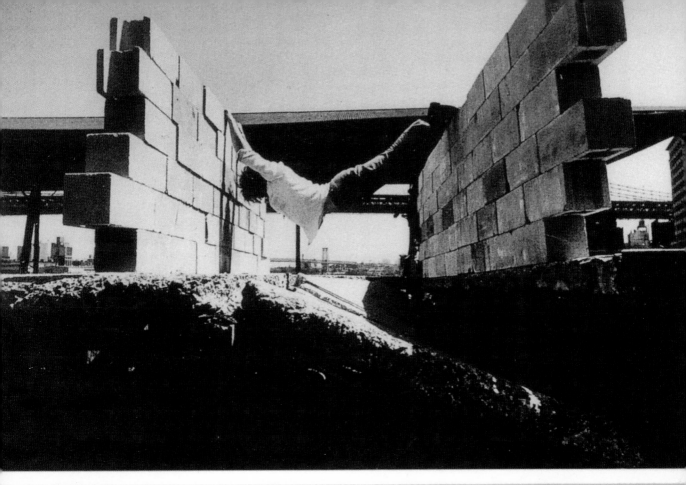

PARALLEL STRESS - A ten minute performance piece - May 1970

Photo taken at greatest stress position prior to collapse. Location:
Masonry block wall and collapsed concrete pier between Brooklyn and
Manhattan bridges. Bottom photo: Stress position reassumed Location:
Abandoned sump, Long Island

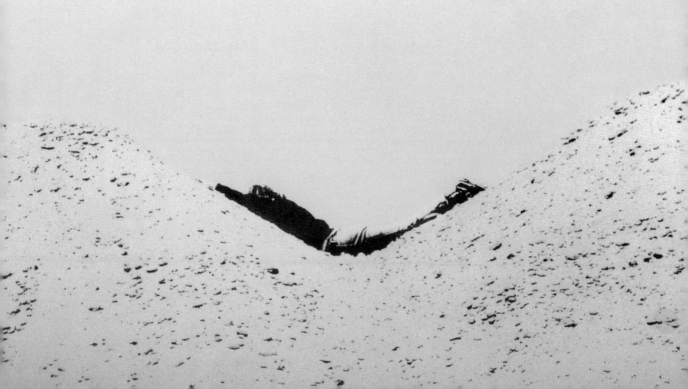

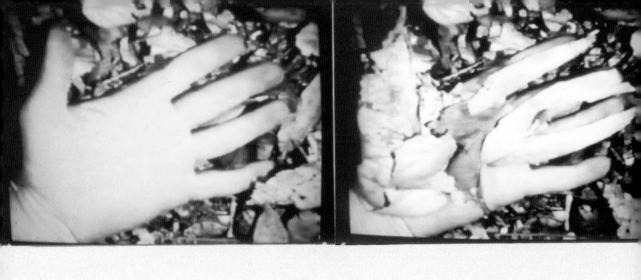

LEAFED HAND Stills from 8 mm film. Aspen, Colorado.

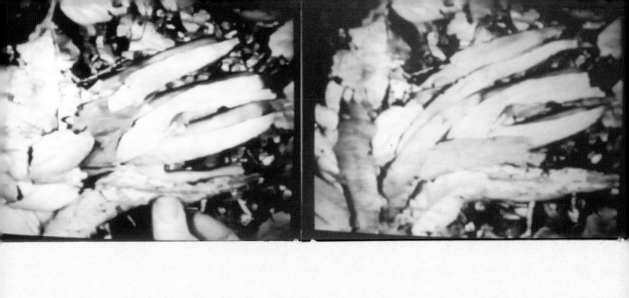

8.
Reading Position For Second Degree Burn
1970

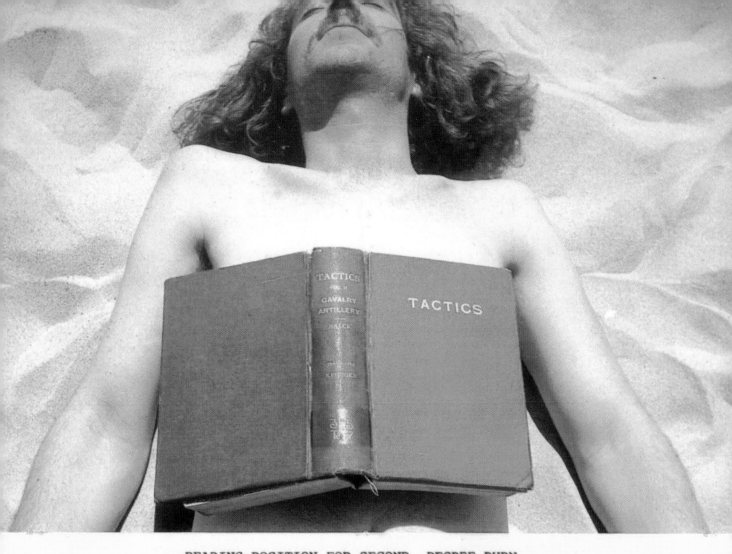

READING POSITION FOR SECOND DEGREE BURN

Stage I, Stage II. Book, skin, solar energy. Exposure time: 5 hours. Jones Beach. 1970

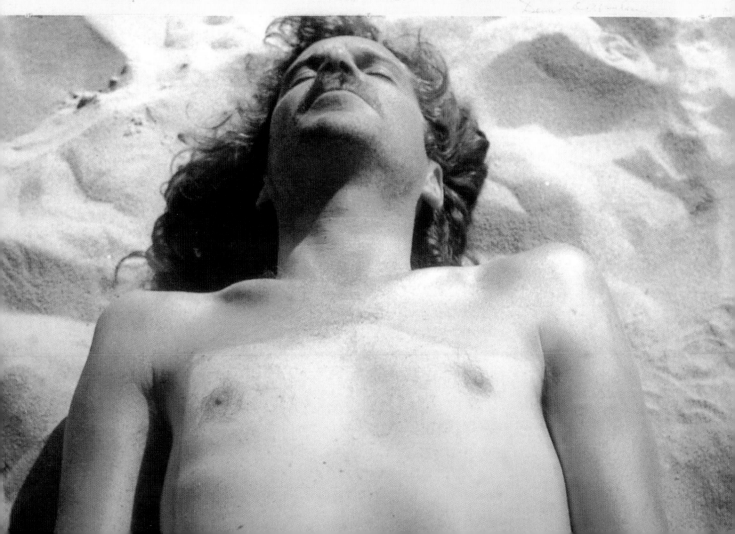

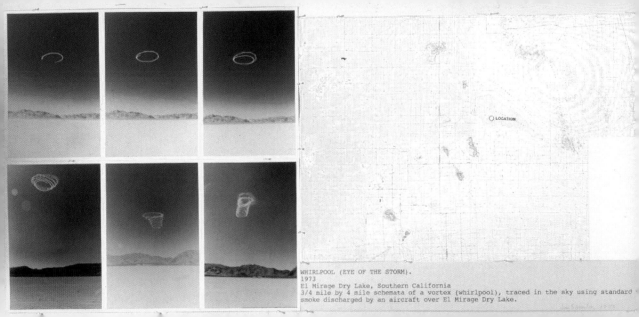

WHIRLPOOL (EYE OF THE STORM).
1973
El Mirage Dry Lake, Southern California
3/4 mile by 4 mile schemata of a vortex (whirlpool), traced in the sky using standard
smoke discharged by an aircraft over El Mirage Dry Lake.

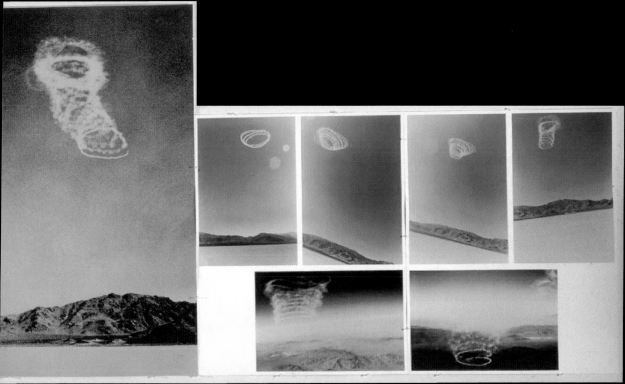

10.
Theme for a Major Hit
1974

11.
Figure with A Future
1984

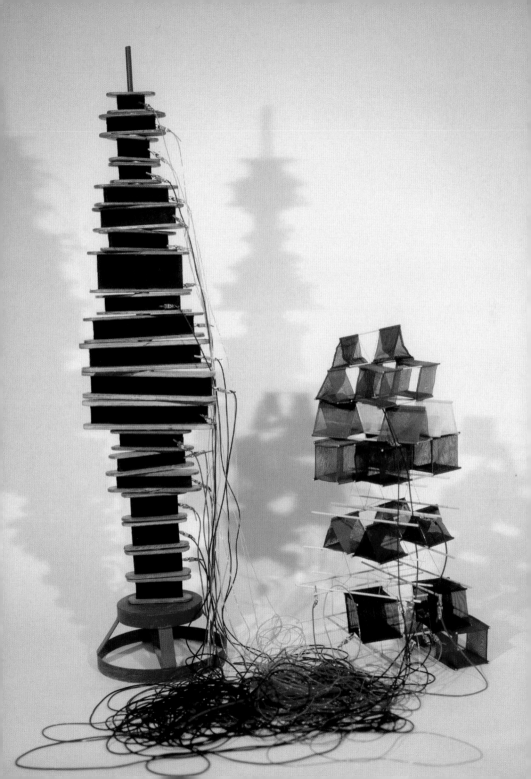

12.
Second Generation Image. Iron/Boat
1988

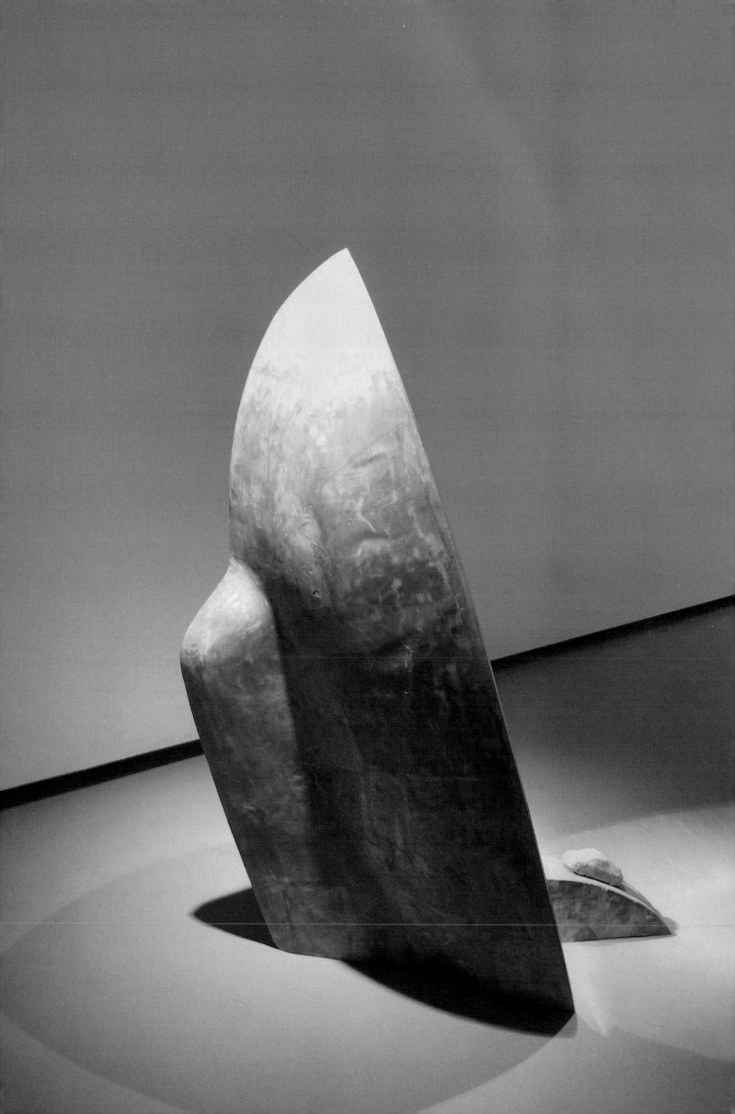

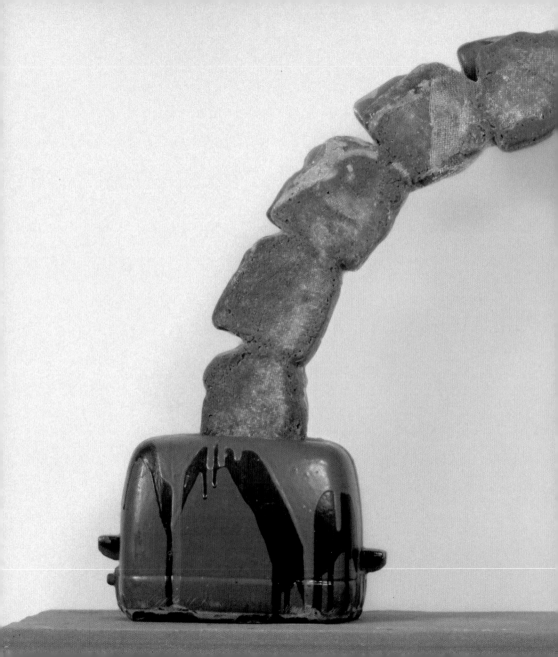

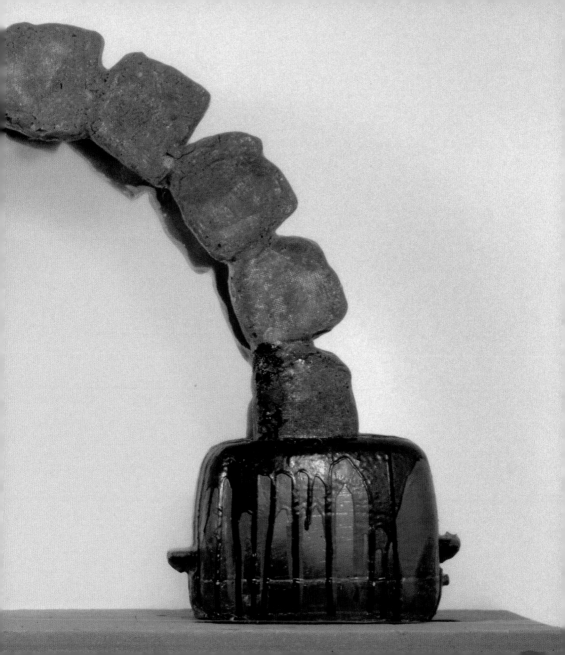

14.
Study for Sponge Trucks
1988

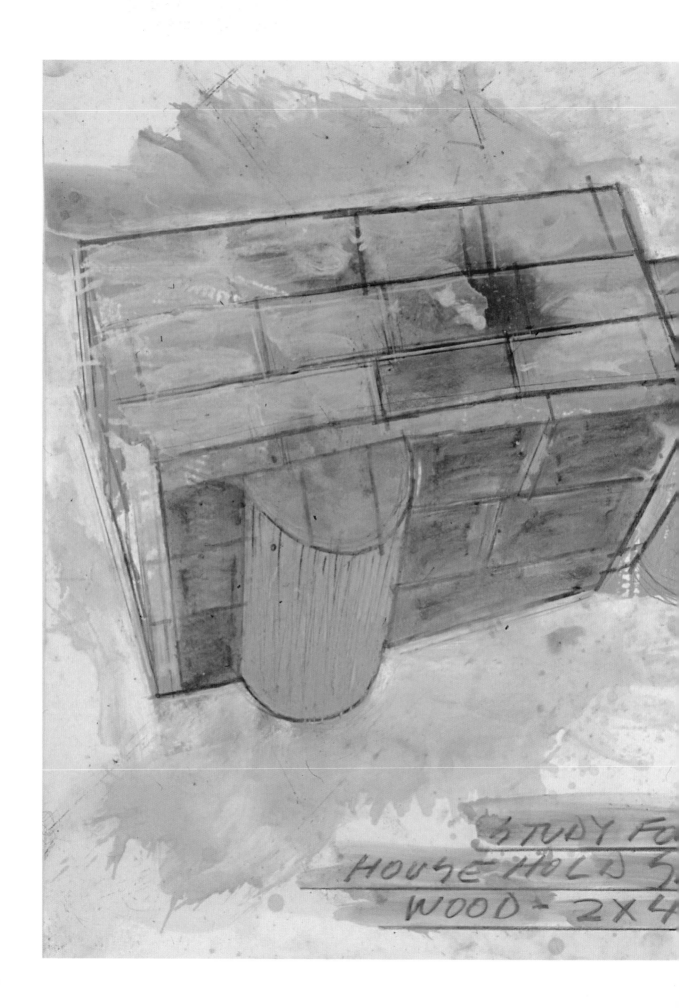

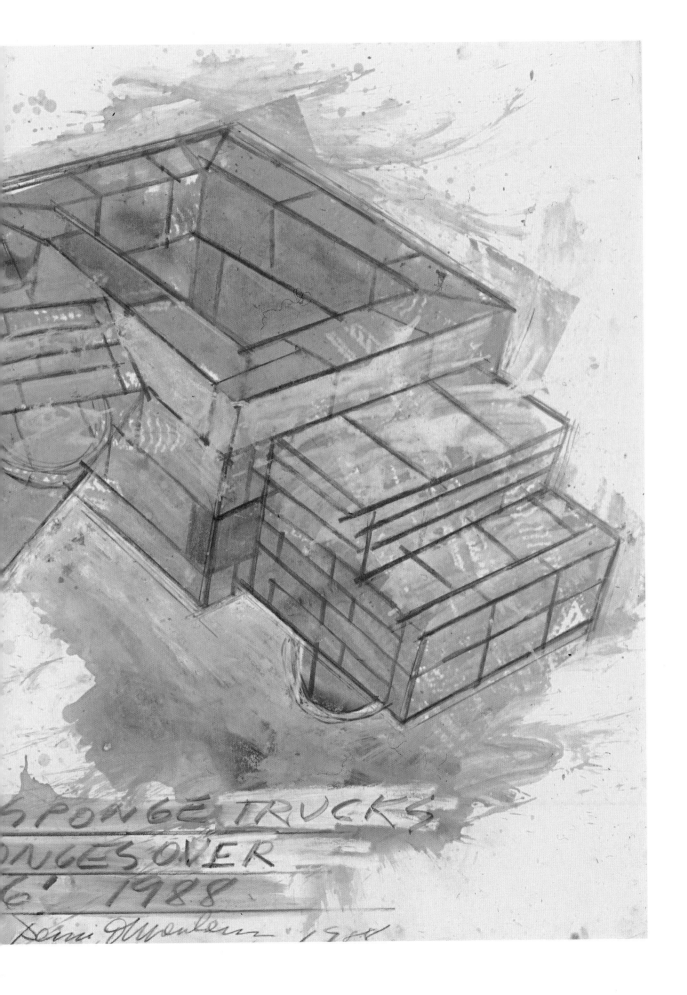

SPONGE TRUCKS
ONGES OVER
6 1988.

15.
Wake Collision
1989

16.
Digestion
1989

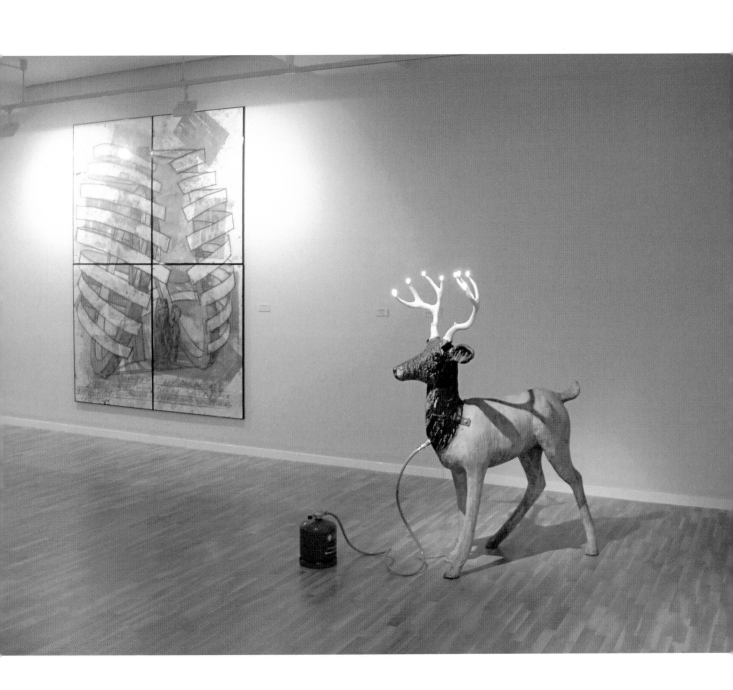

17.
Untitled Wall Piece
1990

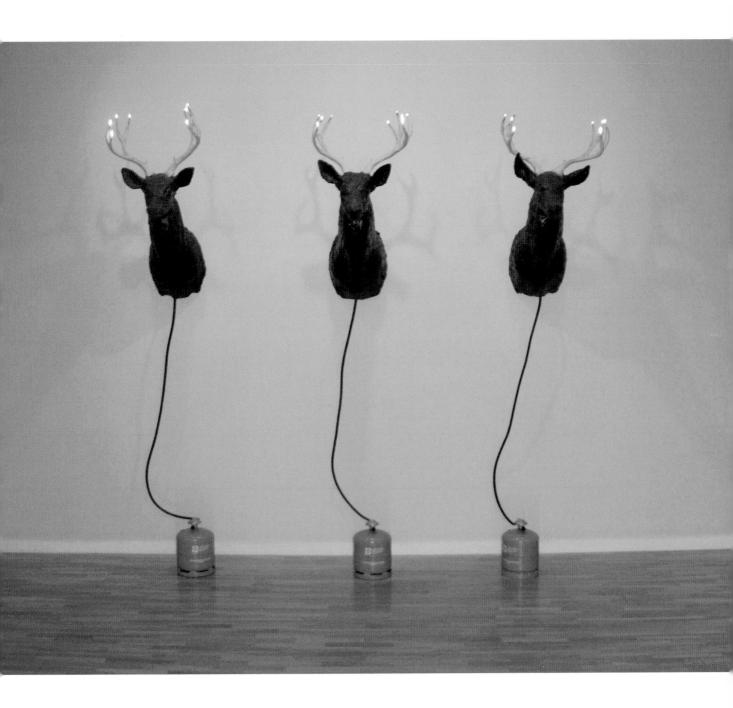

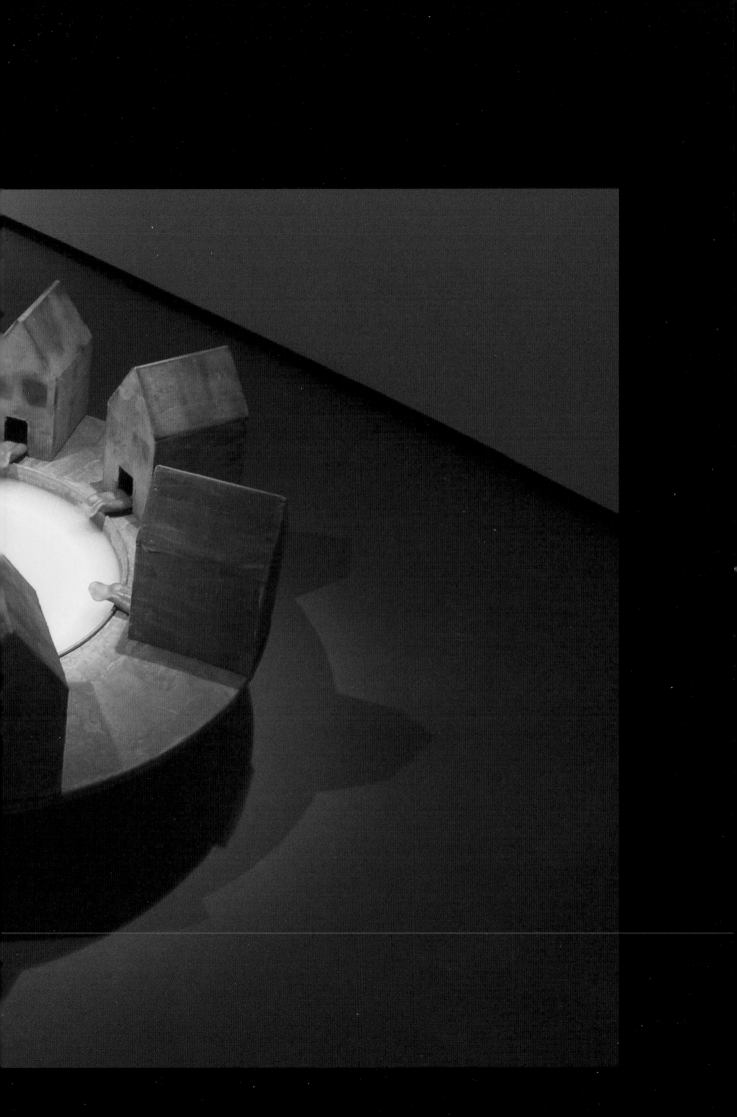

19.
Heavy Dog Kiss
1993

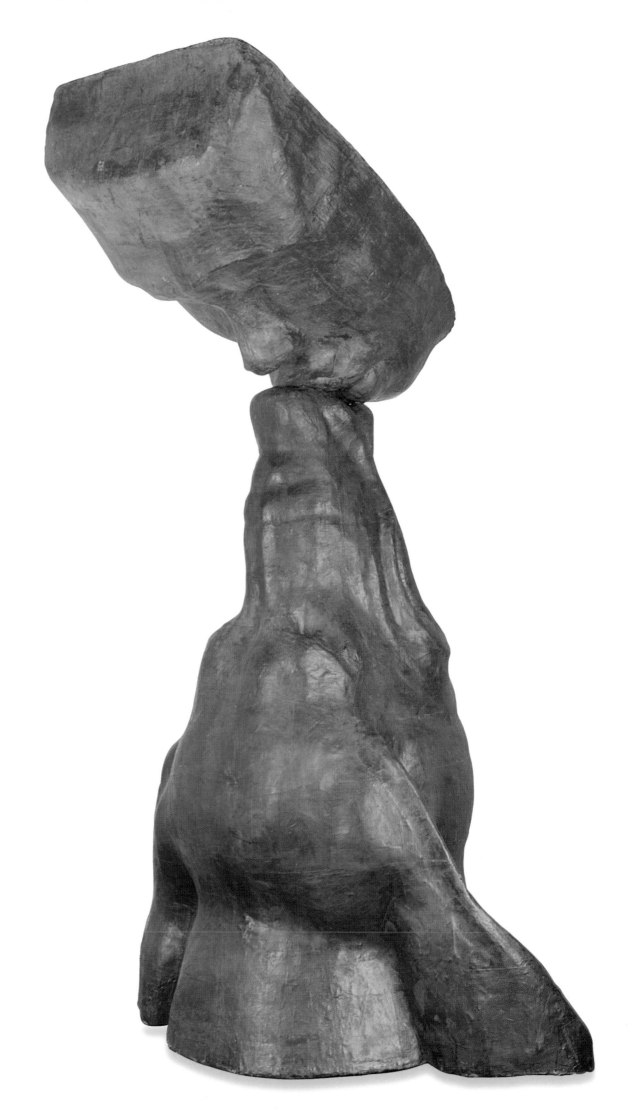

20.
Device to root out of evil
1997

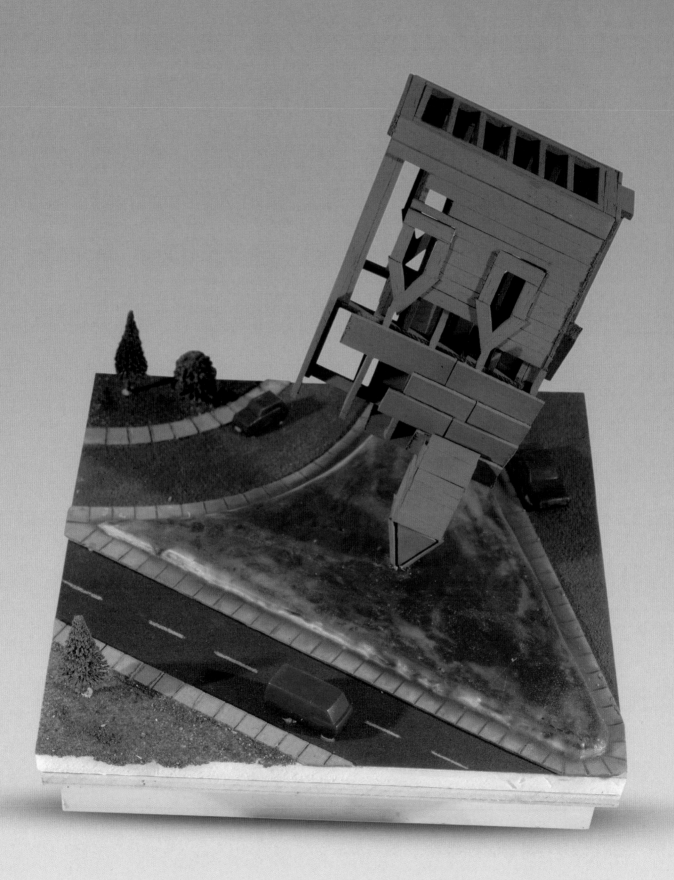

21.
Western piece
1999

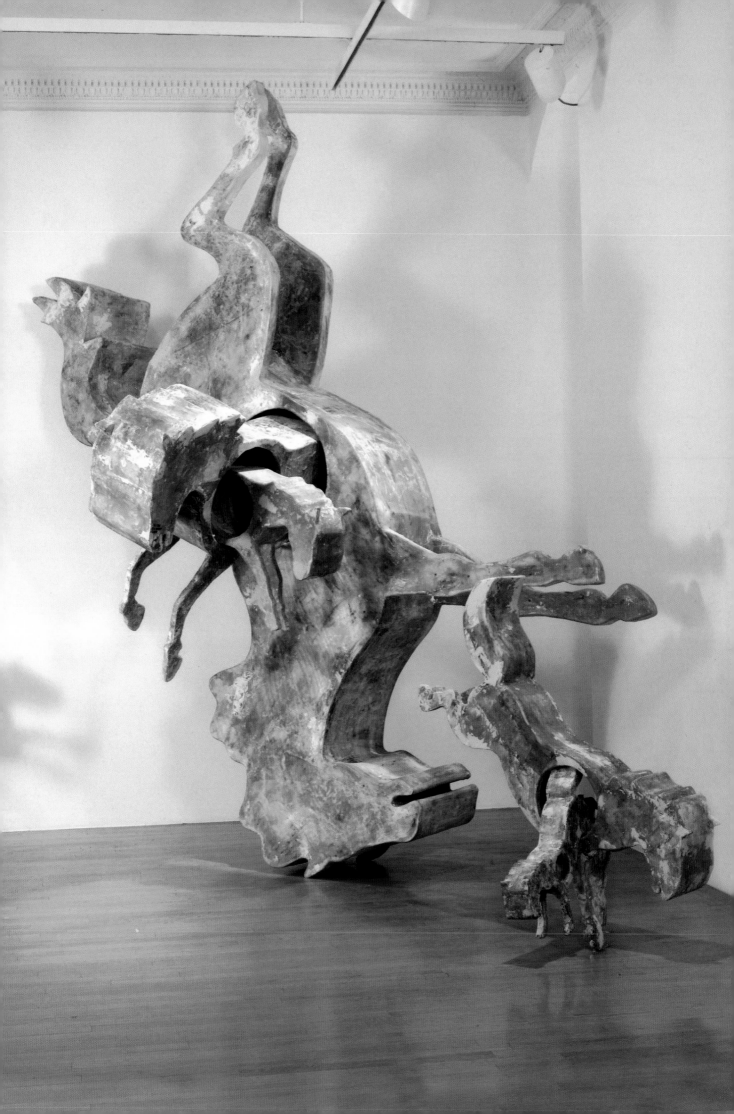

22.
Monument to Escape
2000

Group photo at Mr. Chow's Restaurant, New York, 1980 c. / Foto di gruppo al Ristorante Chow, New York, 1980 c.

Appendix / Apparati

List of works / Elenco delle opere

1. **Ground System** 1968
Diameter precast concrete pipe
Scale model, painted wood, 1'x2'x3' -
30x60x90 cm, two examples, other version:
Collection SMAK, Belgium

2. **Ground System** 1968
Scale 1=1 Hedge type: Euonymusjaponica
Scale model, painted wood, 1'x2'x3' -
30x60x90 cm, two examples, other version:
Collection SMAK, Belgium

3. **Time Line** 1968
Black and white photography, 5'x10' -
150x300 cm

4. **Canceled Crop** 1969
Color photography, black and white photo-
graphy, topographic map, mounted on
museum board, 3'x10' - 150x305 cm, in seve-
ral museum collections, Europe and U.S.A.

5. **Branded Mountain** 1969
Circle-x branding irons, branded skins, color
photography, variables dimensions - dimen-
sioni variabili, two examples, other version:
Brooklyn Museum of Art, U.S.A.

6. **Parallel Stress** 1970
Color photography and collage, 7'x4' - 230 x
150 cm, other versions: Brooklyn Museum
of Art and Tate Gallery

7. **Leafed Hand** 1970
Color and black and white photography,
1'x10' - 50x305 cm

8. **Reading Position For Second Degree
Burn** 1970
Color photography, 7'x5' - 215x150 cm

9. **Whirlpool - Eye of the Storm** 1973
El Mirage Dry Lake, Southern California,
color and black and white photography,
topographic map, collage text, 6'x10' -
205x 305 cm, two examples, other version:
Metropolitan Museum of Modern Art

10 **Theme for a Major Hit** 1974
Motor driven surrogate figure, ceiling
mounted armatures, wood, cloth and felt
figure, soundtrack on tape system with
amplifiers, spotlight, variable dimensions -
dimensioni variabili, versions with ten and
fifteen figures: MOMA, New York; single
figure: Contemporary Art Museum, Chica-
go, U.S.A.

11. **Figure with A Future** 1984
Wood, cloth, steel, electrical cords and clips,
4'x1'x1' - 140x35x15 cm, two examples,
other version: Private Collection, Germany

12. **Second Generation Image. Iron/Boat**
1988
Cast fiberglass, silkscreen, mirror, wood,
pigments, 4'x2'x2' - 135x70x120 cm, two
examples, other version: Allen Memorial Art
Museum, Oberlin, Ohio, U.S.A.

13. **Burnt Rainbow** 1988
Slate, cast resin, cast fiberglass, poured pig-
mented fiberglass, cast plaster, 6'x3'x1' -
185x120x60 cm

14. **Study for Sponge Trucks** 1988
pencil, colored pencil, oil wash, oil pastel on
paper, 4'x7' - 150x230 cm

15. **Wake Collision** 1989
Cast pigmented foam, pigmented fiberglass,
sailboats, steel, translucent acrylic, 11'x1'x1' -
305x60x60 cm

16. **Digestion** 1989
Pigmented fiberglass, gas, wax, rubber
hose, cast resin, regulator, jeweler's torch
tips, steel bolts, 5'x3'x1' - 150x120x60 cm,
version with five deer: Helsinki Museum of
Modern Art; with three deer: Norton Collec-
tion, U.S.A.

17. **Untitled Wall Piece** 1990
Hard foam, beeswax, black tar rubber hose,
cast resin, gas, regulator, jeweler's torch
tips, 7'x6'x1' - 240x210x90 cm

18. **Village around Piss Lake** 1993
Colored beeswax, cardboard, galvanized
pan, electric strobe, cast acrylic, water, pig-
ments, 1'x3' - 60x120 cm in diameter

19. **Heavy Dog Kiss** 1993
Pigmented cast fiberglass, cement block,
rocks, bowling balls, plants, steel brackets,
7'x3'x3' - 240x120x120 cm, two examples,
other version: Private Collection, Italy

20. **Device to root out of evil** 1997
Cast fiberglass, wood, pigments, cast resin,
2'x2'x2 - 70x70x70 cm

21. **Western piece** 1999
Cast fiberglass, wood, pigments, cast resin,
variable dimensions - dimensioni variabili

22. **Monument to Escape** 2000
Scale model for the Monument to the Vic-
tims of State Terrorism, Buenos Aires,
Argentina, steel, wood, acrylic, paint,
5'x5'x3' - 145x145x90 cm

Dennis Oppenheim

Dennis Oppenheim was born on September 6, 1938 in Electric City near the Grand Coulee Dam in Washington State, USA. His family moved to Richmond, California where he went to high school and then to art school at the California College of Arts and Crafts. After a short time in Honolulu where his first child Kristin was born to his wife Karen, he returned to the Bay Area and obtained an M.F.A. from Stanford University in 1965.

In 1966 he moved to New York where he met Smithson, Heizer and other artists who were forging new ideas in contemporary art. His first one person show in New York was at the John Gibson Gallery in 1968, followed by the first solo show in Europe at Yvon Lambert in Paris and in the same year by a show at Françoise Lambert in Milan.

Land Art, Body Art, video and performance in the 1960s were followed by installations which questioned the nature of the artistic process, the self and the concept of representation in the 1970s. Large-scale machine iconography was used in the sculpture of the 1980s as a metaphor for the thought process. Metaphor in works in the 1990s was developed from altered common forms. As the artist constructed larger, permanent public work it became architectural in scale and vision.

Retrospectives of his work have been organized by the Stedelijk Museum in Amsterdam, Musée d'Art Contemporain in Montréal and P.S.1 in New York. He continues to travel and show extensively around the world, with a focus on public commissions. Although divorced from his wife Alice Aycock in 1982, their relationship continues to be meaningful. Dennis lives in Tribeca in New York in a loft he moved to in 1976.

Dennis Oppenheim (Electric City, USA, 1938) fa parte, insieme a Bruce Nauman, Robert Smithson, Michael Heizer, Vito Acconci, Robert Morris e Gunther Uecker, di quella generazione di artisti di area americana che ha contribuito in modo determinante a rinnovare l'idea e i linguaggi dell'arte contemporanea. Già nel 1968, a proposito dei suoi primi "earth-works", Lucy Lippard conia il termine "dematerializzazione", con ciò sottolineando una caratteristica dominante e originale nel lavoro di Oppenheim, quella di una forma che transita da un materiale o un oggetto all'altro facendosi emblema del fare, ma insieme segno fisico epifanico di un divenire che non ha fine. Sotto questo profilo esistono molte opere, sia tra quelle della fine degli anni sessanta, sia tra quelle più recenti, che testimoniano la sua predilezione, tra i vari organi di senso, per il tatto, l'idea epidermica della forma, dell'oggetto, delle cose. Il trasferimento di una forma da un contesto all'altro (idea non manipolatoria) si intreccia con quella di impronta, che richiama pur sempre la mano e il toccare. Per la chiesa di San Paolo, nell'ambito del Festival della Filosofia di quest'anno, che ha per tema "i sensi", Oppenheim propone due sculture realizzate nel 2004, rispettivamente *Device to Cast Light on the Bottom of Feet* (Meccanismo che illumina ai piedi dei piedi) ed *Enlarged Object to Cast Light In-between the Toes* (Oggetto allargato per illuminare tra le dita dei piedi), due opere dotate di una forte carica ironica, come è nello stile dell'artista, due opere fuori scala, pantagrueliche e assolutamente visionarie, nelle quali il tatto si concentra sulla sensibilità dei piedi. Accompagnano la mostra le video-performance *Two-Stage Transfer Drawing*, *Rocked Hand*, *Air Pressure*, *Fusion Tooth and Nail*, *Forming Sounds*, *Nail Sharpening* e *Identity Transfer* realizzate fra il 1970 e il 1971, opere storiche nelle quali la dimensione tattile viene esperita in diverse situazioni: l'artista traccia un segno sulla schiena del figlio che ripete il segno sul muro e viceversa, oppure ricopre di pietre la propria mano, o ancora affila la propria unghia, dipinge di un unico colore denti e unghie, registra i movimenti trasmessi alla pelle della mano da un getto di aria compressa, varia con le mani il suono emesso da una donna, trasferisce l'impronta del pollice destro a quello sinistro e al palmo della mano. C'è l'aspetto ludico, ma in questo caso compone una sorta di teoria applicata che rivela quanto e come la visionarietà dell'artista sia legata a un aspetto "somatico". Completa la mostra la sequenza fotografica di *Reading Position for Second Degree Burn* realizzata nel 1970 alla Jones Beach di New York, quando l'artista è rimasto steso al sole a torso nudo per cinque ore con un trattato ottocentesco di artiglieria a cavallo aperto sul petto. Un disegno epidermico impresso dal tempo di esposizione alla luce.

Solo exhibitions / Mostre personali

2007

Gallery 1600, Savannah College of Art and Design, Atlanta, Georgia
American University Museum, Washington, DC
Montrasio Arte, Milano, Italy
Kunstraum, Potsdam, Germany

2006

Eaton Fine Art, West Palm Beach, Florida
Neuberger Museum, Purchase, New York
Volume, Roma, Italy
Galerie Piece Unique, Paris, France
MOT, London, United Kingdom
Slought Foundation, Philadelphia, Pennsylvania
The Arsenal Gallery, New York

2005

Museo Nacional Centro de Arte Reina Sofia, Madrid, Spain
Mario Mauroner Contemporary Art (MAM), Vienna, Austria
Centre Cultural Bancaixa, Valencia, Spain
Price Tower Arts Center, Bartlesville, Oklahoma
Kogart, Budapest, Hungary
Chiesa di San Paolo, Modena, Italy
Galleria In Arco, Torino, Italy

2004

Kenny Schachter, ROVE, New York
White Box, New York
Galleries de Lycée, Fonds régional d'Art Contemporain de Picardie, Amiens, France
Southwestern College, "Architectural Drawings", Chula Vista, California
ASU Art Museum, "Alternate Current", Tempe, Arizona
Fundación Cristóbal Gabarrón, Valladolid, Spain
Galerie Heufelder Koos, Munich, Germany
Circulo de Bellas Artes, Madrid, Spain
Ecole Regionale des Beaux-Arts de Nantes, France

2003

Whitney Museum of American Art, New York
Nevada Museum of Art, Reno, Nevada

Centre de Cultura, "Sa Nostra", Palma de Mallorca, Spain
Galleria Ierimonti, Milano, Italy
Eaton Fine Arts, West Palm Beach, Florida

2002

Michael H. Lord Gallery, Milwaukee, Wisconsin
John Gibson Gallery, New York
Eaton Fine Arts, West Palm Beach, Florida
Joseph Helman Gallery, New York

2001

Irish Museum of Modern Art, Dublin, Ireland
Guild Hall, East Hampton, New York
Joan Guaita, Palma, Spain
Ludwig Forum für Internationale Kunst, Aachen, Germany
Musée des Beaux-Arts d'Arras, Arras, France
Dorfman Projects, New York

2000

Grand Arts, Kansas City, Missouri
Piece Unique, Paris, France
Gallery of Art, University of Northern Iowa, Cedar Falls, Iowa
ICAR Foundation, Paris, France
Ace Gallery, New York
Joan Guaita, Palma, Spain

1999

Corcoran Gallery of Art, Washington, DC
Haines Gallery, San Francisco, California
Joseph Helman Gallery, New York
Kunsthalle Hamburg, Hamburg, Germany
Hillwood Art Museum, Brookville, New York

1998

Museo de Arte Alvar, Mexico City, Mexico
Galerie Albrecht, Munich, Germany
Velan per l'arte contemporanea, Carignano, Italy
Artcore, Toronto, Canada
Stux Gallery, New York
Museum of Contemporary Art, North Miami, Florida
Galapagos Art and Performance Space, Brooklyn, New York
Eaton Fine Arts, West Palm Beach, Florida

Orlando Museum of Art, Orlando, Florida
Ace Gallery, Los Angeles, California
Galerie Albrecht, Munich, Germany
University of Arizona Museum of Art, Tucson, Arizona

1997

Joseph Helman Gallery, New York
Galerie Anselm Dreher, Berlin, Germany
Stadt Galerie Nordhorn, Nordhorn, Germany
Venice Biennale, Pilkington SIV, Marghera–Venice, Italy
Los Angeles County Museum of Art, Los Angeles, California
Helsinki City Art Museum, Helsinki, Finland
Sarah Moody Gallery of Art, Tuscaloosa, Alabama

1996

Centre International d'Arts Visuels, Marseille, France
Vestsjaellands Kunstmuseum, Soro, Denmark
Galerie Asbaek, Copenhagen, Denmark
Archer M. Huntington Art Gallery, Austin, Texas
Galerie Pro Arte, Freiburg, Germany
Galerie Lucien Durand, Paris, France
Mannheimer Kunstverein, Mannheim, Germany
Rijksmusem Kröller-Müller, Otterlo, Netherlands
Tweed Museum of Art, Duluth, Minnesota
MAMCO, Geneva, Switzerland
Fundaçao de Serralves, Porto, Portugal
Galerie Eugen Lendl, Graz, Austria
Ota Fine Arts, Tokyo, Japan
Masataka Hayakawa Gallery, Tokyo, Japan

1995

Galerie de la Tour, Amsterdam, Netherlands
Galerie Anselm Dreher, Berlin, Germany
Haines Gallery, San Francisco, California
Galerie Albrecht, Munich, Germany
Ierimonti Gallery, Milan, Italy
Kunstsammlung Tumulka, Munich, Germany
Oliver Art Center, Oakland, California
Butler Institute of Art, Youngstown, Ohio

1994

Palau de la Virreina, Barcelona, Spain
Blum Helman, New York

Musée d'Art Moderne de la Communauté Urbaine de Lille, France (*retrospective*)
Joseloff Art Gallery, Hartford, Connecticut
Galería Greca, Barcelona, Spain
Galeria Aele, Madrid, Spain
Hoyt Institute of Art, New Castle, Pennsylvania

1993

Galerie Asbaek, Copenhagen, Denmark
Galerie Albrecht, Munich, Germany
Sala d'Exposicions, Principality of Andorra, Andorra
Blum Helman, New York
Porin Taidesmuseio, Pori, Finland (*retrospective*)
Oulu Taidesmuseo, Oulu, Finland (*retrospective*)
Ujazdoski Castle, Warsaw, Poland (*retrospective*)
Weatherspoon Art Gallery, Greensboro, North Carolina
Boca Raton Museum of Art, Boca Raton, Florida
Galerie Renée Ziegler, Zurich, Switzerland
Margaret Lipworth Fine Art, Boca Raton, Florida
The Fabric Workshop, Philadelphia, Pennsylvania
University Art Museum, University of California at Berkeley, California
Progetto, Roma, Italy

1992

Blum Helman, New York
University Galleries, State University of Illinois, Normal, Illinois
Cleveland Center for Contemporary Art, Cleveland, Ohio
Ace Contemporary Exhibitions, Los Angeles, California
Galerie Marika Malacorda, Geneva, Switzerland
Galería Greca, Barcelona, Spain
Haines Gallery, San Francisco, California
Galerie Tobias Hirschmann, Frankfurt, Germany
High Museum of Art, Atlanta, Georgia
Museum of Fine Arts, Houston, Texas

1991

Galeria Pedro Oliveira, Porto, Portugal
Landfall Press, New York

Galerie Friebe, Lüdenscheid, Germany
Galerie Gastaud, Clermont-Ferrand, France
Galerie Thierry Salvador, Paris, France
The Institute for Contemporary Art, Long Island City, New York
Galerie Berndt + Krips, Cologne, Germany
Howard Yezerski Gallery, Boston, Massachusetts

1990

Liverpool Gallery, Brussels, Belgium
Pierides Museum, Athens, Greece
John Gibson Gallery, New York
Ace Contemporary Exhibitions, Los Angeles, California
Dart Gallery, Chicago, Illinois
Galerie Lohrl, Monchengladbach, Germany
Galerie Berndt + Krips, Cologne, Germany
Galerie Joachim Becker, Cannes, France
Le Chanjour, Nice, France
Galerie Tobias Hirschmann, Frankfurt, Germany

1989

Paris Art Center, Paris, France
Yvon Lambert, Paris, France
Elisabeth Franck, Knokke-le-Zoute, Belgium
John Gibson Gallery, New York
Willoughby Sharp, New York
Anne Plumb Gallery, New York
Holly Solomon Gallery, New York
Pace MacGill Gallery, New York

1988

Gallery 360, Tokyo, Japan
Anne Plumb Gallery, New York
Walker Art Center, Seoul, South Korea

1986

Tolarno Galleries, South Yarra, Australia
Laumeier Sculpture Park St. Louis, Missouri

1985

Sander Gallery, New York
Grand Rapids Art Museum, Grand Rapids, Michigan
Alan Brown Gallery, Hartsdale, New York
Knight Gallery, Charlotte, North Carolina
Elisabeth Franck, Knokke-le-Zoute, Belgium

1984

Braunstein Gallery, San Francisco, California
Hans Mayer, Düsseldorf, Germany
Sander Gallery, New York
Philadelphia Art Alliance, Philadelphia, Pennsylvania
Center for Contemporary Art, Palm Beach, Florida
Françoise Lambert, Milano, Italy
Yvon Lambert, Paris, France
San Francisco Museum of Modern Art, San Francisco, California
La Jolla Museum of Contemporary Art, La Jolla, California
ZHTA-MI, Thessaloniki, Greece
Visual Arts Center, Anchorage, Alaska
Tel Aviv Museum, Tel Aviv, Israel

1983

Akira Ikeda Gallery, Tokyo, Japan
Flow Ace Gallery, Venice, California
Galerie Schurr, Stuttgart, Germany
Galerie Eric Franck, Geneva, Switzerland
Serra di Felice, New York
Seattle Art Museum, Seattle, Washington
Munson-Williams-Proctor Institute, Utica, New York
Yorkshire Sculpture Park, West Bretton, United Kingdom
Whitney Museum of American Art, New York

1982

Marianne Deson Gallery, Chicago, Illinois
Rijksmuseum Kröller-Müller, Otterlo, Netherlands
Mills College Gallery, Oakland, California
Galerie Stampa, Basel, Switzerland
Ikon Gallery, Birmingham, United Kingdom
Lewis Johnstone, London, United Kingdom
Musée d'Art et d'Histoire, Geneva, Switzerland
Olsen Gallery, New York
Bonlow Gallery, New York
Vancouver Art Gallery, Vancouver, British Columbia, Canada
Taub Gallery, Philadelphia, Pennsylvania
University Gallery of Fine Art, Ohio State University, Columbus, Ohio

1981

Sonnabend Gallery, New York
Graduate Center, The City University of New York, New York

The Contemporary Arts Center, Cincinnati, Ohio
Galerie Marika Malacordia, Geneva, Switzerland
Françoise Lambert, Milano, Italy
Lowe Art Museum, Miami, Florida
Richard Hines Gallery, Seattle, Washington

1980

Flow Ace Gallery, Venice, California
Bruce Gallery, Edinboro State College, Edinboro, Pennsylvania
Cranbrook Academy of Art, Bloomsfield Hills, Michigan
Portland Center for the Visual Arts, Portland, Oregon
Yvon Lambert, Paris, France
Pasquale Trisole, Napoli, Italy
Musée d'Art et d'Histoire, Geneva, Switzerland

1979

Kunsthalle Basel, Basel, Switzerland
University Gallery, New York
John Gibson Gallery, New York
The Kitchen Center, New York
The Israel Museum, Jerusalem, Israel
Herron Gallery, Herron School of Art, Indianapolis, Indiana
Winnipeg Art Gallery, Winnipeg, Manitoba, Canada (retrospective)
Eels Gallery, Kent State University, Kent, Ohio
Musée d'Art Moderne de la Ville de Paris, Paris, France
Northern Illinois University, Dekalb, Illinois
Françoise Lambert, Milano, Italy
Kunstverein Stuttgart, Stuttgart, Germany
Paul Robeson Center, Rutgers University, Newark, New Jersey

1978

Musée d'Art Contemporain, Montréal, Canada (retrospective)
Art Gallery of Ontario, Toronto, Canada (retrospective)
Museum of Art, University of Iowa, Iowa City, Iowa
Marian Goodman Gallery, New York
Visual Arts Museum, School of Visual Arts, New York
University Gallery, College at Plattsburg, Plattsburg, New York
Marianne Deson Gallery, Chicago, Illinois

1977

M.L. d'Arc Gallery, New York
CARP, Los Angeles, California
H/M Gallery, Brussels, Belgium
Galerie Hans Mayer, Düsseldorf, Germany
John Gibson Gallery, New York
Multiples, Inc., New York
University of Rhode Island Gallery, Kingston, Rhode Island
Gallery of Visual Art, University of Montana, Missoula, Montana
Fine Arts Gallery, Wright State University, Dayton, Ohio
Yvon Lambert, Paris, France

1976

M. L. D'Arc Gallery, New York
Framartstudio, Napoli, Italy
Museum Boijmans Van Beuningen, Rotterdam, Netherlands (retrospective)
Bo Alveryd Gallery, Kavlinge, Sweden

1975

Galleria Schema, Firenze, Italy
Vega, Liege, Belgium
P. J. M. Self Gallery, London, United Kingdom
Françoise Lambert, Milano, Italy
Oppenheim Studio, Cologne, Germany
John Gibson Gallery, New York
Kitchen Center, New York
Anthology File Archives, New York
Yvon Lambert, Paris, France
Galleria Castelli, Milano, Italy
Palais des Beaux-Arts, Brussels, Belgium

1974

Stedelijk Museum, Amsterdam, Netherlands
John Gibson Gallery, New York
Oppenheim Studio, Cologne, Germany
Galerie D, Brussels, Belgium
Paolo Barrozzi, Milano, Italy
Galleria Forma, Genova, Italy

1973

Galerie Sonnabend, Paris, France
Sonnabend Gallery, New York
Galleria Forma, Genova, Italy
Galerie D, Brussels, Belgium
Gallery Mayor, London, United Kingdom

Museum of Contemporary Art, San Francisco, California
Rivkin Gallery, Washington, DC

1972

Sonnabend Gallery, New York
Nova Scotia College of Art and Design, Halifax, Nova Scotia, Canada
Mathais Felds, Paris, France
Tate Gallery, London, United Kingdom
L'Attico, Roma, Italy
Galerie D, Brussels, Belgium

1971

Yvon Lambert, Paris, France
Françoise Lambert, Milano, Italy
Harcus Krakow Gallery, Boston, Massachusetts
Gallery 20, Amsterdam, Netherlands

1970

Reese Palley, San Francisco, California
John Gibson Gallery, New York
Pennsylvania Art Museum, Erie, Pennsylvania
Lia Rumma, Napoli, Italy
Crossman Gallery, Wisconsin State University, Whitewater, Wisconsin

1969

John Gibson Gallery, "Below Zero Projects", New York
Yvon Lambert, Paris, France
Françoise Lambert, Milano, Italy

1968

John Gibson Gallery, New York

Group Exhibitions / Mostre collettive

2007

P.S.1 Museum, Long Island City, New York, "Not for Sale"
Long House Reserve, East Hampton, New York

2006

Irish Museum of Modern Art, Dublin, Ireland, "Fire and Celebration"
Karlsruhe, Germany, "Leinzell Open 2"
Musée d'Art Contemporain (MAC), Marseille, France, "La Collection en Trois Temps et Quatre Actes"
Museum of Contemporary Art, Tokyo, Japan, "Collection of the Fondation Cartier pour l'art Contemporain"
Centre National d'Art Georges Pompidou, Paris, France, "Le Mouvement des Images"
Milwaukee Art Museum, Milwaukee, Wisconsin, "Crisis of Modernism"
Harvard University Art Museum, Cambridge, Massachusetts, "Nominally Figured: Recent Acquisitions in Contemporary Art"
Bass Museum of Art, Miami, Florida
Sculpture Grande, Prague, Czech Republic
NTT InterCommunication Center, Tokyo, Japan, "Connecting Worlds"

2005

Contemporary Museum, Honolulu, Hawaii, "Honolulu to New York"
Baltimore Museum of Art, Baltimore, Maryland, "Slideshow: Projected images in Contemporary Art"
White Coumns, New York, "Odd Lots: Revisiting Gordon Matta-Clark's Fake Estates"
Kunsthalle Wien, Vienna, Austria, "Superstars: Warhol to Madonna"
Musée d'Art Moderne de Saint-Etienne Metropole, Saint-Etienne, France, "Domicile: privé/public"
Palazzo delle Arti, Napoli, Italy, "The Giving Person"
Mario Mauroner Contemporary Art (MAM), Vienna, Austria, "Auf Wiedersehen"
Eaton Fine Art Sculpture Garden, West Palm Beach, Florida
Centre National d'Art Georges Pompidou, Paris, France, "Comme le leve, le dessin"
Centre National d'Art Georges Pompidou, Paris, France, "Big Bang: Creation and

Destruction in the 20th Century"
Galleria Civica d'Arte Contemporanea, Torino, Italy, "The Discovery of the Electronic Body: Art and Video in the 70s"
Whitney Museum of American Art, New York, "Overhead/Underfoot: The Topographical Perspective in Photography"
Sculpture Biennal Vancouver, Vancouver, British Columbia, Canada, "Something's Happening Here"
Foundation for Art & Creative Technology, Liverpool, United Kingdom, "Critics Choice"
Museum Moderner Kunst Stiftung Ludwig Wien, Vienna, Austria, "X-Screen"
Chiaopanshan International Sculpture Park, Taoyuan City, Taiwan

2004

Haines Gallery, San Francisco, California, "Temporalscape"
Marlborough Chelsea, New York
Los Angeles County Museum of Art, Los Angeles, California, "Beyond Geometry: Experiments in Form, 1940s–70s"
Fundación Joan Miró, Barcelona, Spain. "Behind the Facts (Interfunktionen 1968–75)"
Tecomah, Jouy-en-Josas, France, "Les Environmentales # 3"
Musée d'Art Moderne de Saint-Etienne Metropole, Saint-Etienne, France, "Cabinet des dessins No. 1"
Musée d'Art Moderne de Saint-Etienne Metropole, Saint-Etienne, France, "Object versus Design"
Tate Liverpool, Liverpool, United Kingdom, "The Uncanny"
Fabian + Claude Walter Galerie, Zurich, Switzerland, "Inside Out- Land Art and its Evolution"
Middleton-McMillian Gallery, Charlotte, North Carolina, "My Place, My Choice, My Ride, My Story"
Neue Gesellschaft für Bildende Kunst, Berlin, Germany, "Legal/Illegal"
QCC Art Gallery, Bayside, New York, "An American Odyssey: 1945–1980"
Palazzo Ducale, Genova, Italy, "Arti & Architettura"
Musée d'Art Moderne de la Ville de Paris, Paris, France, "Ready to shoot"
The Lab Gallery, New York, "Stereognost & Propriocept"
Irish Museum of Art, Dublin, Ireland, "Bea-

rings: Landscapes from the IMMA Collection"
FRAC Aquitaine, Bordeaux, France, "Des images qui ne seraient pas du semblant"
FRAC Aquitaine, Bordeaux, France, "Art, Nature, Land Art"

2003

Tate Liverpool, Liverpool, United Kingdom, "Art, Lies and Videotape: Exposing Performance"
Eaton Fine Art, West Palm Beach, Florida, "Metal & Paper"
Fonds régional d'Art Contemporain de Picardie, Amiens, France, "Paysages"
Fonds régional d'Art Contemporain de Picardie, Amiens, France, "Sculptures et Dessins"
Haines Gallery, San Francisco, California, "Works On Paper"
Varart, Firenze, Italy, "Mitologie del Presente"
Museum Moderner Kunst Stiftung Ludwig Wien, Vienna, Austria, "X-Screen"
Paco das Artes, São Paulo, Brazil, "Meta-Corpos"
The Wall Street Journal Building, New York, "Polarities"
The Long Island Museum, Stony Brook, New York, "Face to Face. 200 Years of Figurative Art on Long Island"
Museo Nazionale di Architettura, Ferrara, Italy, "Together"
Valencia Biennial, Valencia, Spain, "The Ideal City"
Walker Art Center, Minneapolis, Minnesota, "The Last Picture Show. Artists Using Photography, 1960–1982"
Kunsthalle Düsseldorf, Düsseldorf, Germany, "Ready to Shoot. Fernsehgalerie Gerry Schum"
Art and Gallery, Milano, Italy, "Blind"
Vancouver International Sculpture Exhibition, Vancouver, British Columbia, Canada, "Open Spaces"

2002

Les Abattoirs, Toulouse, France, "La Conquête de l'Air – Les Colonies de l'Espace"
Station, Houston, Texas
Chelsea Studio Gallery, New York, "Unforgettable"
Tecomah, Jouy-en-Josas, France, "Les Environmentales"

Hausler Contemporary, Munich, Germany, "Concepts on Nature"

Framart Studio, Napoli, Italy, "Masterpieces at Capodimonte"

Irish Museum of Modern Art, Dublin, Ireland, "The Unblinking Eye"

Museo Nacional de Bellas Artes, Buenos Aires, Argentina, "II Buenos Aires International Art Biennial"

Musée d'Art Moderne de Lille Metropole, Lille, France, "Les Chemins de l'Art Brut"

Whitney Museum of American Art, New York, "Visions from America: Photographs from the Whitney Museum of American Art, 1940–2001"

Musée d'art Contemporain de Bordeaux, Bordeaux, France, "Les Annes 70: l'art en cause"

Bunker, Oberschan, Switzerland, "Unloaded – Coming Up for Air"

2001

Stadtische Museen Heilbronn, Heilbronn, Germany, "Maschinen Theater"

Tate Modern, London, United Kingdom, "Century City: Art and Culture in the Modern Metropolis"

Castle Gallery, New Rochelle, New York, "Science and Science Fiction"

Norton Museum of Art, West Palm Beach, Florida, "Burn: Artists' Play with Fire"

Lawrence/Feuer/La Montagne, New York, "Altered Landscape"

The Aldrich Museum, Ridgefield, New York, "Art at the Edge of the Law"

Courthouse Galleries, Portsmouth Museum, Portsmouth, Virginia, "Music in My Soul"

Whitney Museum of American Art, New York, "Into the Light: the Projected Image in American Art 1964–77"

Tel Aviv Museum, Tel Aviv, Israel, "The Return of the Real"

Espace Henri Matisse Creil, Amiens, France, "Paysages"

Venice Biennale, Venezia, Italy, "Markers"

The Box Associati, Torino, Italy, "Ian Davenport, Dennis Oppenheim"

Arsenal de l'ancienne abbaye Saint-Jean-des-Vignes, Soissons, France, "Grand papiers"

Bass Museum, Miami, Florida, "Inside and Out: Contemporary Sculpture, Video and Installations"

The Center for Wine, Food and the Arts, Napa, California, "Come to your Senses"

Scottsdale Museum of Contemporary Art, Scottsdale, Arizona, "Cultural Desert"

The Metropolitan Museum of Art, New York, "Photographs: A Decade of Collecting"

Galeries Contemporaines des Musées de Marseille, Marseille, France, "Living in the Exhibition"

2000

Arnolfini, Bristol, United Kingdom, "Lie Of The Land"

Joseph Helman Gallery, New York, "Andoe, Oppenheim, Simonds"

Monte Carlo, Monaco, "La Sculpture Americaine Contemporaine dans le Cadre Festival International de Sculpture Contemporaine de Monte-Carlo"

Parc de La Courneuve, Bobigny, France, "Art Grandeur Nature"

Framartstudio, Napoli, Italy, "Masterpieces of the Last Millennium at Capodimonte, Second Act"

Willoughby Sharp Gallery, New York, "Double Debut"

Galleria Martano, Torino, Italy, "L'elemento verbale nell'Arte Contemporanea"

Fonds régional d'Art Contemporaine de Picardie, Amiens, France, "Zig-Zag"

Bayly Art Museum, Charlottesville, Virginia, "Hindsight / Fore-site"

The Nelson-Atkins Museum of Art, Kansas City, Missouri, "Tempus Fugit"

Museum für Neue Kunst, Freiburg, Germany, "Totale 02"

Grand Arts, Kansas City, Missouri, "Fast"

Long House Reserve, East Hampton, New York, "Rites of Spring 2000"

2000 Vancouver International Sculpture Project, Vancouver, British Columbia, Canada

Collection Lambert, Musée d'Art Contemporain, Avignon, France, "Rendez-vous No. 2"

The Jewish Museum, New York, "Pairings"

The Museum of Fine Arts, Houston, Texas, "Conceptual Photography from the Permanent Collection"

The Museum of Fine Arts, Houston, Texas, "Contemporary Art and Photography from the Permanent Collection"

The Metropolitan Museum of Art, New York, "Now! Modern Photographs from the Permanent Collection"

Orlando Museum of Art, Orlando, Florida, "Collector's Choice II: Contemporary Art from Central Florida Collections"

Kunstsammlung Nordhein-Westfalen, Düsseldorf, Germany, "The Self is Something Else: Art at the End of the 20th Century"

Generali Foundation, Vienna, Austria, "Re-Play"

1999

The Museum of Contemporary Art, Los Angeles, California, "Afterimage: Drawing Through Process"

The Museum of Modern Art, New York, "The Museum as Muse"

Esso Gallery, New York, "Scripta Manent"

Rupertinum Salzburg, Salzburg, Germany, "Clapping"

Hudson River Museum, Yonkers, New York, "Drip Blow Burn: Forces of Nature in Contemporary Art"

Museu de Arte Contemporânea, Porto, Portugal, "Circa 1968"

Museum of Contemporary Art, Chicago, Illinois, "Perspectives on Terrain"

Neuberger Museum of Art, Purchase, New York, "1999 Biennial Exhibition of Public Art"

Howland Art Center, Beacon, New York, "Heroines & Heroes II"

Center Galleries, Detroit, Michigan, " Dysfunctional Sculpture"

The Whitney Museum of American Art, New York, "The American Century 1950–2000, Part II"

Palma de Mallorca, Palma de Mallorca, Spain, "Universiada '99"

Fonds régional d'Art Contemporain de Picardie, Amiens, France, "Grands Papiers"

LL Gallery, New York, "Spatial Complexities"

Musée d'art Moderne de Lille Metropole, Villeneuve d'Ascq, France, "Changement d'air"

University Gallery Fine Arts Center, Amherst, Massachusetts, "Head to Toe: Impressing the Body"

Arthouse, Dublin, Ireland, "Freeze II"

Galeria Baró Senna, São Paulo, Brazil

Central Hall of the Legislature of the City of Buenos Aires, Buenos Aires, Argentina

1998

XXIV Bienale de São Paulo, São Paulo, Brazil

Melbourne International Festival, Melbourne, Australia, "Remanence"
Yale University Art Gallery, New Haven, Connecticut, "Now and Later"
Fonds régional d'Art Contemporain Bretagne, Chateaugiron, France, "Lieu personne temps"
Espace Jean Legendre, Compiegne, France, "Entre quatre ciels"
Claudia Gian Ferrari Arte Contemporanea, Milano, Italy, "Pollution"
Fuori Uso '98, Pescara, Italy, "Shown"
The Chicago Athenaeum, Chicago, Illinois, "The City as a Memory"
Abraham Lubelski Gallery, New York, "Acts of Faith"
Museum für Moderne Kunst, Frankfurt, Germany, "Artists"
Galerie Tobias Hirschman, Frankfurt, Germany, "Lick auf die Zeichung"
Elaine Benson Gallery, Bridgehampton, New York, "Artists Against Abuse"
Ota Fine Arts, Tokyo, Japan, "Tracin'"
Palais Liechtenstein, Vienna, Austria, "Sarajevo 2000"
Museum of Modern Art, Kamakura, Japan, "Arcadia in Celle"
Museum of Contemporary Art, Miami, Folrida, "Selections from the Permanent Collection"
Museum of Contemporary Art, Honolulu, Hawaii, "Highlights from the Collection"
Museum of Contemporary Art, San Diego, California, "Double Trouble: The Patchett Collection"
Museum of Fine Arts, Boston, Massachusetts, "Photo Image: Printmaking 60s to 90s"
Norton Museum of Art, West Palm Beach, Florida, "Animal as Muse"
Port Art Museum, Pori, Finland, "Animal.Anima.Animus"
Art Gallery of South Australia, Adelaide, Australia, "Pure"
Museum of Art and History, Santa Cruz, California, "Altered: The Animal in Contemporary Art"

1997

2nd Johannesburg Biennial, Johannesburg, South Africa, "Transversions"
Centre Georges Pompidou, Paris, France, "L'empreinte"
Flint Institute of Arts, Flint, Michigan, "Dis-crimination, Cruelty and Hope"
La Salle Gallery, Charlotte, North Carolina, "The Private Eye in Public Art"
Videonale Bonn, Bonn, Germany
Joseph Helman Gallery, New York, "Allegory"
Institute for Contemporary Art, P.S.1 Museum, Long Island City, New York
Akron Art Museum, Akron, Ohio, "Maps, Graphs and Plans: A Seventies Approach"
Index Gallery, Osaka, Japan, "The Power of Words and Signs"
Dan Bernier Gallery, Los Angeles, California, "Works from the Seventies"
Kunstmuseum Bonn, Bonn, Germany, "Multiple Identity"
Art in General, New York, "Moving Time"

1996

Haines Gallery, San Francisco, California, "Matters of the Heart"
California Center for the Arts Museum, Escondido, California, "Narcissism: Artists Reflect Themselves"
Musée d'art moderne et d'art contemporain, Nice, France, "Chimeriques Polymeres"
Museum of Contemporary Art, La Jolla, California, "Selections from the Collection"
Espace Belleville, Paris, France, "Outlook on Contemporary Sculpture"
MAC Galeries Contemporaines des Musées de Marseille, Marseille, France, "The Art Embodied"
Newport Harbor Art Museum, Newport Beach, California, "Machine"
Milwaukee Art Museum, Milwaukee, Wisconsin, "Landfall Press, Twenty-Five Years of Printmaking"
Alexander Soutzos Museum, Athens, Greece, "Selection from the Whitney Museum of American Art"
William Patterson College, Wayne, New Jersey, "Sensory Overdrive"
Kunsthallen Brandts Klaedefabrik, Odense, Denmark, "Trilogy: Art, Nature, Science"
Pardo View Gallery, New York, "Sculptor's Drawings"
Mannheimer Kunstverein, Mannheim, Germany, "Landvermesser"
Mercer Union, Toronto, Canada, "Love Gasoline"
Fine Arts Center, University of Massachusetts, Amherst, Massachusetts, "In Vivo"
College of Art, Maryland Institute, Baltimore, Maryland, "Spaces & Forms"

1995

Humphrey Gallery, New York, "Forces"
American Fine Arts, New York, "Mapping"
Exit Art, New York, "Endurance"
Museum of Contemporary Art, Los Angeles, California, "Reconsidering the Object of Art, 1965–1975"
Biennale de Lyon, Lyon, France
Phoenix Art Museum, Phoenix, Arizona, "It's Only Rock 'n Roll: Currents in Contemporary Art"
Mitzpe Ramon, Israel, "Construction in Process"
Hill Gallery, Birmingham, Michigan, "Popular Culture"
Ludwig Museum, Koblenz, Germany, "Sound Sculpture"
The Children's Museum, San Diego, California, "Happening"
Newport Harbor Art Museum, Newport Beach, California, "Machine"
Allen Memorial Art Museum, Oberlin, Ohio, "Action/Performance"
Fundação de Serralves, Porto, Portugal, "Modernism"
The Whitney Museum of American Art, New York, "Altered and Irrational"
Lawrence Gallery, Rosemont, Pennsylvania, "Foundations"
Presentation House Gallery, Vancouver, British Columbia, Canada, "Death and the Family"
Burchfield-Penney Art Center, New York, "20 Years of Hallwalls"
Vered Gallery, East Hampton, New York, "Food in Art"
Randolph Street Gallery, Chicago, Illinois, "Better Living through Chemistry"

1994

Städtische Galerie Göppingen, Göppingen, Germany, "Zuge"
The Nathan Cummings Foundation, New York
California Crafts Museum, San Francisco, California, "Transparency + Metaphor"
Ecole des Beaux-Arts de Lorient, Lorient, France
San Diego, California & Tijuana, Mexico, "In SITE '94"

Festival Iberoamericano de Teatro de Bogotá, Bogotá, Columbia
Museum Schloss Mosigkau, Mosigkau-Dessau, Germany, "East of Eden"
Galerie de la Tour, Amsterdam, Netherlands, "Personal Heroes"
National Gallery of Art, Washington, DC, "From Minimalism to Conceptual Art"
California Center for the Arts Museum, Escondido, California, "Wildlife"
Hill Gallery, Birmingham, Michigan, "Popular Culture"
Hartman & Company, La Jolla, California

1993

Gemeentemuseum Arnhem, Sonsbeek '93, Arnhem, Netherlands, "The Uncanny"
Brooklyn Museum, Brooklyn, New York, "The Second Dimension: Twentieth Century Sculptor's Drawings"
Galería Senda, Barcelona, Spain, "Heads"
Helander Gallery, New York, "The Pet Show"
Chicago Cultural Center, Chicago, Illinois, "The Nature of the Machine"
Turbulence, New York, "Art/Functional Art"
Fonds régional d'Art Contemporain de Picardie, Amiens, France, "Portraits"
Galería Greca, Barcelona, Spain, "Hommage to Miró"
Epaces Art-Defense, Paris, France, "Differentes Natures"
Haggerty Museum of Art, Marquette University, Milwaukee, Wisconsin
Aldrich Museum of Contemporary Art, Ridgefield, Connecticut, "Fall from Fashion"
Haines Gallery, San Francisco, California, "Body Parts"
Center for the Fine Arts, Miami, Florida, "Photoplay: The Chase Manhattan Collection"
Arts & Projects, Salzburg, Austria, "Leading Edge"
Museum of Modern Art, New York, "Recent Acquisitions: Prints"
Musée d'Art Moderne Saint-Etienne, Saint-Etienne, France, "La Donation Vicky Remy"
Centro Espositivo della Rocca Paolina, Perugia, Italy, "Presenze"
Turner/Krull Galleries, Los Angeles, California, "Action/Performance and the Photograph"
Savage Fine Art, Portland, Oregon, "It's a Beautiful Thing"
Blum Helman, New York, "The Bestiary"

1992

Blum Helman, New York, "The Figure"
Blum Helman, New York, "Nauman, Oppenheim, Serra"
Musée d'Art Moderne et Contemporain, Geneva, Switzerland
Annina Nosei Gallery, New York, "America Mundo 1992"
Franklin Parrasch Gallery, New York, "The Endowed Chair"
Galería Senda, Barcelona, Spain, "Inauguración"
Musée-Abbaye Saint-Léger, Soissons, France, "Cercles"
Fonds régional d'Art Contemporain de Picardie, Amiens, France, "Dessins d'Ameriques"
Musée d'Art Moderne de la Communauté Urbaine de Lille, Villeneuve d'Ascq, Lille, France, "Yvon Lambert Collections"
Gorinchen, Netherlands, "Braom: Internal Affairs"
Galleria degli Uffizi, Firenze, Italy, "Paolo Uccello: Battles in the Art of XX Century"
Musei di Spoleto, Cortona, Italy, "Carmina Urbana"

1991

Michael Klein, Inc., New York, "Trains: Burden, Kessler, Oppenheim"
The Contemporary Arts Center, Cincinnati, Ohio, "Mechanika"
Simposio Internacional de Escultura al Aire Libre, Madrid, Spain
III Biennal de Sculpture, Monte Carlo, Monaco
Fay Gold Gallery, Atlanta, Georgia, "Outside America: Going into the 90s"
The Oakland Museum, Oakland, California, "Persona"
Contemporary Arts Museum, Houston, Texas, "Word as Image"
Gallery 360, Tokyo, Japan, "Long, Heizer, Oppenheim"
Galerie 1900-2000, Paris, France, "After Duchamp"
Framartstudio, Milano, Italy, "Singolarità. L'Orizzonte degli Eventi"
Le Conseil régional de Picardie, Amiens, France
Winnipeg Art Gallery, Manitoba, Canada, "Wild Things"
Tacoma Art Museum, Tacoma, Washington,

"Glass: Material in the Sercie of Meaning"
John Gibson Gallery, New York, "Sixties"
Espace 2000, Arachon, France, "Autour de la Sculpture"

1990

Aldrich Museum of Contemporary Art, Ridgefield, Connecticut, "Project: Installation"
Casino Municipale di Venezia, Venezia, Italy, "Casino Fantasma"
Albany Museum of Art, Athens, Georgia, "Immaterial Objects"
La Defense, Paris, France, "Une Collection pour la Grande Arche"
Carlo Lamagna Gallery, New York, "Life Before Art: Images from the Age of Aids"
Exit Art, New York, "Illegal America"
Jan Kesner Gallery, Los Angeles, California, "Pharmacy"
The Art Advisory Service, MOMA, New York, "Exchange of Information"
The Art Advisory Service, MOMA, New York, "Menagerie"
Galerie 1900-2000, Paris, France, "Art Conceptuel Formes Conceptuelles"
Galerie Cremniter-Laffanour, Paris, France, "Cinq Sculpteurs Contemporains"
History Museum of Lodz, Lodz, Poland, "Construction in Process: Back in Lodz, 1990"
Pennsylvania Academy of Fine Arts, Philadelphia, Pennsylvania, "Twentieth Century Realism"
Usine de Meru, Meru, France, "Les Quatre Elements"
Independent Curators, Inc., Benefit, New York
John Gibson Gallery, New York, "American Express"
Security Pacific Corporation Gallery, Los Angeles, California, "The Magic Circle"
Katonah Museum of Art, Katonah, New York, "The Technological Muse"
USX Tower, Philadelphia, Pennsylvania, "Downtown Kinetic"
Vered Gallery, East Hampton, New York, "La Fantastique"
Musée Rath, Geneva, Switzerland, "Collections: Tinguely à Armleder"

1989

John Gibson Gallery, New York, "Intuition"
Mai 36 Galerie, Ruine, Geneva, Switzerland, "Art in Safe"

North Carolina Museum of Art, Raleigh, North Carolina, "Immaterial Objects"
The Aldrich Museum of Contemporary Art, Aldrich, Connecticut, "Project: Installation"

1987

Helander Gallery, Palm Beach, Florida, "Works of Wood"
Charles Cowles Gallery, New York, "Stanford Artists in New York"
Aspen Museum of Art, Aspen, Colorado, "Pop Art, Minimal Art, Etc."
Corcoran Gallery of Art, Washington, DC, "American Masters: Works on Paper"
Elisabeth Galasso Gallery, Ossining, New York, "Madness in America"
John and Mabel Ringling Museum of Art, Sarasota, Florida, "This is not a Photograph"
Akron Art Museum, Akron, Ohio
Laguana Gloria Art Museum, Laguana, Texas, "Art That Moves"
Christopher Felver, Roma, Italy
Furniture of the Twentieth Century, New York, "Personal Visions"
Herter Art Gallery, University of Massachusetts, Amherst, Massachusetts, "Contemporary American Collage 1960–1986"

1986

Elisabeth Franck Gallery, Knokke-le-Zoute, Belgium
Department of Cultural Affairs, New York, "A Celebration of the Arts Apprenticeship Program"
Queens Museum, New York, "Television's Impact on Contemporary Art"
Butler Institute of American Art, Youngstown, Ohio, "Fireworks"

1985

Whitney Museum of American Art at Philip Morris, New York, "Modern Machines"
Paleis voor Schone Kunsten, Brussels, Belgium, "Time: The Fourth Dimension in Art"
Symposium National de Sculpture Monumental Metallique, Thiers, France
Anne Plumb Gallery, New York
Hillwood Art Gallery, Greenvale, New York, "The Doll Show: Dolls and Figurines"
Edith C. Blum Art Institute, Annandale-on-Hudson, New York, "The Maximal Implication of the Minimal Line"

1984

Jacksonville Art Museum, Jacksonville, Florida, "Currents: A New Mannerism"
Bette Stoler Gallery, New York, "Art Ex Machina"
University Art Museum, University of New Mexico, Albuquerque, New Mexico, "Bruce Nauman/Dennis Oppenheim: Drawings and Models for Albuquerque Commissions"
Edith C. Blum Art Institute, Bard College, Annandale-on-Hudson, New York "Land Marks"
Malmö Konstall, Malmö, Sweden, "New Media II"
Chicago International Sculpture Exposition, Chicago, Illinois, "Mile 3"
Artpark, Lewiston, New York
Museum of Contemporary Art, Chicago, Illinois, "Selections form the Permanent Collection"
Galerie Littmann, Basel, Switzerland, "Dennis Oppenheim, Christo, Heinz Tesar"
Quebec, Canada, "Quebec 1534-1984"
Patty Aande Gallery, San Diego, California
Lehigh University Art Galleries, Bethlehem, Pennsylvania, "Sculptural Ideas"
Philadelphia Art Alliance, Philadelphia, Pennsylvania, "Sculptural Ideas"
Pennsylvania Academy of Fine Arts, Philadelphia, Pennsylvania, "Recent Acquisitions"
Hirshhorn Museum and Sculpture Garden, Washington, DC, "Content: A Contemporary Focus, 1974–1984"
Ted Greenwald Gallery, Inc., New York, "Artist's Weapons"
Stellweg Seguy Gallery, New York, "Soul Catchers"

1983

Ceolfrith Gallery, Sunderland Arts Centre, Sunderland, United Kingdom, "Drawings in Air"
The Banff Centre, School of Fine Arts, Banff, Alberta, Canada
Tel-Hai College Art Institute, Upper Galilee, Israel, "Tel-Hai '83"
Palais des Beaux-Arts, Brussels, Belgium, "Video Art: Retrospectives/Perspectives"

Manhattan Art, New York, "Christmas Present"
Museum of Contemporary Art, Chicago, Illinois, "Earthart from the Permanent Collection"
Washington Project for the Arts, Washington, DC, "Sound Senn"
Kunsthaus Zürich, Zürich, Switzerland, "Selections form the Collection"
Nationalgalerie Berlin, Berlin, Germany, "Kunst mit Photographie"
Städtische Kunstmuseum Bonn, Bonn, Germany, "Video"

1982

Württembergischer Kunstverein Stuttgart, Stuttgart, Germany, "Past, Present-Future"
Musée d'Art Moderne de la Ville de Paris, ARC 2, Paris, France, "Alea"
Guild Hall, East Hampton, New York, "Artist and Printmaker: Printmaking as a Collaborative Process"
Fattoria di Celle, Pistoia, Italy
Kassel, Germany, "Documenta Urbana"
Chicago Sculpture Society, Chicago, Illinois, "Mile of Sculpture"
Oakland Museum, Oakland, California, "100 Years of California Landscape"
Franklin Furnace, New York, "Illegal America"
University of Southern Florida, Tampa, Florida, "Currents: A New Mannerism"
Creative Time, Inc., New York, "Art on the Beach"
Galerie Isy Brachot, Brussels, Belgium, "Art Sans Fontieres"
Express/Network, New York, "Model Citizens Against Post-Modernism"
14 Sculptors Gallery, New York, "Drawings, Models, Sculptures"
Gowanus Memorial Artyard, Brooklyn, New York, "The Monument Redefined"
Galleria Mario Pieroni, Roma, Italy, "Accardia, Oppenheim, Pistoletto"
Mura Aureliane, Roma, Italy, "Avanguardia Transavanguardia"

1981

Institute of Contemporary Art, University of Pennsylvania, Philadelphia, Pennsylvania, "Machineworks"
Städtisches Kunstmuseum Bonn, Cologne, Germany, "Highlights"

Independent Curators, Inc., New York, "Mapped Arts: Charts, Routes, Regions"
Württembergischer Kunstverein Stuttgart, Stuttgart, Germany, "Natur-Skulpter"
Kunsthaus Zurich, Zurich, Switzerland, "Mythos and Ritual"
Elise Meyer Gallery, New York, "Schemes"
Rosa Esman Gallery, New York, "Architecture by Artists"
Whitney Museum of American Art, New York, "Biennal '81"
The New Museum, New York, "Alternatives in Retrospect"
Espace Lyonnais d'Art Contemporain, Lyon, France, "Les Oeuvres Plastique des Artistes de la Performance"
Hirshhorn Museum and Sculpture Garden, Washington, DC, "Metaphor"
Pratt Graphics Center, New York, "Artists and Printmaker: Printmaking as a Collaborative Process"
Jacksonville Art Museum, Jacksonville, Florida, "Currents: A New Mannerism"
Neuberger Museum, Purchase, New York, "Soundings"
Bronx Museum, Bronx, New York, "Video Classics"
Aldrich Museum of Contemporary Art, Richfield, Connecticut, "New Dimensions in Drawing"
Cranbrook Academy of Art, Bloomfield Hills, Michigan, "Instructional Drawings"

1980

Institute for Art and Urban Resources, Long Island City, New York, "Image and Object in Contemporary Sculpture"
The Museum of Modern Art, New York, "Printed Art: A View of Two Decades"
Sonnabend Gallery, New York, "Morris, Acconci, Oppenheim"
Internationale Skulpturen, Wenkenpark, Basel, Switzerland
ROSC International, Dublin, Ireland
Wave Hill, Riverdale, New York, "Temporal Structures"
Los Angeles Institute of Contemporary Art, Los Angeles, California, "Architectural Sculpture"
University of California at Irvine, Irvine, California, "Architectural Sculpture"
Center for Photography, Tucson, Arizona, "Reasoned Spaces"
Venice Biennale, Venezia, Italy, "The Pluralist Decade"

Musée d'Art Moderne de le Ville de Paris, Paris, France, "Ecouter pas les Yeux"
Marian Goodman Gallery, New York, "Dennis Oppenheim and Les Levine"
John Michael Kohler Arts Center, Sheboyan, Wisconsin, "cARTography"
Institute of Contemporary Art, Philadelphia, Pennsylvania, "The Pluralist Decade"

1979

Hampshire College, Amherst, Massachusetts, "Images of Self"
King County Arts Commission, Seattle, Washington, "Land Reclamation as Sculpture"
Customs House, sponsored by Creative Time, New York, "Custom and Culture"
Biennale, Vienna, Austria, "Expansion"
Institute for Art and Urban Resources, Long Island City, New York, "The Great Big Drawing Show"
Institute for Art and Urban Resources, Long Island City, New York, "Sound"
Surrey Art Gallery, Surrey, British Columbia, Canada, "Creative Flight"
Musée National d'Art Moderne, Centre Georges Pompidou, Paris, France, "Video Art Symposium"
Detroit Institute of Arts, Detroit, Michigan, "Object and Image in Contemporary Sculpture"
Art Association of Newport, Newport, Rhode Island, "Narrative Realism"
Aspen Center of Contemporary Art, Aspen, Colorado, "Portraits/Self-Portraits"
Museum of Contemporary Art, Chicago, Illinois, "Concept, Narrative, Document"
American Foundation for the Arts, Miami, Florida, "Storytelling in Art"
Marian Goodman Gallery, New York, "With a Smile"
Akron Art Center, Akron, Ohio, "Dialogue"
Philadelphia College of Art, Philadelphia, Pennsylvania, "Afterimages/Projects of the 70s"
Akademie der Kunst, Berlin, Germany, "Für Augen und Ohren"

1978

Centre d'Arts Plastiques, Bordeaux, France, "Sculpture/Nature"
Contemporary Arts Museum, Houston, Texas, "Narrative Art"

Independent Curators, Inc., Washington, DC, "The Sense of the Self"

1977

Brown University/Rhode Island School of Design, Providence, Rhode Island, "Space Window"
Sterling and Francine Clark Art Institute, Williamstown, Massachusetts, "The Dada and Surrealist Heritage"
Institute of Contemporary Art, Boston, Massachusetts, "Wit and Wisdom"
Eugenia Cuclon Gallery, New York
Galerie Magers Bonn, Bonn, Germany, "Kunst und Architektur"
Documenta 6, Kassel, Germany
Palais des Beaux-Arts, Brussels, Belgium, "American Works from Belgium Collectors"
Philadelphia College of Art, Philadelphia, Pennsylvania, "Time"
The New Museum, New York, "Early Works by Five Contemporary Artists"
Teheran Museum of Contemporary Art, Teheran, Iran
Whitney Museum of American Art, New York, "Biennial '77"
Whitney Museum of American Art, New York, "Words"
Contemporary Arts Museum, Chicago, Illinois, "A View of a Decade"

1976

Venice Biennale, Venezia, Italy
John Gibson Gallery, New York
Athens Museum, Athens, Georgia, "New Art for Jimmy Carter"
Institute for Art and Urban Resources, P.S.1, Long Island City, New York, "Rooms"
Institute of Contemporary Art, Philadelphia, Pennsylvania, "Vogel Collection"
Galerie Isy Brachot, Brussels, Belgium, "Body Art"
Louisiana Museum of Modern Art, Humlebæk, Denmark

1975

Museum of Contemporary Art, Chicago, Illinois, "Body Art"
Lunds Konsthall, Lund, Sweden, "Camera Art"
Passaic County Community College, Paterson, New Jersey, "Camera Art"

Galerie Stadler, Paris, France, "Body Art"
New York Cultural Center, New York, "Nude in American Art"
Museum of Contemporary Art, Chicago, Illinois, "Menace"
Fine Arts Building, New York, "Self-Portraits"
Philadelphia College of Art, Philadelphia, Pennsylvania, "Labyrinth"
Artpark, Lewiston, New York
XIII Bienal de São Paulo, São Paulo, Brazil, "Video Art"
Institute for Art and Urban Resources, The Clocktower, New York, "Selections from Vogel Collection"
Institute of Contemporary Art, Philadelphia, Pennsylvania, "Video Art"
Kunsthalle Leben, Wien, Austria, "Art as Living Ritual"
Whitney Museum of American Art, Resource Center, New York, "Art in Landscape"

1974

112 Greene Street, New York
Massachusetts Institute of Technology, Boston, Massachusetts, "Interventions in Landscape"
Bruce Gallery, Edinboro State University, Edinboro, Pennsylvania, "Instructions"
Kunsthalle Köln, Cologne, Germany, "Project '74"
Institute for Art and Urban Resources, The Clocktower, New York, "Words and Works"
Stefanotty Gallery, New York, "Live!"
Artists Space, New York, "Video Tapes"
Kennedy Center for the Performing Arts, Washington, DC, "Art Now"

1973

Whitney Museum of American Art, New York, "American Drawings"
Sonnabend Gallery, New York, "Drawings"
Yvon Lambert, Paris, France, "Actualité d'un Bilan"

1972

School of Visual Arts, New York, "Performance Spaces"
Memorial Art Gallery, Rochester, New York, "Art Without Limits"
New York Cultural Center, New York, "Making Megalopies Matter"

New York Cultural Center, New York, "American Prints"
Sonnabend Gallery, New York, "Thirteen Artists Chosen for Documents"
Incontri Internazionali d'Arte, Roma, Italy, "Persona 2"
Festival di Spoleto, Spoleto, Italy, "420 West Broadway"
Pamplona, Spain, "Encurentros en Pamplona"

1971

Boston Museum of Fine Arts, Boston, Massachusetts, "Elements"
Reese Palley, New York, "Environmental Surfaces"
Françoise Lambert, Milano, Italy
Museum of Modern Art, New York, "Pier 18"
Rijksmuseum Kröller-Müller, Otterlo, Netherlands, "Films/Sonsbeek"
Kunsthalle Düsseldorf, Düsseldorf, Germany, "Projection '71"
Biennale, Paris, France
Center for Art-Communication, Buenos Aires, Argentina, "Art Systems"
98 Greene Street, New York, "Film, Video, Performance"
Art Museum, University of Kentucky, Lexington, Kentucky, "Kith and Kin"
Finch College, New York, "Artist/Video/Performance"
Whitney Museum of American Art, New York, "Sculpture Annual"
Stedelijk Museum, Amsterdam, Netherlands, "Beyond Law and Order"
John Gibson Gallery, New York, "Body"

1970

Chicago Art Institute, Chicago, Illinois, "Films-Wasash Transit"
Institute of Contemporary Art, Philadelphia, Pennsylvania, "Against Order"
Videogal Schum, Düsseldorf, Germany, "Identifications"
Japan Art Society, Tokyo, Japan, "International Exhibition"
Multiples, New York, "Artists and Photographs"
Museum of Contemporary Art, Chicago, Illinois, "Evidence on the Flight of Six Fugitives"
Museum of Modern Art, New York, "Information"

Museum of Modern Art, New York, "Recorded Activities"
Museum of Contemporary Art, San Francisco, California, "Body"
New York Cultural Center, New York, "Concept Art/Aspects"
School of Visual Arts, New York, "Films by Dennis Oppenheim"
Parrish Museum, South Hampton, New York, "Land Projects by Six Artists"
Taxis Palais Gallery, Innsbruck, Austria, "Situation/Concepts"
Museo d'Arte Moderna, Torino, Italy, "Arte Povera, Concept Art, Land Art"
Arts Council of United Kingdom, London, United Kingdom, "New Multiple Art"
Whitney Museum of American Art, New York, "Sculpture Annual"
Yvon Lambert, Paris, France, "American Drawings"

1969

Museum of Modern Art, New York, "A Report-Two Ocean Projects"
Museum of Modern Art, New York, "New Media – New Methods"
Andrew Dickson White Museum of Art, Cornell University, Ithaca, New York, "Earth Art"
Fernsehgalerie, Berlin, Germany, "Land Art"
Stedelijk Museum, Amsterdam, Netherlands, "Op Losse Schtoeven"
San Francisco Art Institute, San Francisco, California, "Eugenia Butler Exhibition"
Städtische Kunsthalle, Düsseldorf, Germany, "Prospect"
Seth Siegelaub, New York, "March"
John Gibson Gallery, New York, "Ecological Art"
Richmond Art Center, Richmond, Virginia, "Return to Abstract Expressionism"
Berne Kunsthalle, Berne, Switzerland, "When Attitude Becomes Form"
Museum of Contemporary Art, Chicago, Illinois, "Art by Telephone"
Edmonton Art Gallery, Edmonton, Alberta, Canada, "Place and Progress"
Jewish Museum, New York, "The Artist's View"
Berne Kunsthalle, Berne, Switzerland, "Art After Plans"
Seattle Art Museum, Seattle, Washington, "587–087"

Vancouver Art Gallery, Vancouver, British
Columbia, Canada, "955,000"
Galerie Swart, Amsterdam, Netherlands
Fort Worth Art Museum, Fort Worth, Texas,
"Contemporary American Drawings"

1968

Dwan Gallery, New York, "Language II-III"
Dwan Galley, New York, "Earthworks"
Whitney Museum of American Art, New
York, "Sculpture Annual"

Selected Public Collections / Collezioni pubbliche (selezione)

Akron Art Institute, Akron, Ohio

Albright-Knox Art Gallery, Buffalo, New York

Art Gallery of New South Wales, Sydney, Australia

Art Gallery of Ontario, Toronto, Canada

Art Gallery of South Australia, Adelaide, Australia

Art Gallery of Winnipeg, Winnipeg, Manitoba, Canada

Art Institute of Chicago, Chicago, Illinois

ArtPark, Lewiston, New York

Atlantic Richfield Center for Visual Arts (ARCO), Los Angeles, California

Ball State University, Muncie, Indiana

Bard College, Annandale-on-Hudson, New York

Beuhl Foundation, New York

Bonner Kunstverein, Artothek, Bonn, Germany

Boijmans Van Beuningen, Rotterdam, Holland

Brainerd Art Gallery, State University of New York at Potsdam, New York

Brooklyn Museum of Art, Brooklyn, New York

Bundesgarten, Berlin, Germany

Cargo Centre International d'Arts Visuels, Marseille, France

Cedarhurst Sculpture Park, Mount Vernon, Illinois

Centre d'Art Plastique Contemporain, Bordeaux, France

Chiba City Museum, Chiba City, Japan

The City of Valladolid, Spain

The City of Palma de Mallorca, Spain

The City of Leoben, Austria

Corcoran Gallery of Art, Washington, DC

Cranbrook Academy of Art, Bloomfield Hills, Michigan

Danforth Museum of Art, Farmingham, Massachusetts

Denison University, Granville, Ohio

Denver Art Museum, Denver, Colorado

Des Moines Art Center, Des Moines, Iowa

Detroit Art Institute, Detroit, Michigan

Edmonton Art Gallery, Edmonton, Canada

Emanuel Hoffman-Stiftung, Basel, Switzerland

Everson Museum of Art, Syracuse, New York

Fattoria di Celle, Pistoia, Italy

Florida Atlantic University, Fort Lauderdale, Florida

Florida International University Art Museum, Miami, Florida

Fonds National d'Art Contemporain, La Defense, France

Fort Lauderdale Museum of Art, Fort Lauderdale, Florida

Fort Wayne Museum of Art, Fort Wayne, Texas

F.R.A.C. Nord pas-de-Calais, Lille, France

F.R.A.C. Picardie, Amiens, France

F.R.A.C. Aquitaine, Aquitaine, France

Fundação de Serralves, Porto, Portugal

Grand Rapids Art Museum, Grand Rapids, Michigan

Gröninger Museum, Gröningen, Holland

Guild Hall, East Hampton, New York

Haags Gemeentemuseum, Den Haag, Holland

Hallwalls Contemporary Arts Center, Buffalo, New York

Helsinki City Art Museum, Helsinki, Finland

Herbert F. Johnson Museum of Art, Ithaca, New York

High Museum of Art, Atlanta, Georgia

Hiroshima City Museum, Hiroshima City, Japan

Houston Contemporary Arts Museum, Houston, Texas

Indianapolis Museum of Art, Indianapolis, Indiana

Institute for Art and Urban Resources, Long Island City, New York

Israel Museum, Jerusalem, Israel

Jewish Museum of Art, New York

Kunsthaus Zürich, Zürich, Switzerland

Lannan Foundation, Los Angeles, California

L'Art Contemporain au Musée Departementl des Vosges, Epinal, France

Laumeier Sculpture Park, St. Louis, Missouri

Le Musée d'Art Moderne de Saint-Etienne, Saint-Etienne, France

List Visual Arts Center, Massachusetts Institute of Technology, Cambridge, Massachusetts

Montclair Museum of Art, Montclair, New Jersey

Los Angeles County Museum of Art, Los Angeles, California

Louisiana Museum of Modern Art, Humlebæk, Denmark

Ludwig Forum für Internationale Kunst, Aachen, Germany

Ludwig Museum, Cologne, Germany

Metropolitan Museum of Art, New York

Milwaukee Art Museum, Milwaukee, Wisconsin

Mint Museum, Charlotte, North Carolina

Mississippi Museum of Art, Jackson, Mississippi

Montclair Art Museum, Montclair, New Jersey

Mot, The Museum of Contemporary Art, Tokyo, Japan

Munson-Williams-Proctor Institute, Utica, New York

Musée d'Art Contemporain Entrepot, Bordeaux, France

Musée d'Art et d'Histoire, Geneva, Switzerland

Musée d'Art Moderne de la Ville de Paris, France

Musée d'Art Moderne et d'Art Contemporain, Nice, France

Musée de Toulon, Toulon, France

Musée de Grenoble, Grenoble, France

Musée National d'Art Moderne, Centre Georges Pompidou, France

Musée Royaux des Beaux-Arts, Brussels, Belgium

Museum Ludwig, Cologne, Germany

Museum of Art, Fort Lauderdale, Florida

Museum of Fine Arts, Houston, Texas

Museum of Contemporary Art, Chicago, Illinois

Museum of Contemporary Art, Miami, Florida

Museum of Contemporary Art, Honolulu, Hawaii

Museum of Contemporary Art, Los Angeles, California

Museum of Modern Art, Hide Park, Melbourne, Australia

Museum of Modern Art, New York

Museum van Hedendaagse Kunst, Gent, Belgium

National Gallery of Art, Ottawa, Canada

National Gallery of Art, Washington, DC

National Gallery of Australia, Canberra, Australia

National Museum of Contemporary Art, Kyungkido, Korea

Neuberger Museum, Purchase, New York

Newark Museum, Newark, New Jersey

Newport Harbor Art Museum, Newport Beach, California

Niagara University, Castellani Art Museum, Niagara, New York

Norton Gallery of Art, West Palm Beach, Florida

Oakland Museum, Oakland, California

Oberlin College, Allen Memorial Art Museum, Oberlin, Ohio

Ohio State University, Wexner Center for the Arts, Columbus, Ohio
Olympic Park, Seoul, South Korea
Orlando Museum of Art, Orlando, Florida
Oulu Art Museum, Oulu, Finland
Pennsylvania Academy of Fine Arts, Philadelphia, Pennsylvania
Philadelphia Art Alliance, Philadelphia, Pennsylvania
Philadelphia Museum of Art, Philadelphia, Pennsylvania
Phoenix Art Museum, Phoenix, Arizona
Pori Taidemuseo, Pori, Finland
P.S.1 Institute for Art and Urban Resources, Long Island City, New York
Queensland Art Gallery, Brisbane, Australia
Reina Sofia, Madrid, Spain
Rijksmuseum Kröller-Müller, Otterlo, Holland
Rose Art Museum, Brandeis University, Massachusetts
Samsung Foundation of Art and Culture, Korea
San Diego Museum of Contemporary Art, La Jolla, California
San Francisco Museum of Modern Art, San Francisco, California
San Jose Museum of Art, San Jose, California
Seattle Art Museum, Seattle, Washington
Skulpturen Museum der Stadt Marl, Marl, Germany
Sohio Development Company, Cincinnati, Ohio
Spencer Museum of Art, Lawrence, Kansas
Sprengel Museum, Hanover, Germany
Staatsgalerie Stuttgart, Stuttgart, Germany
Städtischer Museum Abteiberg Monchengladbach, Germany
Stadtisches Kunstmuseum Bonn, Bonn, Germany
Stedelijk Museum, Amsterdam, Netherlands
Tate Gallery, London, United Kingdom
Tel Aviv Museum, Jerusalem, Israel
Tel Hai, Upper Galilee, Israel
Total Art Museum, Korea
University of Alaska, Anchorage, Alaska
University of California Art Museum, Berkeley, California
University of Freiburg, Freiburg, Germany
University of Illinois Art Museum, Normal, Illinois
University of Massachusetts, University Gallery, Massachusetts
University of Minnesota, Tweed Art Museum, Duluth, Minnesota

University of Nebraska, Sheldon Memorial Art Galleries, Lincoln, Nebraska
University of New Mexico Art Museum, Albuquerque, New Mexico
Ville de Thiers, Thiers, France
Wadsworth Atheneum, Hartford, Connecticut
Walker Hill Art Center, Korea
Whitney Museum of American Art, New York
Weisman Foundation, Los Angeles, California
Worcester Art Museum, Worcester, Massachusetts

Books and Catalogues / Monografie e cataloghi

2007

Dennis Oppenheim: short circuit, Raffaele Bedariola e Ruggero Montrasio, SilvanaEditoriale | Montrasio Arte, Milano, Italia.

2006

Connecting Worlds, Shikata Yukiko, NTT InterCommunication Center, Tokyo, Japan
Escritos de Artistas, Jorge Zahar, Jorge Zahar Editor Ltda., Rio de Janerio, Brazil
Ethics and the Visual Arts, eds E.A.King and G. Levin, Allworth Press, New York
Art Metropole: the Top 100, K. Scott and J. Shaughnesy, National Gallery of Art, Ottawa, Canada
Art and Video in the 70s, Silvana Editoriale Spa, Milano, Italy
Collection of the Fondation Cartier at MOT, Foil Co., Ltd., Tokyo, Japan

2005

Slideshow: Projected images in Contemporary Art, Darcie Alexander, Baltimore Museum of Art, American University Presses, Pennsylvania
Odd Lots: Revisiting Gordon Matta-Clark's Fake Estates, eds Jeffrey Kastner, Sina Najafi and Frances Richard, Cabinet Books, New York
40 years at the ICA, ed. Johanna Plummer, Institute of Contemporary Art, University of Pennsylvania, Pennsylvania
Superstars: Warhol to Madonna, ed. Sigrid Mittersteiner, Hatje Cantz Verlag, Germany
Comme le reve, le dessin, Centre Geroges Pompidou, Paris, France
Dennis Oppenheim: Project Drawings, Demetrio Paparoni, In Arco Books, Torino, Italy
La Poetica de lo Neutro, Victoria Combalia, Debolsillo, Barcelona, Spain
Domicile: privé/public, Lorand Hegyi, Somogy Editions d'Art, Paris
The Chiaopanshan International Sculpture Park, Gerard Xuriguera, Taoyuan County Government, Taiwan

2004

The Context of Art / The Art of Context, Seth Siegelaub, Marion
Fricke and Roswitha Fricke, Navado Press, Trieste, Italy
Ana Mendieta: Earth Body, Olga M. Vison,

Hirshhorn Museum and Hatje Cantz, Ostfildern-Ruit, Germany
Ready to Shoot – Fernsehgalerie Gerry Schum, Ulrike Groos, Snoek Verlagsgesellschaft, Cologne, Germany
Art in Transit, Pallas Lombardi, Charlotte Area Transit System, Charlotte, North Carolina
The Museum: Conditions and Spaces, Andrea Douglas, University of Virginia Art Museum, Charlottesville, Virginia
One Hour Ahead, Dean Sobel, Aspen Art Museum, Aspen, Colorado
Prototypes: 1990–2003, Maurice Vatin, Fonds régional d'Art Contemporain de Picardie, Amiens, France
Beyond Geometry: Experiments in Form, 1940s–70s, Lynn Zelevansky, The Mit Press, Cambridge, Massachusetts
Parque de la Memoria, Comision pro Monumento a las Victimas del Terrorismo de Estado, Buenos Aires, Argentina
Behind the Facts (Interfunktionen 1968–75), Gloria Moure, Ediciones Poligrafa, Barcelona, Spain
Un Sociologue sur les terres du Land Art, Jean-Paul Brun, L'Harmattan, Paris, France
The Visual Experience, Jack Hobb, Davis Publications, Inc., Worcester, Massachusetts
Contemporary Color, Steven Bleicher, Thomson/Delmar Learning, Clifton Park, New York
Contre-Images, Regis Durand, Musée d'art contemporain de Nîmes, Nîmes, France
Video: Un Art Contemporain, Françoise Parfait, Editions du Regard, Paris, France
Ed Ruscha and Photography, Sylvia Wolf, Whitney Museum of American Art and Stedl Verlag, Gottingen, Germany
Bearings: Landscapes from the IMMA Collection, Irish Museum of Modern Art, Marguerite O'Molloy, Irish Museum of Modern Art
Architecture & Arts: A Century of Creative Projects in Building, Design, Cinema, Painting, Photography, Sculpture, Germano Celant, Skira, Milano, Italy
Legal/Illegal: Art beyond Law, ed. Corinna Weidner, NGBK, Berlin

2003

Dennis Oppenheim: Galloping through the West, Diane Deming, Nevada Museum of Art, Reno, Nevada

Dennis Oppenheim. De l'art a camp obert a l'art urba, Maria Lluisa Borras, Fundacio "Sa Nostra", Palma de Mallorca, Spain
Valencia Biennial: The Ideal City, Luigi Settembrini, Charta, Milan, Italy
X-Screen Film Installations and Actions in the 1960s and 1970s, Matthias Michalka, Verlag der Buchhandlung Walther König, Cologne, Germany
Metacorpos, Vitoria Daniela Bousso, Paco das Artes, São Paulo, Brazil
Siting Jefferson, Jill Hartz, University of Virginia Press, Charlottesville, Virginia
Art, Lies and Videotape: Exposing Performance, Adrian George, Tate Publishing, Liverpool, United Kingdom
Open Spaces, Barrie Mowatt, Buschlen Mowatt Gallery,Vancouver, Canada
The Last Picture Show: Artists Using Photography, 1960–1982, Douglas Fogle, Walker Art Center, Minneapolis, Minnesota
American Art at the Flint Institute, John B. Henry III, Hudson Hills Press, New York
La Collection, Musée d'Art Moderne, Jacques Beauffet, Musée d'Art Moderne de Saint-Etienne, Paris
Unloaded-Coming Up for Air, Catherine Hug, Edizioni Periferia Oberschan, Switzerland
The Castle – The Collection, Castello di Rivoli, Ida Gianelli, Desktop Publishing Editoday, Torino, Italy

2002

Visions from America: Photographs from the Whitney Museum of American Art, 1940–2001, Sylvia Wolf, Prestel, New York
La Conquête de l'Air – Les Colonies de l'Espace, Alain Mousseigne, les Abattoirs, Toulouse, France
Les Années 70: l'art en cause, Maurice Frechuret, Musée d'Art Contemporain de Bordeaux, France
New Materials as New Media, Marion Boulton Stroud, The MIT Press, Cambridge, Massachusetts
Le Livre du Frac-Collection Aquitaine, Alain Rousset, Le festin/FRAC Aquitaine, France
Earthworks Art and the Landscape, Suzaan Boettger, University of California Press, Berkeley, California
An American Odyssey 1945/1980, Stephen Foster, Circulo de Bellas Artes, Madrid, Spain
Le peuple des images, Philippe-Alain Michaud, Desclée de Brouwer, Paris

2001

Oppenheim Explorations, Germano Celant, Charta, Milan, Italy
Out of the Box The Reinvention of Art, 1965–1975, Carter Ratcliff, Allworth Press, New York
Sticky Sublime, ed. Bill Beckley, Allworth Press, New York
Zwischen Body Art und Videokunst, Barbara Engelbach, Verlag Silke Schreiber, Munich, Germany
Into the Light: the Projected Image in American Art 1964–77, Chrissis Iles, Cantz, Ostfildern, Germany
Performance Art nach 1957, Thomas Dreher, Wilhelm Fink Verlag, Munich, Germany

2000

Site-Specific Art: Performance, Place and Documentation, Nick Kaye, Routledge, London, United Kingdom
Lie of the Land, John Hansard Gallery, University of Southampton, Southampton, United Kingdom
Art Grandeur Nature, Conseil générale de la Seine – Saint-Denis, Bobigny, France
Totale 02, Museum für Nueue Kunst, Freiburg, Germany
Re-Play, Generali Foundation, Sabine Breitwieser, Generali Foundation, Vienna, Austria

1999

Drip Blow Burn: Forces of Nature in Contemporary Art, The Hudson River Museum of Art, Yonkers, New York
De Verzamellion, Stedelijk Museum voor Achele Kunst, Gent, Belgium
Electronic Vibration Pop Kulture Theorie, Gabrielle Klein, Rogner and Bernhard GmbH & Co., Hamburg, Germany
Sarajevo 2000, Lorand Heygi, Museum Moderner Kunst Stiftung Ludwig Wien, Palais Liechtenstein, Austria
Contemporary Outdoor Sculpture, Brooke Barrie, Rockport Publishers, Glouchter, Massachusetts
Sculpture in the Age of Doubt, Thomas McEvilley, Allworth Press, New York
Circa 1968, Vincente Toldi, Museu de Arte Contemporanea de Serralves, Porto, Portugal
The Museum as Muse, Kynaston McShine,

The Museum of Modern Art, New York
Biennal Exhibition of Public Art, Judy Collischan, Neuberger Museum of Art, Purchase, New York
Universiada '99, Maria Lluisa Borras, Consorci Mirall Palma Centre, Palma de Mallorca, Spain
The American Century, Lisa Phillips, The Whitney Museum of American Art, New York
Technologies of Landscape, eds James Dickinson and David E. Nye, University of Massachusetts Press, Amherst, Massachusetts
Parque de la Memoria, Editorial Universitaria de Buenos Aires, Buenos Aires, Argentina

1998

XXIV Bienal de São Paulo Nucleo Historico: Antropofagia e Historias de Canibalismos, Paulo Herkenhoff, Fundação Bienal de São Paulo, São Paulo, Brazil
Art of the 20th Century, ed. Ingo F. Walther, Taschen, Cologne, Germany
Performance Live Art Since 1960, Roselee Goldberg, Harry N. Abrams Inc., New York
New York Living Rooms, Staley and Wise, New York
Remanence, Maudie Palmer, Melbourne International Festival of the Arts, Ltd., Melbourne, Australia
Pollution, Claudia Gian Ferrari and Manlio Brusatin, Charta, Milan, Italy
Artostrada Dunes, Art & Electricity, Igal Galai, Israel Electric Corporation, Israel
Razgovori o Likovnoj Umetnosti III, Zoran L. Bozovic, Belgrade, Yugoslavia
Land and Environmental Art, ed. Jeffrey Kastner, Phaidon Press, Ltd., London, United Kingdom
Animal as Muse, Christina Orr-Cahall, Norton Museum of Art, West Palm Beach, Florida
Fuori USO 98, Giacinto Di Pietrantonio, Edizioni Arte Nova, Pescara, Italy
Double Trouble. The Patchett Collection, Pilar Perez, The Museum of Contemporary Art, San Diego and the Auditorio de Galicia, Santiago de Compostela, Spain
The Art of the X Files, William Gibson, Harper Prism, New York
Photo Image: Printmaking 60s to 90s, Clifford S. Ackley, The Museum of Fine Arts, Boston, Massachusetts
Tempi e Forme, Mario Bertoni, Hopeful Monster, Torino, Italy

1997

Dennis Oppenheim, Germano Celant, Charta, Milan, Italy
Dennis Oppenheim, Fundação de Serralves, Porto, Portugal
The Private Eye In Public Art, Joyce P. Schwartz, LaSalle Partners, Charlotte, North Carolina
Blurring the Boundaries: Installation Art 1969–1996, ed. Anne
Farrell, Museum of Contemporary Art, San Diego, California
L'Empreinte, Georges Didi-Huberman, Centre Georges Pompidou, Paris, France
Trade Routes 2nd Johannesburg Biennale, Greater Johannesburg
Metropolitan Council, Johannesburg, South Africa
Esthétique du livre d'artiste, Anne Moeglin-Delcroix, Bibliothèque nationale de France, Paris, France
The 47th Biennal International, Electa, Venice, Italy
Visual Arts in the Twentieth Century, Edward Lucie-Smith, Harry N. Abrams Inc. Publishers, New York
Allegory, Frederic Tuten and Diane Waldman, Joseph Helman Gallery, New York
Death in the Family, Russell Keziere, presentation House Gallery North Vancouver, British Columbia, Canada

1996

Dennis Oppenheim Land Art 1968–78, Vestsjaellands Kunstmuseum, Storgade, Denmark
Dennis Oppenheim Recent Sculpture and Large Scale Project Proposals, Mannheimer Kunstverein, Mannheim, Germany
Art into Theatre, Nick Kaye, Harwood Academice Publishers, United Kingdom
Landvermesser, Mannheimer Kunstverein, Mannheim, Germany
Aus der klassischen und spaten Moderne, Alexander Duckers, Staatliche Museen zu Berlin, Berlin, Germany
L'art au corps, Musées de Marseille, Marseille, France
Chimeriques polymeres. Le plastique dans l'Art du XXème siècle, Tita Reut, Musée d'Art Moderne et d'Art Contemporain, Nice, France
Artists Narcissism Reflect Themselves, Ree-

sey Shaw, California Center for the Arts Museum, Escondido, California
Regards sur la sculpture contemporaine, Gérard Xuriguera, Espace Belleville Confederation Française Democratique du Travail, Paris, France
Art at the end of the 20th Century, Johanna Drucker, National Gallery, Athens, Greece
Trilogy Art-Nature-Science, Kunsthallen Brandts Klaedefabrik, Odense, Denmark
Reel Work: Artist's Film and Video of the 1970s, ed. Bonnie Clearwater, Museum of Contemporary Art, Miami, Florida
Derde Druk, Sensory Overdrive, Alice Hutchison, Ben Shahn Galleries of William Patterson College, Wayne, New Jersey *Theories and Documents of Contemporary Art: A Sourcebook of Artist's Writings*, Kristine Stiles and Peter Selz, University of California Press, Berkeley and Los Angeles, California
Jaarverslag 1996, Stichting Kröller-Müller Museum, Otterlo, Netherlands

1995

Dennis Oppenheim. Obra 1967–1994, Ajuntament de Barcelona, Barcelona, Spain
Dennis Oppenheim. The Old In And Out, Galerie de la Tour, Amsterdam, Netherlands
Dennis Oppenheim, Kim Bradley, Ierimonti Gallery, Milano, Italy
It's Only Rock and Roll: Rock and Roll Currents in Contemporary Art, David S. Rubin, Prestel-Verlag, Munich, Germany
Reconsidering the Object of Art 1965–1975, Ann Goldstein and Anne Rorimer, The Museum of Contemporary Art, Los Angeles, California
Biennal de Lyon d'art contemporain: installation cinema video informatique, Reunion des Musées Nationaux Lyon, France

1994

Dennis Oppenheim, Palau de la Virreina, Barcelona, Spain
Dennis Oppenheim: Selected Works 1967–1991, Alanna Heiss and Thomas McEvilley, Musée d'Art Moderne de la Communauté Urbaine de Lille, Lille, France
Drawings, Ecole des Beaux-Arts de Lorient, Lorient, France
inSITE 94, Sally Yard, Museum of Contemporary Art, San Diego, Department of Culture of the City of Tijuana, Tijuana, California

East of Eden, Wolfgang Savelsberg, Museum Schloss Mosigkau, Mosigkau-Dessau, Germany
From Minimal to Conceptual Art, Ruth Fine, National Gallery of Art, Washington, DC
Wildlife, Reesey Shaw, California Center for the Arts Museum, Escondido, California
The Second Parrish Art Museum Design Biennial: Mirrors, Margo Majewska, Parrish Art Museum, Southampton, New York
Differentes Natures. Visions de l'Art Contemporain, Liliana Albertazzi, Ministère de la Culture et de la Francophonie, France
XIV Salon de los 16, Miguel Fernandez-Cid, Museo Nacional de Antropología, Madrid, Spain
IV Festival Iberoamericano de Teatro de Santa Fe de Bogotá, Bogota, Columbia

1993

Dennis Oppenheim: Recent Works, Ministre d'Educacio e Cultura del Governo d'Andorra, Andorra
Art and Application, A.C. Danto, Turbulence, New York
Dolls in Contemporary Art: A Metaphor of Person Identity, Curtis L. Carter, Marquette Univeristy, Milwaukee, Wisconsin
La Donation Vicky Remy, Editions du Musée d'Art Moderne, Saint-Etienne, France
The Nature of the Machine, Chicago Cultural Center, Chicago, Illinois
Paolo Uccello: Battaglie nell' arte del XX secolo nei luoghi romani di Santa Maria del Popolo, Achille Bonito Oliva, Electa, Milano, Italy
The Uncanny, Mike Kelley, Sonsbeek 93 Gemeentemuseum Arnhem, Netherlands and Fred Hoffman, Los Angeles, California
Action Performance and the Photograph, Robert C. Morgan, Turner/Krull Galleries, Los Angeles, California

1992

Expo Sevilla '92, Fundação de Serralves, Porto, Portugal
Dennis Oppenheim Drawings, Barbara Rose, La Difference, Paris, France
Dennis Oppenheim Drawings and Selected Sculpture, Kim Levin and Peter Spooner, University Galleries and Illinois State University, Normal, Illinois
Carmina Urbana, Editrice Grafica L'Etruria, Cortona, Italy
Art in the Age of Aquarius 1955–1970, eds William C. Seitz and Marla Price, Smithso-

nian Institution Press, Washington, DC
Collections, The Macedonian Centre for Contemporary Art, Thessaloniki, Greece
De Bonnard à Baselitz, Estampes et Livres d'Artistes de Bibliothèque, Paris, France
There is a Minute of a Fleeting World, Bernardo Pinto de Almeida, Fundação de Serralves, Porto, Portugal
Krittik 100, Hans Hage and Paul Erik Tojner, Gyldendalske Boghandel Publishers, Copenhagen, Denmark
Video at Après. La Collection Video du Musée National d'art Moderne, Christine Van Assche, Centre Georges Pompidou, Paris, France

1991

Dennis Oppenheim: Selected Works 1967–90, Thomas McEvilley and Alanna Heiss, Harry N. Abrams, Inc. and the Institute for Contemporary Art, New York
Dennis Oppenheim: Between Drinks, Galerie Gastaud, Clermont-Ferrand, France
Trains: Burden Kessler Oppenheim, Michael Klein, Inc., New York
Mechanika, The Contemporary Arts Center, Cincinnati, Ohio *DePersona*, Ronald Jones, The Oakland Museum, Oakland, California
Words As Image, Contemporary Arts Museum, Houston, Texas
After Duchamp, Edouard Jaguer and Jean Jacques Lebel, Galerie 1900-2000, Paris, France
Sculpture in the Rijksmuseum Kröller-Müller, eds Marianne Brouwer and Rieja Brouns, Otterlo, Netherlands
The Art Collection of Pacific Enterprises, Jan Butterfield, Los Angeles, California
Books As Art, Timothy A. Eaton, Boca Raton Museum of Art, Boca Raton, Florida
Glass: Materials in the Service of Meaning, Kim Levin, Tacoma Art Museum and the University of Washington Press, Seattle, Washington
Video, ed. Lori Zippay, Electronic Arts Intermi New York

1990

Dennis Oppenheim, Liverpool Gallery, Brussels, Belgium
Dennis Oppenheim. Retrospective 1970–1990, Pierides Museum of Contemporary Art, Athens, Greece
Dennis Oppenheim, Galerie Lohrl, Mon-

chengladbach, Germany
Ladon: Monsters of Mythology, Bernard Evslin, Chelsea House Publishers, New York
Word as Image, Milwaukee Art Museum, Milwaukee, Wisconsin *The Technological Muse*, S. Fillin-Yeh, Katonah Musem of Art, Katonah, New York
Casino Fantasma, The Institute for Contemporary Art, New York
Trains, Michael Klein, Inc., New York
Mondo Materials, G. Beylerian and J. Osbourne, Harry N. Abrams, Inc., New York
The Faces of An Era, Carlo Prosperi, Edition Sine Invest, Paris, France
Art Conceptual Formes Conceptuelles, M. Fleiss and C. Schlatter, Galerie 1900-2000, Paris, France
Une Collection pur la Grande Arche, l'Arche de la Fraternité, Paris, France
Pulse 2, University Art Museum, Santa Barbara, California

1989

Dennis Oppenheim, Elisabeth Franck Gallery, Knokke-le-Zoute, Belgium
Art in Safe, Ian Anull, Verlag Vexer, St. Gallen, Switzerland
Intuition, R. Nickas, John Gibson Gallery, New York
Project: Installation, Ellen O'Donnell, The Aldrich Museum of Contemporary Art, Ridgefield, Connecticut
Art Symposium, Minos Beach, Crete, Greece
Photo-Kunst, Jean-François Chevrier, Edition Cantz, Stuttgart, Germany
Immaterial Objects, Richard Marshall, The Whitney Museum of American Art, New York
Video-Skulptur Retrospektic und Aktuekk 1963-1989, W. Herzongenrath and E. Decker, Kölnischer Kunstverein Dumont, Cologne, Germany
Coming to Terms with Medieval Cypriot Ceramics through Contemporary Art, Sania Papa, The Pierdes Foundation, Larnaka, Cyprus
Art Against Aids, ed. Cynthia Chapman, Livet Reichard Co., Inc., New York

1988

Dennis Oppenheim, Walker Hill Art Center, Seoul, South Korea
Beyond Modernism, Kim Levin, Harper & Row Publishers, New York
Lost and Found in California. Four Decades of Assemblage Art, James Corcoran Gallery, Santa Monica, California
The Turning Point: Art and Politics in 1968, Nina C. Sundell, The Cleveland Center for Contemporary Art, Cleveland, Ohio
Kröller-Müller The First Hundred Years, Kröller-Müller Museum, Otterlo, Netherlands
The Tate Gallery Illustrated Catalogue of Acquisition 1984–86, Millbank, London, United Kingdom
A Bid for Human Rights, Lia Belli, Brendan Walter Gallery and Adelphia Society, Santa Monica, California

1987

Photography and Art, A. Grundberg and K. Gauss, Abbeville Press, New York
Contemporary American Collage 1960–1986, Herter Art Gallery, University of Massachusetts, Amherst, Massachusetts
Art Against Aids, eds Stephen Reichard and Anne Livet, Reichard Company Inc., New York
Art in Bookform, Maurizio Nannucci, Alvar Aalto Museum, Jyvaskyla, Finland
Eccentric Machines, Joanne Cubbs, John Michael Kohler Arts Center of the Sheboygan Arts Foundation, Inc., Sheboygan, Wisconsin
Artistes et Professeurs Invités 1975-1985, Catherine Queloz, Ecole Superieure d'art Visuel Geneve, Geneva, Switzerland
Twenty Seven Installations, Brian O'Doherty, Portland Center for the Visual Arts, Portland, Oregon

1986

The Tate Gallery 1982–84, Tate Gallery Publications, Millbank, United Kingdom
Fireworks American Artists Celebrate the Eighth Art, Pamela Lawrentz, The Butler Institute of American Art, Youngstown, Ohio
American Masters: Works on Paper from the Corcoran Gallery of Art, Edward J. Nygren and Linda Crocker Simmons, The Corcoran Gallery of Art, Washington, DC
Television's Impact on Contemporary Art, Marc H. Miller, The Queens Museum, Flushing, New York

1985

Dennis Oppenheim: Accelerator for Evil Thoughts, Alain G. Joyau Ball State University Art Gallery, Ball State, Indiana
Sculptures, Foundation Cartier, Jouy-en-Josas, France
Symposium National de Sculpture Monumentale Metallique, La Ville de Thiers, Thiers, France
The Maximal Implications of the Minimal Line, L. Weintraub, Edith C. Blum Art Institute at Bard College, Annandale-on-Hudson, New York
Reclamation Art, Paul Klite, Paul Klite Publisher, Denver, Colorado
The Doll Show: Artist's Dolls and Figurines, Judy Collischan Van Wagner and Carol Becker Davis, Hillwood Art Gallery of C.W. Post Long Island University, Hampton, New York

1984

Dennis Oppenheim, The Tel Aviv Museum, Tel Aviv, Israel
Dennis Oppenheim, AMAM Geneva and Erik Franck Gallery, Geneva, Switzerland
Collection, Erika and Rouf Hoffmann, Monchengladbach, West Germany
Chicago Sculpture International, Chicago, Illinois Contemporary Artists, St. Martin's Press, New York
Ecritures dans la Peinture, Vols 1 and 2, Claude Mollard, Centre National des Arts Plastiques Villa Arson, Nice, France
Land Marks, Lawrence Alloway, Bard College, Annandale-on-Hudson, New York
New Media, Malmö Konsthall, Sweden Resource/Reservoir, San Francisco Museum of Modern Art, San Francisco, California
Sculptural Ideas, Marsha Moss, Lehigh University Art Galleries, Bethlehem, Pennsylvania
SOLS, Marie-Claude Volfin and Lina Nahmias, Foundation Nationale des Arts Graphiques et Plastiques, Paris, France
The Art Dealers, L. de Coopet and A. Jones, Clarkson N. Potter, Inc., New York
Selection from the Permanent Collection, Vol. 1, ed. Terry Ann R. Neff, Museum of Contemporary Art, Chicago, Illinois
Munson Williams Proctor Institute Yearbook 1983–84, Paul J. Farinella, Dodge Graphic Press, Utica, New York
A Second Talent, Robert Metzger, Aldrich Museum of Contemporary Art, Ridgefield, Connecticut
Artpark 1984 Visual Arts Program, Donald Kuspit, Artpark, Lewiston, New York

1983

Dennis Oppenheim, Akira Ikeda Gallery, Tokyo
Japan Currents: Contemporary Directions in the Visual Arts, H.J. Smagula, Prentice-Hall, Inc., Englewood Cliffs, New Jersey
Overlay, L.R. Lippard, Pantheon Books, New York
World Art Trends 1982, ed. J.L. Pradel, Harry N. Abrams Inc., New York
Contemporary Paintings Drawings and Sculpture, Sotheby's Parke Bernet, Inc., New York
Minimal Earth and Conceptual Art, Jazzpetie, Prague, Czechoslovakia
American Drawings Watercolors Pastels and Collages, The Corcoran Gallery of Art, Washington, DC
ARC 1973-1983, Suzanne Page and Juliette Laffon, Musée d'Art Moderne de La Ville de Paris, Paris, France

1982

American Artists Talk on Art: From 1940–1980, E.H. Johnson, Harper and Row, New York
A Concise History of World Sculpture, G. Bazin, Alpine Fine Arts Collection, Ltd., New York
Avanguardia/Transavanguardia, Achille Bonito Oliva, Electa, Milano, Italy
60-80: Attitudes/Concepts/Images, Stedelijk Museum, Amsterdam, Netherlands
Metaphor: New Projects by Contemporary Sculptors, Howard N. Fox, Hirshhorn Museum and Smithsonian Institution Press, Washington, DC
Mile of Sculpture, Chicago Sculpture Society, Chicago, Illinois
Louisiana: The Museum and the Buildings, Louisiana Museum of Modern Art, Humlebæk, Denmark
Illegal America, Jeanette Ingberman, Exit Art Press, New York
Sichtbar Machen, Documenta Urbana, Kassel, Germany
Past Present Future, Tilman Osterwold, Württembergischer Kunstverein Stuttgart, Stuttgart, Germany
112 Workshop / 112 Greene Street, New York
Prints by Contemporary Sculptors, Richard S. Field and Daniel Rosenfeld, Yale University Art Gallery, New Haven, Connecticut

1981

New Dimensions in Drawing, Richard Anderson, Aldrich Museum of Contemporary Art, Ridgefield, Connecticut
Instruction Drawings, Cranbrook Academy of Art, Bloomfield Hills, Michigan
Mythos and Ritual, Erika Billeter, Kunthaus, Zürich, Switzerland *Machineworks*, Institute of Contemporary Art, Philadelphia, Pennsylvania
Biennial Exhibition, Whitney Museum of American Art, New York
Models and Drawings for Large Scale Sculpture, Richard Hines Gallery, Seattle, Washington
Alternatives in Retrospect, New Museum, New York
The Shock of the New, R. Hughes, Knopf Publishers, New York
Art in Our Times, P. Sekz, Harry Abrams Publishers, New York
Schemes: A Decade of Installation Drawings, Shelley Rice, Elise Meyer, Inc., New York
Varieties of Visual Experience, E. Feldman, Prentice-Hall, Inc. and Harry Abrams Publishers, New York
California. The State of Landscape 1872–1981, Betty Turnbull, Newport
Harbor Art Museum, Newport Beach, California
Soundings, Suzanne Delehanty, Neuberger Museum, Purchase, New York

1980

Drawings The Pluralist Decade, Janet Kardon, Institute of Contemporary Art at University of Pennsylvania, Philadelphia, Pennsylvania
The Arts of Twentieth Century America, University Press of America, Lanham, Maryland
Architectural Sculpture, Vol. 2, Bridget Johnson and Howard Singerman, Los Angeles Institute of Contemporary Art, Los Angeles, California
Printed Art: A View of Two Decades, Museum of Modern Art, New York
Reasoned Spaces, Center for Creative Photography, Tucson, Arizona
Skulptur in 20. Jahrhundert, Werlag Weiner Duck AG, Basel, Switzerland
Leben mit Zeitgenossen, Emanuel Hoffmann-Stiftung, Basel, Switzerland

Für Augen und Ohren, Rene Block, Akademie der Kunste, Berlin, Germany
Wave Hill 1980: Temporal Structures, Wave Hill, Bronx, New York
ROSC 80 The Poetry of Vision, Dorothy Walker, Irish Printers, Ltd., Dublin, Ireland
The Institute for Art and Urban Resources Inc. P.S.1 The Clocktower, Alanna Heiss, Peter F. Mallon Inc., New York
Projects Architectural Sculpture, Bridget Johnson, Los Angeles *Institute of Contemporary Art*, Los Angeles, California
Ecouter par les Yeux. Objets et Environements Sonores, Suzanne Page, ARC Musée d'Art Moderne de la Ville de Paris, Paris, France

1979

Dennis Oppenheim, Kunsthalle Basel, Basel, Switzerland
Dennis Oppenheim, Musée d'Art Moderne de la Ville de Paris, Paris, France
Dennis Oppenheim Israel Projects, Martin Weyl, The Israel Jerusalem, Israel
Dennis Oppenheim Power Passage, Herron Gallery at Purdue University, Indianapolis, Indiana
American Art, Sam Hunter, Prentice-Hall Englewood Cliffs, New Jersey and Harry N. Abrams Publishers, New York
The Writings of Robert Smithson, N. Holt, New York University Press, New York
Earthworks: Land Reclamation as Sculpture, R.G. Hess, Seattle, Washington
Image and Object in Contemporary Sculpture, Detroit Institute of Arts, Detroit, Michigan
Kollektie de Groot, Frans Haks, Gröninger Museum, Gröninger *Holland Narrative Realism*, Marve H. Cooper, The Art Association of Newport, Newport, Rhode Island
Gerry Schum, Edy De Wilde, Isabella Puliahito, Stedelijk Museum, Amsterdam, Netherlands and Genova, Italy

1978

Dennis Oppenheim: Retrospective Works 1967–1977, Musée d'Art Contemporain, Montréal, Canada
Die Collectie Modern Kunst van Museum Boijmans Van Beuningen, Museum Boijmans Van Beuningen, Rotterdam, Holland
New Artists Video, ed. G. Battcock, E.P. Dutton, New York

Artitudes, F. Pluchart, Galerie de la Marine, Nice, France

Artforms, D. Preble, Canfield Press, San Francisco, California

Sculptur/Nature, Centre d'Arts Plastique Contemporaines de Bordeaux, Bordeaux, France

The Sense of Self, Independent Curators, Inc., Washington, DC

16 Projects/4 Artists, Wright State University, Dayton, Ohio

Esthetics Contemporary, R. Kostelanetz, Prometheus, Buffalo, New York

Topics in American Art Since 1945, ed. L. Alloway, Norton Publishers, New York

1977

American Art in Belgium, Palais des Beaux-Arts, Brussels, Belgium

History of Modern Art, Harry Abrams, New York

Why Art, ed. G. Battcock, E.P. Dutton Publishers, New York

The Dada and Surrealist Heritage, Sterling and Francine Clark Art Institute, Williamstown, Massachusetts

Documenta 6, Vol. 3, Paul Dierichs KG and Company, Germany

Early Work by Five Contemporary Artists, Marcia Tucker, The New Museum, New York

Kunst und Architektur, Galerie Magers, Bonn, Germany

Art Now, Edward Lucie Smith, William Morrow and Company, Inc., New York

Biennial Exhibition, Whitney Museum of American Art, New York

Individuals, ed. A. Sondheim, E.P. Dutton Publishers, New York

Video Visions, J. Price, Plume Publishers, New York

Rooms P.S.1, Institute for Art and Urban Resources, New York

Space Window, Eve Vaterlaus and Joan Waltemath, Brown University, Providence, Rhode Island

Art America, M. Tighe and E. Lang, McGraw-Hill, New York

Time, Janet Kardon, Philadelphia College of Art, Philadelphia, Pennsylvania, U.S.A.

A View of a Decade, Martin Friedman, Museum of Contemporary Art, Chicago, Illinois

Skira Annuel, Editions Skira S.A., Geneva, Switzerland

American Narrative / Story Art, Contemporary Arts Museum, Houston, Texas

Documenti di Cinema d'artista, Zona Film, Firenze, Italy

1976

Artpark: The Program in the Visual Arts, Lewiston, New York

La Biennale di Venezia, Vol. 2, Alfieri Edizioni d'Arte, Venezia, Italy

Precronistoria 1966-1969, Germano Celant, Firenze, Italy

Amerikanische Kunst von 1945 bis Heute, D. Honisch and J. Jensen, Dumont Buchverlag, Cologne, Germany

Modern Art and the Object, E. Johnson, Harper Row Publishers, Inc., New York

Open to New Ideas, Georgia Museum of Art Bulletin, Vols 2–3, University of Georgia, Athens, Georgia

Video Art: An Anthology, J. Schedier and B. Korot, Harcourt Brace and Jovanovich, New York

Soho: Downtown Manhattan, Berliner Restwochen, Berlin, Germany

Europe/America: The Different Avant-Garde, Achille Bonito Oliva, Deco Press, New York

The Kitchen: Center for Video and Music 75–76, Haleakala Press, New York

1975

Dennis Oppenheim, Palais des Beaux-Arts, Brussels, Belgium

Topics in American Arts Since 1945, ed. L. Alloway, Norton Publishers, New York

American Sculpture in Progress, W. Anderson, New York Graphic Society, New York

Art in Landscape, Marianne Nanne-Brahammar Independent Curators, Inc., Washington, DC

Camera Art, Lunds Konsthall, Lund, Sweden

On ne Regards pas la Lune Mais le Doigt qui Montre la Lune, W. de la Vaissiere, Les Ateliers de Realisations Graphiques, Paris, France

American Art of the 20th Century, Sam Hunter, Harry N. Abrams Publishers, New York

Proposals 1967–1974 Dennis Oppenheim, Lebeer-Hossman, Brussels, Belgium

The Tate Gallery, Tate Gallery Publications, Millbank, United Kingdom

Video Art, Institute of Contemporary Art, Philadelphia, Pennsylvania

Video Art U.S.A., David A. Ross, XIII Bienal de São Paulo, São Paulo, Brazil

Skira Annuel, Editions Skira S.A., Geneva, Switzerland

The Roots and Routes of Art in the 20th Century, M. Cone, Horizon Press, New York

Vito Acconci, M. Diacone , Out of London Press, New York

Art in the World, S. Russell, Corte Madera Holt Rinehart Winston, New York

Painting Drawing and Sculpture of the 60s and the 70s from the Dorothy and Herbert Vogel Collection, Institute of Contemporary Art, Philadelphia, Pennsylvania

1974

Dennis Oppenheim, Stedelijk Museum, Amsterdam, Netherlands

Art Now, Artrend Foundation, Washington, DC

Great Western Salt Works, ed. J. Burnham, George Braziller Publishers, New York

Images and Icons of the Sixties, N. Calas and E. Calas, E.P. Dutton, Inc., New York

Senza Titolo, Germano Celant, Bulzoni Editore, Roma, Italy

Art as a Living Ritual, Pool der Poolerie, Germany

Kunst Bleibt Kunst, Kunsthalle Köln, Cologne, Germany

Indentations Dennis Oppenheim, Galerie Yaki Kornblit, Amsterdam, Netherlands

Schema Informazione 2, Galleria Schema, Firenze, Italy

Il corpo come linguaggio, Lea Vergine, Giampaolo Prearo Editore, Roma, Italy

1973

Actualité d'un bilan, Yvon Lambert, Paris, France

Aspects de l'Art Actuel, Centro Di, Firenze, Italy

Six Years: The Dematerialization of the Art Object, Lucy Lippard, Praeger Publishers, New York

Man Creates Art Creates Man, Duane Preble, Canfield Press, San Francisco, California

American Drawings 1963–1973, Elke M. Solomon, Whitney Museum of American Art, New York

1972

Museums in Crisis, B. O'Doherty, George Braziller, New York

Il Territorio Magico, Achille Bonito Oliva, Centro Di, Firenze, Italy

Documenta 5, Paul Dierichs KG & Co., Germany

Varieties of Visual Experience, E. Feldman, Prentice-Hall, Inc.,
Englewood Cliffs, New Jersey and Harry Abrams Publishers, New York

Kunst van de 20e eeuw, Museum Boijmans Van Beuningen, Rotterdam, Holland

Mathias Felds Exposition, Galerie Mathias Felds, Paris, France

Conceptual Art, Ursula Meyer, E.P. Dutton Publishers, New York

Pop Art & Cie, F. Pluchart, Editions Martin-Malburet, Paris, France

1971

Dennis Oppenheim, Jorge Glusberg, Centro de Arte y Communicación, Beunos Aires, Argentina

The Structure of Art, J. Burnham, George Braziller, New York

Earth Air Fire Water, Boston Museum of Fine Arts, Boston, Massachusetts

Concept Art, K. Honnef, Phaidon Publishers, New York

Art and Life, U. Kultermann, Praeger Publishers, New York

Lithographs, Nova Scotia College of Art and Design at Halifa Nova Scotia, Canada

Multiples: The First Decade, Philadelphia Museum of Art, Philadelphia, Pennsylvania

New Multiple Art, Art Council of United Kingdom, London, United Kingdom

Prospect 71: Projection, Art Press Verlag, Düsseldorf, Germany

Situation Concepts, Galerie im Taxi Palais, Innsbruck, Austria

Sonsbeek 71, ed. Geert van Beijerene Coosjekapteyn, Sonsbeek Foundation, Arnheim, Holland

Lithographs. Nova Scotia College of Art and Design, Gerald Ferguson, National Gallery of Canada, Ottawa, Canada

1970

Land Art, Fernsehgalerie Gerry Schum, Berlin, Germany

Concept Art/Arte Povera/Land Art, Germano Celant, Praeger Publishers, New York

Information, Kynaston L. McShine, Museum of Modern Art, New York

Leben und Kunst, U. Kultermann, Studio Wasmuth, Tübingen, Germany

955,000, Vancouver Art Gallery, British Columbia, Canada

Recorded Activities, Moore College of Art, Philadelphia, Pennsylvania

Annual Exhibition of Contemporary American Sculpture, Whitney Museum of American Art, New York

1969

Arte Povera, Germano Celant, Praeger Publishers, New York

Earth Art, Andrew Dickson, White Museum of Art at Cornell University, Ithaca, New York

557,087, Lucy Lippard, Seattle Art Museum, Seattle, Washington

Live in Your Heads: When Attitudes Become Form, Harald Szeemann, Kunsthalle Bern, Berne, Switzerland

Square Pegs in Round Holes, Stedelijk Museum, Amsterdam, Netherlands

Prospect 69, Stadtische Kunsthalle Düsseldorf, Düsseldorf, Germany

Drawings, Henry Hopkins, Fort Worth Art Center Museum, Fort Worth, Texas

1967

Richmond Art Center Thirtieth Anniversary Exhibition, Hazel Salmi, Richmond Art Center, Richmond, California

Major articles / Principali recensioni

2007

Rocky Mountain News, "Justice Center hired", Mary Chandler, December 13

2006

Artinfo, "The AI Interview: Dennis Oppenheim", October 11
Artseen, "Dennis Oppenheim. Alternative Landscape Components", Christopher Howard, November, p. 33
Atelier, "Dennis Oppenheim, An Interview", K. Lopatova and J. Horsky, no. 21, October, p. 15
Corvallis Gazette-Times, "Sculpture get a New Hue", Marchy Ann Albright, August 30
Cultura, "Espectaculos", February 10, p. 81
Kultura, "Sculpture Grande", July 7, p. 9
Palm Beach Daily News, "Eaton debuts show", John Sjostrom, February 19
Penn Current, "Art in the Open", Heather Davis, May 11, pp. 1–3
The Architect's Newspaper, "Dennis Oppenheim's Alternative Landscape Components: A New Land Art", Nancy Owens and Owen Serra, November 11, p. 24
The Kansas City Star, "Let the Art debate start", Lynn Horsley, February 9
The New York Times, "Commuter Art", Carol Vogel, July 14, p. E28
The Tribeca Trib, "Artist's-Style Nature Blooms Downtown", Barry Owens, September, p. 49

2005

Art US, "Dennis Oppenheim: Alternate Currents", Kathleen Vanesian, March, p. 8
Balkon, "Interview with Dennis Oppenheim", Erdosi Aniko, no. 5, p. 31
Bartlesville Examiner – Enterprise, "Price Tower arts Center to Present Dennis Oppenheim", Editorial Board, February 27, p. C1
Budapest Observer, "Az Invencio a Lenyeo", Lipovszky Csenge, June 15
Budapest Observer, "A vilagszellem a rnyeka", Hajdu Istvan, June 9
Budapest Observer, "Az Oppenheim-Csavar", Banky Bea, June 13
Budapest Observer, "Kepes Lapok", Marchtos Gabor, June 11
Budapest Observer, "Best Bets: Dennis the Menace", Stephen Anthony, May 30

Budapest Buisness Journal, "Best Bets: Dennis the Menace", Stephen Anthony, March 30
Descubrir el Arte, "Mil Rostros", Perez Segura, December, p. 102
Estilo Clásico, "La Passion Mediterránea de dos Esquiadores", Raquel Alba, p. 100
Exit, "Az Invencio A Lenyeo", Lipovsky Csenge, June 15
Exit, "Egy Metropolisz Tortenetmoseloge", Gromek, March 12
Flash Art, "In ARCO", Norma Mangione, August–September, p. 117
Greek Arts Newspaper, "Dennis Oppenheim", Adrian Dannatt, May, p. 27
Kog Art, "Kiallitása", Brigitta Ivanyi, May
Lift kultur, "Fast im Kanst", March, p. 75
Magyar Hirlap, "Az Oppenheim-Csavar", Banky Bea, June 13
Manesu, "A Vilagszellem arnyeka", Hajdu Istvan, June 9
Minerva, "Dennis Oppenheim", Cris Gabarron, December, p. 4
Nepszava, "Kepes Lapok", Mantos Babor, June 11
Nepszabadsag, "Oppenheim Kozep – Europaban", March 18
Pestiest, "Oppenheim Szerint a Vilag", June 23–29
Sacramento.com, "Rare Birds", Patricia Beach Smith, January 22
Sacramento Union, "Plotting a Course", J.T. Long, May, p. 50
Sacramento Business Journal, "Taking off in Style", Robert Celaschi, May 27, p. S4
Sculpture, "Public art is Dangerous", David Grant, April, p. 41
Siggy Urbanite, "Standing the Church on Its Ear", Darcy Siggelkow, November 1
Sonnen Deck, "Legal/Illegal", March, pp. 28–29
Stilus Magazine, "Csokirevolver", June 15
Stuttgarter Zeitung, "Grenzange Zwischen Kunst und Politik: Kunstverein Neuhausen zeigt Ausstelung 'Legal/Illegal'", March, p. 21
The Art Newspaper, "Artist Interview: I could never stay with just one thing", Adrian Dannatt, March, p. 35
The East Hampton Star, "Artists' Summit at Guild Hall" Sheridan Sansegundo, July 14, p. C6
The Vancouver Sun, "Artworks sprout up around city for sculpture Biennale", Amy O'Brian, October 1, p. D1

Vilaggazdasag, "VGArt Klub Dennis Oppenheim", March 20

2004

ABC, "Dennis Oppenheim", Ana Belen Hernandez, April 5, p. 57
Art in America, "Perils of Public Art: Art vs Religion and Commerce", Stephanie Cash, November, p. 45
Artforum, "The Last Picture Show", David Deitcher, February
Arti & Architettura, "Una progessione di sorprese", Stefano Boeri, October 3, p. 38
Artnet, "Weekend Update", Walter Robinson, www.artnet.com, February 27
Artnet, "Oppenheim Commission quashed in Stanford", October 8, www.artnet.com
Artnews, "Stanford Keeps Church out of School", Erica Brody, December, p. 54
Columns, "A round table discussion: Public Art and Architecture", October 4, pp. 6–13
Columns, "A roundtable discussion, Public Art and Architecture", Anne J. Swager, AIA Pittsburgh.
Corriere Mercantile, "Celant lancia il fazzoletto", Alberto Bruzzone, February 3, p. 19
Cultura, "Oppenheim recupera 30 anos de arte ideado como 'Manequinania de critica'", Miguel Angel Vergaz, October 19, p. 35
Cultura, "Arte y arquitectura, frente a frente", Irene Hidez Velasco, October 12, p. 79
Cultura, "Maquinas Subversivas", Marchia Aurora Viloria, October 29, p. 52
Diario de Mallorca, "La escultura de Oppenheim ha regresado a su plaza", Redacion, January 24 p. 34
Die Tageszeitung, "Lady Liberty Errötet", Arcus Woellner, October 21
El Pais, "El arte conceptual de Oppenheim llega a los proyectos públicos", F.S., December 15, p. 48
Hampton Style, "Dennis Oppenheim talks about art out East", Claire Bradford, September 6, pp. 46–48
Irish Museum of Modern Art, "Bearings", Marguerite O'Molloy, April
La Cultura, "Retrospectiva de Oppenheim con pinturas, maquetas, fotos y maquinas", Fransisco Piedra, November 3, p. 47
Les Environmentales 2004, "Dennis Oppenheim", Oliver Kaeppelin, pp. 18–19, July
Minerva (Circulo de Bellas Artes, Madrid, Spain Describir el Arte), "Mil Rostros" Javier Perez Segura, Madrid, Spain, December, p. 102

Nacional, "Marchco revive las tecnicas y tendencias fotographicas entre los anos 60 y 80", E. Perez, May 29, p. 14

Newsday, "Standing on the Corners", Ariella Budick, August 22, p. 109

Palo Alto Daily News, "Banned Art is thought-provoking", Diana Diamond, October 7, pp. 12–14

Palo Alto Weekly (weekend edition), "Rooting out evil at Stanford?", Robyn Israel, October 29, pp. 8–9, 11

Passion Jardins Décoration, "Land Art au Campus", Anne Kerner, May, p. 51

Reno Gazette-Journal, "Time running out for art displays", Jason Kellner, January 2, p. 3

Sacramento Bee, "High hopes for airport", Cameron Jahn, August, p. 30

Sacbee.com, "Preflight car routine is rising to new heights", Ed Fletcher, September 24

San Jose Mercury News, "Stanford President rejects Sculpture", Jack Fischer, October 2, p. 3B

San Jose Mercury News, "Stanford's art decision needs airing", Scott Herhold, October 3, p. B1

San Jose Mercury News, "Readers show anger… and a little insight", Scott Herhold, October 13

Sculpture, "News", Editorial Board, December, p. 10

SFgate.com, "Device fails to get blessing at Stanford", Kenneth Baker, September 28

Shanghai Star, "The next Dalí" Yvonne Zhang, November 4, p. 29

Stanford Daily, "Stanford censors Sculpture", Sarah Lustbader, September 28

Stanford Daily (online edition), "President wisely rejected Sculpture", Editorial Board, October 8

The Architect's Newspaper, "For Art's Sake", Aric Chen, October 19, p. 3

The Chronicle of Higher Education, "Sense and Censorship", Sara Lipka and John Gravois, November 12

The Daily (letters to the editor), "Sculpture offers pertinent critique of American society", Daniel Phelps, October 12

The Daily Californian, "Stanford Speech Silenced", Editorial, October 5, P. 6

The Herald, "Latin art fair gets fresh start", Elisa Turner, p. 3B, March 28

The Los Angeles Times, "Photo-synthesis", Christopher Knight, March 7, p. E1

The New York Times (arts and leisure section), "God and Man at Stanford", Andrew Blum, October 17, p. 4

The Los Angeles Times, "In brief: University President turns down Sculpture", October 3, p. B4

The Shanghai Wednesday, "Art Gallery" Editorial Board, November, p. 3

The Valley, "Stanford President Rejects Sculpture", Jack Fischer, October 2, p. 3B

Ultima Hora, "Buena corecha para los ocho galeristas balearas que participa en Arco", Marchian Diaz and Joan Torres, February 13, p. 62

Village Voice, "Clocking Into Dennis Oppenheim's Thought Collision Factories", Kim Levin, www.villagevoice.com/issues, February 3

Vivir, "Oppenheim: Los politicos no escuchan a los artistas", H. Madicoo, October 29, p. 13

2003

Art and Gallery, "Blind", Manuela Gandini, pp. 2–4.

Art in America, "Milwaukee's 'Blue Shirt' Left Hanging", David Ebony, April 1, p. 160

ArtReview, "Blue-collar Blues", Anthony Haden Guest, April 1, pp. 32–33

Contra Costa Times, "Panel Picks Lesher Center Sculpture", Dogen Hannah, April 9

Contra Costa Times, "Walnut Creek Considers Sculptures for Downtown", Dogen Annah, April 4

Daily Post, "Still happening years later", Phillip Key, November 21

Denver Post, "9/11 pushed sculptor Dennis Oppenheim to enter Denver firehouse proposal", Kyle MacMillan, www.denverpost.com/cda/article, August 8

Dominical, "Oppenheim: icono del concepto", Gudi Moragues, p. 15, October 26

Encore, "Nevada Museum of Art: Dennis Oppenheim", p. 14, October

L'Espirn, "Dennis Oppenheim El temple de l'art", Christina Ros, p. 4, November

Milwaukee Magazine, "Shirtless", David Bamberger, May 1, p. 36

Milwaukee Journal Sentinel, "Alteration of 'Blue Shirt' approved", Dave Umhoefer, January 18

Milwaukee Journal Sentinel, "Strife aside, art makes cities more interesting", Whitney Gould, January 27

Milwaukee Journal Sentinel, "Request for extension leaves 'Blue Shirt' hanging", Dave Umhoefer, January 29

Milwaukee Journal Sentinel, "Walker moves to kill 'Blue Shirt'", Dave Umhoefer, January 31

Milwaukee Journal Sentinel, "Don't put 'Shirt' out to dry", Editorial, February 1

Milwaukee Journal Sentinel, "Artists blue about 'Shirt'", James Auer, February 2

Milwaukee Journal Sentinel, "Supervisors worry county could lose its shirt in legal battle over 'Blue'" Bruce Murphy, February 5

Milwaukee Journal Sentinel, "Artist's lawyer alleges county breached 'Shirt' contract", Dave Umhoefer, February 7

Milwaukee Journal Sentinel, "'Stodgy' is in the eyes of the beholder", Laurel Walker, February 7

Milwaukee Journal Sentinel, "Local artist's airport alteration may not get off the ground", Jim Stingl, February 19

Milwaukee Journal Sentinel, "Museum might host debate on 'Blue Shirt'", Dave Umhoefer, February 19

Milwaukee Journal Sentinel, "'Blue Shirt' artist makes plea to board", Dave Umhoefer, February 20

Milwaukee Journal Sentinel, "Artist accuses County of Censorship", Dave Umhoefer, February 21

Milwaukee Journal Sentinel, "A Blue Shirt Gets Trashed", Editorial, February 22

Milwaukee Journal Sentinel, "Shared input May ease acceptance of art", James Auer, February 26

Milwaukee Journal Sentinel, "Don't hang public art out to dry", Edie Boatman, March 7

Milwaukee Journal Sentinel, "Hold the Mothballs: New Sites Suggested for 'Blue Shirt'", Whitney Gould and Tom Heinen, March 10

Milwaukee Journal Sentinel, "The Artful Dodger", Whitney Gould, May 18

Milwaukee Journal Sentinel, "Committee uncovers Oppenheim piece to replace 'Blue Shirt'", Dave Umhoefer, October 25

Milwaukee Journal Sentinel, " From 'Blue Shirt' to boats", Editorial, October 30

Moonshine Ink, "Evoking the Wild West, Wild Thoughts", December

NYFA Quarterly, "Artistic Rivalry: An Ongoing Story or So Past-Century?", Suzaan Boettger, p. 7

Reno Gazette-Journal, "Galloping through changing times", Forrest Hartman, October 17, www.rgj.com/news

Reno News & Review, "All in his head", D. Brian Burghart, pp. 1, 12–15, October 23

Sculpture, "Oppenheim's Blues", News Editor, June 1, p. 12

Star Tribune, "The F-Stops Here", Mary Abbe, October 10

Tech Transfer, "Excellence in Transportation", Summer, p. 5

The Business Journal, "Civic Pride + Artistic Creativity = Controversy", Becca Mader, March 21, pp. A17, A22, A23

The New York Times, "Blue Shirt Battle", Carol Vogel, February 14

Ultima Hora, "El arte mas misterioso de Dennis Oppenheim se acerca a Mallorca", Laura Moya and Marchiana Diaz, October 3, p. 9

Ultima Hora, "Es Baluard", p. 12, December 31

2002

Art in America, "Report from Arizona: Not a Mirage", Raphael Rubinstein, December

Artes Visuales, "Bellas Artes ya Prepara la Bienal Internacional 2002", Jorge Glusberg, October 1

Artes Visuales, "Artistas e Renombre en la Bienal de Arte 2002", Jorge Glusberg, October 22

Artes Visuales, "Trae Artistas de 45 Paise la Segunda Bienal de Arte", Jorge Glusberg, October 29

Artnews, "Pop Over, Word Up", Katie Clifford, January

Artweek, "Oppenheim's Public Art Project Unveiled", July–August

BAM, "Cover Artist", Deborah Bowie, April

Buenos Aires Herald Magazine, "A Park to Prevent Forgetting", Andrew Graham-Yooll, January 5

The East Hampton Star, "Dennis Oppenheim Art as Radical Process", Sheridan Sansegundo, August 15

Footlights, untitled article, September

FraMart Studio, "Masterpiece at Capodimonte, past Millennium", June

Future Focus, "Artist-Designed Bus Transfer Centre Scheduled to Open in Ventura", April–June

Houston Chronicle, "Art on the Edge", Patricia C. Johnson, September 14

Irish Museum of Modern Art, "The Unblinkng Eye", Marguerite Molloy, September

Joseph Helman Gallery, "The New York Artworld", Lily Faust, May

L'Express, "Les Environnementales", July 6

La Naction, "La Bienal Muestre el Nuevo Arte Expresivo", Alicia de Arteaga, November 9

Le Figaro, "Le Patrimoine se met au Vert", Caroline Salle, May 31

Le Figaro, "Les Poesies Farceuses de la Nature", Marie-Guy Baron, June 10

Le Moniteur, "Tecomah Organise ses Deuxiemes Environnementales", Francis Gouge, May 31

Le Nouvel Observateur, "La France en Campagne", Bernard Genies, May, p. 132

Le Parisien, "Les Eleves Devoilent Leur Galerie d'Art a Ciel Ouvert", Veronique Beaugrand, May 17

Liberation, "Poesies en vert", Anne-Marie Fevre, May 17, p. 27

Los Angeles Times, "Bus Station Sculpture a Traffic Stopper", Steve Chawkins, April 5

Los Angeles Times, "Celebrating the Vital Spirit of Ventura's Late Art City", Josef Woodard, June 6

Milwaukee Magazine, "Fashion or Faux Pas?", Barbara Kiely Miller, September

Milwaukee Journal Sentinel, "County candidates back arts", Greg Borowski and Tom Held, April 17

Milwaukee Journal Sentinel, "'Blue Shirt' Artist Shows Some other Items in his Wardrobe", James Auer, September 25

Milwaukee Journal Sentinel, "Several openings to contribute to unofficial gallery night", James Auer, September 13

Milwaukee Journal Sentinel, "Jeers greet supervisor at town hall meeting", Jesse Garza, February 26

Milwaukee Journal Sentinel, "Ament gets messages – mostly bad ones", Jessica McBride, February 6

Milwaukee Journal Sentinel, "In Town of Ixonia, public art installation just isn't what it used to be", Laurel Walker, January 25

Milwaukee Journal Sentinel, "Don't let stuffed shirt ruin the 'Blue Shirt'", Laurel Walker, February 4

Milwaukee Journal Sentinel, "Cartoon", Stuart Carlson, February 4

Milwaukee Journal Sentinel", Public art tries to carve its niche", Whitney Gould, July 15

Milwaukee Journal Sentinel, "Parking garages need their share of architectural beauty, too", Whitney Gould, October 7

Milwaukee Journal Sentinel, "Public art's emergence offers different ways to experience the city", Whitney Gould, October 28

Milwaukee Journal Sentinel, "'Blue Shirt' pressed", Whitney Gould, February 1

Ozaukee County Guide, "Area Gallery Showcases Conceptual Art", September 11

Palm Beach Daily News, "Eaton Fine Arts Crafts Tranquil Outdoor Gallery", Christine Davis, March 1

Palm Beach Daily New, "Dennis Oppenheim March 1–30", advertisement, p. A9

Paysart, "Le Land Art, Program Update, Artist Update", Spring

Program Update, "Letter from the Founder", Summer

State of the Arts, "Artist Designed Bus Transfer Center 'Bus Home' Arrives in June", April–July, p. 3

The Rice Thresher, "New Contemporary Arts Venue Full of Visual Surprises", Elizabeth Pienkos, September 20

The Star, "Waiting for Bus Turns into an Art", March 30

The Star, "Ventura Bus Stop", June 26

Traditional Home, untitled article, Elvin McDonald, November

Valeurs, "Jardins: l'art se met au Vert", Valerie Collet, August 21

VC Reporter, "Transit-ory Masterpiece", Jodi Mirisch, May 30

Ventura County Star, "Mall's Sculpture Stirs Debate about Art", Amy Bently, April 21

Vogue, "Purifications Celestes", S. Mazeaud, F.Verley and A.Taupin, June–July, pp. 188–91

2001

Absolutearts, "Dennis Oppenheim: One of the Key Figures of American Conceptual Art", February 28

Art and Culture, "Hole for Sale", Arthur C. Danto, Summer, p. 43

Artforum, "Art at the Edge of the Law", FR, October

Artforum, "Dennis Oppenheim. Land and Body from the 1960s and '70s", RW, January

Artreview, "The Rise of the Landed Gentry", Morgan Falconer, March, pp. 38–39

Boynton Times, "Burn: Artists Play With Fire", May 23

Clarin, "El Monumento al escape en el Parque de la Memoria", Ana Marchia Battistoz-

zi, December 8, p. 64

Connaissance des Arts, "Mind, Land and Body", Anne Leigniel, November

Contemporary Visual Arts, "Art at the Edge of the Law"

CVA, "Art at the Edge of the Law", KP, May–September

Diari de Balears, "El ferro y el plastic blau donen forma al caos de Dennis Oppenheim", P., February 1, p. 2

Diari de Balears, "Arco 2001 es fa Resso del 'Zapping' Cultural a Que s'han sotmes els Artistes del Segle XX", Carme Castells, February 14

Diario de Mallorca, "Arco '01, La Feria de las Variedades", Lourdes Duran, February 15

Dorfman Projects, "Dennis Oppenheim: Upper Cut", February

El Mundo, "Dennis Oppenheim se instala en Joan Guiata", Pilar Ribal, February 1, p. 82

El Mundo, "Calidad y Variedad en la Aportacion Balear a la Feria, February 16

Images, "Reading Position for Second Degree Burn", March–April

Issue, "Shirt Blues", Joshua Long, Winter, p. 46

Ivenus, "Pioneering Conceptual Art at the Irish Museum of Modern Art", Marchianne Hartigan, March

La Nacion, "Differentes Caras de la Historia Judia", May 6

Les Carnets du Paysage, "Extrait de Dentro l'architettura", Vittorio Gregotti, Winter, pp. 119–45

Milwaukee Journal Sentinel, "Open Letter to the Milwaukee County Board of Supervisors", Ad Hoc Committee of Citizens in Support of Public Art, February 27, p. 5A

Milwaukee Journal Sentinel, "When Everyone's a Critic", Editorial, February 12

Milwaukee Journal Sentinel, "Singing the Public Art Blues", Editorial, February 18, p. 4J

Milwaukee Journal Sentinel, "Buttoned-down 'Blue Shirt'", Editorial, March 4

Milwaukee Journal Sentinel, "Plan Showing a Few Wrinkles", Editorial, February 19

Milwaukee Journal Sentinel, "'Blue Shirt' Makes Fine Fashion Statement", James Auer, February 15

Milwaukee Journal Sentinel, "'Blue Shirt' Survives Round 1", James Auer and Linda Spice, February 16, pp. 1A–10A

Milwaukee Journal Sentinel, "Official Says Art Ad takes the Wrong Track", Jesse Gar-

za and Meg Kissinger, February 28, p. 3B

Milwaukee Journal Sentinel, "This City's Shirt Art Fuss is Just Unseamly", Jim Stingl, February 2

Milwaukee Journal Sentinel, "Deja vu: City has argued about Modern Art Before", John Gurda, March 4, p. 3J

Milwaukee Journal Sentinel, "Shirt Sculpture will Hang In, After all", John Gurda, March 4

Milwaukee Journal Sentinel, "Is Shirt Art the Right Fit?" Linda Spice, January 31, p. 1A

Milwaukee Journal Sentinel, "Ament Defends Public Art Program", Linda Spice, February 6, p. 3B

Milwaukee Journal Sentinel, "Supervisors Seek Ax for 'Blue Shirt'", Linda Spice, February 9, pp. 1B–5B

Milwaukee Journal Sentinel, "'Blue Shirt' Survives Panel's Vote", Linda Spice, March 1, pp. 1B–3B

Milwaukee Journal Sentinel, "Feeling Blue: Why so little defense of Public Art", Marchilu Knode, February 11

Milwaukee Journal Sentinel, "Art World Keeps Eye on 'Shirt'", Marchy Louise Schumacher, February 16, pp. 1A–11A

Milwaukee Journal Sentinel, "If you hate it, is it still art?", Mary Louise Schumacher and James Auer, February 4, pp. 1A, 8A

Milwaukee Journal Sentinel, "'Blue Shirt' Unbuttoned", Tom Bamberger, February 26, pp. 1E–3E

Milwaukee Journal Sentinel, "Shirt Leaves 'em Hanging", Tom Held, February 1, p. 1A

Milwaukee Journal Sentinel, "Tinted Windows Dim Museum Luster", Whitney Gould, February 5, pp. 1B–5B

Milwaukee Journal Sentinel, "Art for Whose Sake?" Whitney Gould, February 5

Milwaukee Journal Sentinel, "In the way? Di Suvero abstract sculpture creating a stir again", Whitney Gould

Milwaukee Journal Sentinel, "Walker, Ryan seem to rule out raising taxes", Greg Borowski, April 8

Palm Beach Daily News, "Burn: Artists Play With Fire", April 3

Palm Beach Daily News, "Burn, Baby, Burn", January Sjostrom, April 29

Palm Beach Society, "Burn: Artists Play with Fire", May 18

Sculpture, "Commissions in Brief", December

Tema Celeste, "Dennis Oppenheim", Robert C. Morgan, September–October

The Aldrich, "Art at the Edge of the Law", May 31

The Dubliner, "Land and Body", February

The Independent, "Modern Metropolis", January 31

The Irish Times, "Land And Body", Aidan Dunne, February 28

The Irish Times, "Ready for the Final Stretch", Aidan Dunne, March 5

The New York Times, "Dennis Oppenheim at Ace Gallery", January 5, p. E41

The New York Times, "Accurate Projections: Illuminating the Recent Past", Michael Kimmelman, October 19

The New Yorker, "Galleries–Downtown", February 5, p. 19

The Sacramento Bee, "Capital flying high with Artist's Proposal", Dorothy Korber, March 21, pp. A1–A14

The Sacramento Bee, "Arts panel approves airport contract", Dorothy Korber, March 22, p. B2

The Sacramento Bee, "Think about it: Public art creates 'Sense of Place'", Chuck Myer, August 3

The Star, "Venturans get Another Chance to Vilify Art", John Scheibe, June 24

The Star, "Public Art: Do you like it?", Stephen Schafer, July 29, p. B8

The Star, "Bus-Home project will transport Passengers", Kerry Adams and Thomas Mericle, July 29, p. B8

The Sunday Tribune, "A conceptual Mouthful", Marchianne Hartigan, March 4

The Tate, "Parallel Bodies", Spring

The Village Voice, "Dennis Oppenheim" January 9, p. 68

The Voice, "Art: Dennis Oppenheim", review, January 9

Ultima Hora, "Dennis Oppenheim vuelve a mostrar en Palma", February 1, p. 69

Ultima Hora, "El Rey Inaugura en Madrid una Edicion del Arco mas Eclectico", Mariana Diaz, February 14

Volkstimme, "Faszinierendes Maschinentheater mit Tanzenden Schuhen und Marionetten", Jorg-Heiko Bruns, October 6

Whitney Museum of American Art, "Into the Light: The projected Image in American Art", press release, September

2000

Art News, "The Bus Stops Here", Katie Clifford, Summer, p. 5

Cote, "La Sculpture Fait un Festival", July

FraMart Studio, "Drawings and Projects", November 24

Kunstler, "Dennis Oppenheim", Pamela C. Scorzin, April–June, pp. 3–16

I.C.A.R., "Materiality, Technology and Virtuality in Dennis Oppenheim", Arkady Plotnitsky

Le Figaro, "Floraison artistique au Parc", Anne-Sophie Cathala, May 3, p. 13

Le Figaro, "La Sculpture au Champ d'Azur", Jean-Marie Tasset, July 4

Le Monde, "Balloons sous l'eau. Sculptures en l'air", August 5

Los Angeles Times, "Art would add Leap of Fun to Waiting of Bus", Catherine Blake, November 28, p. B6

Monaco Hebdo, "La Biennale de Sculpture a Trouve une Suite", July–August

NY Arts, "Interview with Dennis Oppenheim", Maria Torres, May

PAJ, "The Artist As Toymaker: The Vicious Amusement Park of the Premillennial Baroque", Lee Klein, Spring, pp. 72–75.

Public Art Review, "Stage Set for a Film", Fall–Winter

Review, "Andoe, Oppenheim and Simonds", Herbert Reichert, April 15, pp. 8–12

The Flint Journal, "Upper Cut enhances Flint Institute of Arts' collection", Carol Azizian, January 9, p. 1

The Glass Art Society, "Dennis Oppenheim", pp. 21–22

The Irish Times, "Has Video Killed the Visual Arts?" Aidan Dunne, January 12, p. 5

The Tribeca Trib, "Dennis Oppenheim has Designs on Tribeca", Carl Glassman, February, p. 5

1999

Art das Kunstmagazin, "Tollkuhne Kisten", July, pp. 8–9

Bauwelt, "Kunstbauwerk", Sebastian Redecke, June 11, pp. 1252–53

Corcoran Views, "Collection in Focus: New Acquisitions", J. Rothschild, Summer, p. 13

Cover, "Dennis Oppenheim", Brandon Ballengeeles, vol. 13, p. 49

Flatiron News, "Line of Site", Wendy Malloy, vol. 4, p. 13

Frankfurter Allgemeine Zeitung, "Androiden schauen dich an", Werner Jacob, July 16, p. 1

Glasforum, "Jump and Twist", Guido Kirsch, November, pp. 33–35

Haines Gallery, 1999-2000, "Dennis Oppenheim", Chad Anderson, Winter, p. 5

New York Contemporary Art Report, "Dennis Oppenheim New Works", February, pp. 77–85

Palm Beach Times, "Beyond The Limits", Bruce Helander, January, p. 18

Review, "Recent Works", Robert C. Morgan, March 15, p. 20

San Francisco Chronicle, "Back to Land Art", Kenneth Baker, February 5, p. E1

Sculpture, "Drinking Structure with Exposed Kidney Pool", Ariane Fehrenkamp, October, p. 15

Spirit, "A Broken 'Engagement'", Matthew Blanchard, July 16, p. 1

Standard Examiner, "Artist Uses Diverse Tools To Express His Life and World", Amy Pray, February 5, p. 30

The Journal News, "Water, wind, fire: Contemporary Artists Try Elemental Approach", Georgette Gouveia, March 5, pp. 1E–2E

The Journal News, "A Public Viewing", Georgette Gouveia, July 1, pp. 1–2

The New York Times, "Contemporary Art", Eleanor Charles, February 4, p. 20

The New York Times, "Dennis Oppenheim Realized/Unrealized", Helen Harrison, February 14, p. 22

The New York Times, "Celebrating the Planet In Water, Air and Fire", Dominick Lombardi, June 6, p. 14

The New York Times, "For 82 Artists, Immortality is Worth Rising Early", Jean Nathan, September 26, p. 2

The New Yorker, "Dennis Oppenheim", March 22, p. 26

The Sciences, "Miracles of Rare Device", Freeman J. Dyson, March–April, pp. 32–33

The Sciences, "Quantum Computing", Lov K.Grover, July–August, pp. 24–30

Washington City Paper, "Out of Sight, Out of Mind", Glenn Dixon, May 28, p. 48

Where, "Engagement", Alyssa C. Schottland, February, p. 88

1998

Art and Gallery, "Tutti i nomi di Dio", Manuela Gandini, Winter, p. 31

Art in America, "The Return of the Red-Brick Alternative", Eleanor Heartney, January, pp. 57–67

Artfocus, "Four April Shows in Toronto", Virginia MacDonnel Eichhorn, Spring–Summer, pp. 15–16

Broadsheet, "Deep Breath / Energy Transfer", Christopher Chapman, Winter, pp. 10–11

Broadsheet, "Render Imperfect", Linda Marie Walker, Winter, pp. 19–20

Cultura La Jornada, "México: una Ciudad para Expresar mi Fantasia: Oppenheim", M. McMasters, May 12, p. 28

El Mundo, "La apertura de la glorietas del Matadero anuncia el fin de las obras en La Rubia", F. Marchtin, December 10, pp. 10–11

El Mundo, "Escultura para una Pelicula", December 9, p. 22

El Norte de Costilla, "La escultura 'Escenario para una pelicula' sera instalada en una glorieta en La Rubia", May 3, pp. 6–8

El Norte de Costilla, "Una escultura homenajea al cine en La Rubia", December 9, pp. 1, 8–9

El Universal, "Dennis Oppenheim escudriña la complejidad de la ciudad", May 12, pp. 1–3

Flatiron News, "Line of Site", W. Malloy, August, p. 13

Glass, "Glass Outside of Glass", John Perreault, Spring, pp. 26–29

Ierimonti Milano, "In mostra a Roma i nostri ultracorpi", Manuela Gandini, April, p. 7

Kunst Nu, "Dennis Oppenheim", G.Vandecaveye, September 5, pp. 1–5

Mexico City Times, "Artist Unwinds Private Journey Through Unknown City", B. Kastelein, May 15, pp. 1–5

New York Arts, "Flying Theatres", April, pp. 26–27

New York Magazine, "Lord of the Rings", E. Newhall, August 17, p. 74

Parachute, "Revêries, Assaults and Evaporating Presences", Jim Drobnick, Winter, pp. 10–19

Sculpture, "Engagement", December, p. 14

SZ ExtraAusstellungen, "Galerie-Tip", March 4, p. 26

The East Hampton Star, "The Early Days of Video Art", Sheridan Sansegundo, July 16, p. III.1

The Jewish Chronicle, "Artist Breaks Ground – Literally", Deborah Ziskind Reich, June 4, p. 5

The New York Observer, "Dennis Oppenheim, Engaged?", Jeffrey Hogrefe, June 15, p. 27

The New York Observer, "Flatiron Awaits Steel Rings", Greg Sargent, April 27, p. 14

The New York Times, "A One Year Engagement", May 28

The New York Times, "An Engagement Downtown", July 21, p. B3

The New York Times, "Dennis Oppenheim", Ken Johnson, May 15, p. E35

The New York Times, "Flatiron Traffic Island", G. Gluek, August 17, p. E37

The Providence Journal, "Arts Panel Torn Between Proposals for Airport Installation", July 30, p. 1

The Sciences, "All Wet", Stanton Peele, March–April, pp. 17–21

Torino Sette, "Oppenheim e gli Omini Colorati", Guido Curto, April 9, p. 67

Tuscon Weekly, "Border Disorder", M. Regan, September 9, p. 5

Valladolid, "Tuneles y esculturas", Maribel Rodicio, May 3

Unomasuno, "Dennis Oppenheim", May 10, p. 17

Unomasuno, "Dennis Oppenheim se dejara seducir por bancos de madera y cajas de plastico para crear Spree", Adriana Moncada, May 12, p. 32

1997

Art in America, "Dark LAugusthter", Eleanor Heartney, April, pp. 102–07

Art in America, "The 1997 Venice Biennial", Marcia Vetrocq, September, pp. 66–77

Art Press, "L'empreinte Making Marks", Pierre Sterck, May, pp. 3–7

Arte, "Formas como simbolo del cine", November, p. 12

At the Museum, "Recent Acquisitions", Los Angeles County Museum of Art, July–August, p. 5

Corriere della Sera, "Biennale, una signora così così", Gillo Dorfles, July 14, p. 30

Des Moines Art Center News, "Dennis Oppenheim Enters Collection", Des Moines Art Center, January–February, p. 3

Eesti Ekspress, "Veneetsia biennaal-kaasaja kunstielu Votmesundmus", Heie Treier, June 20, p. 3

Grafsch Nachriechen, "US-Star und Fantasy-Artist", April 4, p. 3

Grafsch Nachriechen, "Schneller Abgang aus dem Delirium", Thomas Kern, April 29, p. 9

Grafsch Wochenblatt, "Dennis Oppenheim Ausstellung", May 1, p. 7

Grafsch Wochenblatt, "Oppenheim-Ausstellung", June 7, p. 16

Hessische Allgemeine, "Eine Kirche auf dem Kopf", Dirk Schwarze, February 27, p. 10

Il Gazzettino, "Oppenheim si rivela", June 13, p. 1

Il Gazzettino, "E in fabbrica spunta l'arte", June 14, p. 13

Il Giornale, "Il rottamaio dell'avanguardia", Francesco Specchia, June 21, p. 21

Il Mattino, "Kiefer e Oppenheim, folla per l'arte", June 13, p. 17

Il Secolo XIX, "Ora tocca al pubblico", Francescca Pasini, June 6, p. 13

KultuRegional, "Fantasy-Artist und Visionar", April 25, p. 8

L'Espresso, "Il bello del 900", Alessandra Mammì, June 3, p. 22

La Nuova, "Lo sbarco della Cultura dai Giardini a Marghera", Claudia Fornasier, June 11, p. 26

La Nuova, "Utopia e delirio di Oppenheim", Sileno Salvagnini, June 15, p. 15

Lingener Tagespost, "Ideenreicher Fantasy-Artist", May 15, p. 12

Lokales, "Made in Styria", October 27, p. 18

Sculpture, "The Millennial Body", Thomas McEvilley, October, pp. 24–29

Sculpture, "Dennis Oppenheim. A Mysterious Point of Entry", Carolee Thea, December, pp. 28–31

The New York Times, "A Slice of Long Island Art Makes It To Venice", Phyllis Braff, July 27, p. 33

1996

24 Heures, "A Geneve, Dennis Oppenheim fait planer ses menaces sur le MAMCO", Francoise Jaunin, May 7, p. 16

Art Press, "Dennis Oppenheim. Interview", Collins and Milazzo, no. 17, pp. 93–96

Art Review, "Sculptures push viewers to demand more from Art", Ann Klefsted, April 28, p. 9

Artis, "Dennis Oppenheim, Galerie Lendl, Graz", Franz Niegelhell, October, p. 71

Austin American Statesman, "Still provocative after all this time", Madeline Irvine, February 21, p. E11

Basler Zeitung, "Die Machine Mensch", Carole Gurtler, June 3, p. 4

Der Bund, "Die Kunst am Puls der Zeit", Jost Marchtin Imbach, July 20, p. 2

Der Standard, "Opferkerzen für gierige Sammler", Doris Krumpl, November 21, p. A8

Feuilleton, "Bruckenschlag: Neues in Berliner Kupferstichkabinett", August, p. C4

Interni, "Da Dennis Oppenheim", Andrea B. Del Guercio, July–August, pp. 141–44

Journal de Genève, "Dennis Oppenheim, artiste paysagiste de la pensée humaine", Jean-Pierre Wittwer, April 11, p. 12

Kleine Zeitung, "Witz & Schrecken", June 30, p. 105

La Tribune de Genève, "Dennis Oppenheim opere un double retour a la casa zero", Lionel Bavier, March 30, p. 12

Le Courrier, "Le MAMCO fête le printemps avec une foule d'artistes", Isabelle Bratschi, April 13, p. 11

Libération, "Oppenheim a la poursuite de lui-même", Herve Gauville, April 25, p. 5

Next, "Interview with Dennis Oppenheim", Emma Ercoli, Autumn, pp. 100–04

Sculpture, "Laumeier Sculpture Park", January Garden Castro, November, pp. 12–15

Tages Anzeiger, "Schach! Kunst für die Galle", Von Simon Maurer, April 9, p. 7

The New York Times, Roberta Smith, January 12, p. C23

The Nouveau Quotidien, "Avec Dennis Oppenheim, les gens se sentent normaux et la monde parait très bizarre", Laurent Wolf, p. 6

The San Diego Union Tribune, "Dreaming of Me", Robert L. Pincus, February 11, p. 9

Tribune des Arts, "Genève rend curieusement hommage à Dennis Oppenheim", Etienne Dumont, May, p. 4

1995

Amsterdams Nieuws, "Voor harde beelden ben id de geremd", Els Roes, May 16, p. CO4

Arte, "Entorno a Dennis Oppenheim: 1967–1994", Maite Lopez and Carmen Zaera, January, pp. 47–49

Arte, "Dennis Oppenheim. El Significado Vertiginoso", Kim Bradley, April–June, pp. 19–24

Cover, Robert C. Morgan, Winter, p. 38

Der Tagesspiegel, "Knockout für die Utopie", Nicola Kuhn, July 8, p. 21

El Tiempo, "Proyectos, viajes y vacios arti-

sticos", José Hernan Aguilar, October 1, p. 11

Kunstforum International, "Light for the Bunker", Justin Hoffmann, August, p. 39

L'Espresso, "Metti l'arte in cuffia", Renato Barilli, March 24, p. 195

Los Angeles Times, "Going Through the Motions", Cathy Curtis, November 7, p. F12

Los Angeles Times, "It's Art, Because They Say It's Art", Kristin McKenna, October 8, pp. 6–7

Münchner Merkur, "Durchs Mundtunnel fahrt die Eisenbahn", Claudia Teibler, October 9, p. 6

Next, "Interview with Dennis Oppenheim", Emma Ercoli, Spring, pp. 12–17

OC Weekly, "Machine", Doree Dunlap, November 23, p. 9

Recherches Poetiques, Anne-Francoise Penders, Spring, no 2, pp. 96–113

Rekarte, "Dennis Oppenheim", Marga Perera, March, p. 16

SZ, "Der Horror lauert uberall", Justin Hoffman, October 6, p. 8

Village Voice, "The Age of Ouch", Peter Schjedahl, March 28, p. 10

1994

Arte, "Dennis Oppenheim: Recent Works", Francisco Miralles, December, pp. 32–33

Artnews, "When Artists go to the Movies", Paul Gardner, December, p. 124

Casting, "Dennis Oppenheim", Franco di Matteo, March, pp. 42–43

Culture, "Just Add Water", Paul Aho, March–May, pp. 2–4

Da Giovedì, "The Black Humor of Oppenheim", Patricia Ferri, January, p. 19

Flash Art International, Laura Cherubini, March, p. 76

Kiosk, "An Interview with Artist Dennis Oppenheim", J.W. Morson, Spring, pp. 8–12

La Vanguardia, Juan Bufill, November, p. 36

La Vanguardia, Olga Spiegel, November, p. 48

Olympic, "Suite Olympic Centennial: Oppenheim", Mercedes Basso, November, p. 26

Parachute, Sherry Gache, November, p. 45

Sculpture, Valerie Mavridorakis, October–December, pp. 44–45

The Hartford Courant, "Artist Sees Beauty in the Bothersome", Jocelyn McClurg, August, p. E1

The New York Times, William Zimmer, October 2, p. 18

1993

Artspace, "Looking for Love Gas", Tobey Crockett, March–April, pp. 46–49

Art Press, Eleanor Heartney, January, pp. 12–19

Clockwatch Review, "The Storm at the End of the Rainbow", James Plath, vol. 8, pp. 113–23

Shift Fifteen, Maria Porges, vol. 7, pp. 52–55

SPOT, "Dennis Oppenheim: No Photography", Alison de Lima Greene, Spring, p. 3

1992

Atelier, "Wishing the Mountains Madness", Kay Larson, April, pp. 4–21

Arts, Dorothy Spears, March, p. 74

Artnews, George Melrod, March, p. 123

Los Angeles Times, Susan Kandel, April 3, p. 16

New York Magazine, "High Wire Act", Kay Larson, January 6, pp. 52–53

New York Newsday, "Cold War Politics Meets the Art Scene", Amei Wallach, January 7, pp. 4–81

Parkett, "A Poesy of Diagnostics or the Object-Neurology of Dennis Oppenheim", Roger Denson, pp. 20–29

The Pantagraph, "Artwork Gives Sense of Mystery and Fun", Spencer Sauter, March 20, p. C2

1991

Artforum, "The Dark Side of Dennis Oppenheim", Tobey Crockett, December, pp. 68–73

Art Press, Paul Ardenne, October, p. 94

Dialogue, "Mechanike", January Riley, May–June, p. 36

Feuilleton, "Land Art: Landschaft als Kunst", February 8, p. 8

Flash Art, Luk Lambrecht, March–April, p. 149

Het Parool, "Saboterende Kamikaze-piot", Ijsbrand Van Veelen, June 28, p. 11

Lapiz, "Art as Imperative", Bernardo Pinto de Almeida, March, pp. 42–50

Lüdenscheid Nachrichten, "Land Art: Landschaft als Kunst", Britta Hueck-Ehmer, February 8, p. 16

Newsday, "Mixing Stars, Stripes and Statements", Alistair Gordon, July 10, p. 4

Rogue, Interview, January 2, p. 29

Sculpture Magazine, "Stalking the Invisible", Tobey Crockett, March–April, pp. 40–47

Tema Celeste, "A Conversation with Tricia Collins & Richard Milazzo", March–April, pp. 68–74

The Journal of Art, "Existential Collisions and Ghostly Herds", Calvin Reid, December, pp. 39–42

The New York Times, Phyllis Braff, July 7, p. 12

The New York Times, "Rebuking Tradition", Michael Kimmelman, December 20, p. C18

1990

Artweek, "Encounters with the Imagination", M. Timberman, April 26, p. 12

Contemporeana, "Dennis Oppenheim", Sania Papa, September, p. 95

Diagonals, Olivier Zahm, November–December, pp. 33–37

Galeries Magazine, "Dennis Oppenheim", Sania Papa, February–March, pp. 82–85

L'Express, "La Mecanique d'Oppenheim", Guy Gilsoul, October 5, p. 165

Los Angeles Reader, "Documentary Art from Caves to Conceptualism", L. Andreoli-Woods, May 18, p. 13

Tableau, "Dennis Oppenheim. Slaat Niewe Weg In", Marlot Bloemhard, October, pp. 124–28

Village View, "Nudge, Nudge, Wink, Wink", vol. 4, June 15, p. 29

Village Voice, Kim Levin, May 29, p. 112

Westdeutsche Zeitung, Heike Bynm, March 5, p. 7

1989

Art in America, Calvin Reid, July, p. 101

Art News, Eleanor Heartney, April, p. 202

Artforum, David Rimanelli, April, p. 101

Arts, Robert Morgan, April, p. 96

Beaux-Arts, "Dennis Oppenheim", Vanessa Costa, March, p. 88

Los Angeles Times, "An Artful Turnaround", H. Harper, January 16, p. 18

New Art International, "The Theatre of Memory", A. Izzo, Summer, p. 16

New Art International, Carlo Prosperi, Summer, p. 24

Splash, "Ghosts in the Machine", Tobey Crockett, February, pp. 80–87
The New York Times, "The Aldrich Fills Its Rooms with Expansive Sculptures", William Zimmer, November 12, p. 35
The New York Times, "Kinetic Sculpture Using Toys, Fire and Water", Roberta Smith, January 20, p. C24

1988

Anchorage Times, "Art Talk", Karen Stahlecker, October 23, p. F1
Arts, P. Cyphers, October, p. 105
Artweek, "Out of Context", R. Dolnit, April 17, p. 1
Korea Times, "2nd International Open Air Sculpture Symposium Produces Works of Metal Composites", I. Kim, April 30, p. 28
New York Press, R. Mahoney, August 5, p. 8
The East Hampton Star, "Olympic Sculpture", June 30, p. 16
The New York Times, M. Kimmelman, August 19, p. 33
The New York Times, "For the 60s Devotees, A Show Fraught with Nostalgia", J. Russell, November 27, p. 36
The New York Times, "A Potent Look Back at 1968: A Visual Memory of Social Change", William Zimmer, November 27, p. 36
Village Voice, "Sleeper's Awake?", J. Perreault, December 13, p. 113

1987

Austin-American Statesman, "Art That Moves", M. McCombie, March 19, p. G3
Daily Texan, "Power of Movement Pevades Laguna Exhibit", L. Foerster, April 2, p. 10
Milwaukee Journal, "Nuts and Bolts of Art", J. Auer, August 2, p. 14E
New Art Examiner, "Eccentric Machines", J. Schultz, September, p. 55
Seattle Post Intelligencer, "Nuts and Bolts Art", R. Hackett, June 12, p. 1
The New York Times, "American's Sculpture Will Top West Berlin Gate", February 15, p. 73

1986

Pittsburgh Post Gazette, "Need for Self-Analysis Exhibited in Ohio Show", D. Miller, October 4, p. 11
Plain Dealer Cleveland, "Metal Works Exhi-

bit Shows Artist's Mettle", F.H. Cullinan, December 6, p. 21A
St. Louis Post Dispatch, "Oppenheim Drawings Shown at Laumeier", J. Harris, May 30, p. 48
St. Louis Post Dispatch Sunday Magazine, P. Degener, September 14, p. 22
Vindicator, "Launching Structure", October 2, p. 4

1985

Ball State Daily News, "Artists Comments on Themes of Anarchy, Irrationality in Works", S. Uptgraft, April 4, p. 6
Citizen's Journal Press, "Ground breaking Gala on Tap for OSU's Visual Arts Center", I. Edwards, September, p. 11
Grand Rapids Post, "Dennis Oppenheim's Piece is a Delight at Art Museum", M. Pierce, September 2, p. 7
Grand Rapids Press, "Oppenheim to Lecture at Art Museum", August 25, p. 9
Michigan Press, "Artist to Lecture at Art Museum", August 28, p. 287
Michigan Press, "Large Sculpture Shown at GR Museum", August 23, p. 287
Michigan Press, "Exhibition Features Inventions", July 31, p. 6
Michigan Press, "Sculptor Scheduled for Museum Lecture", September 3, p. 3
Newsletter, Grand Rapids Art Museum, Grand Rapids, Michigan, September–October, p. 2
Ohio State Lantern, "Senior Class Gift Is First of a Series", J. O'Connor, August 9, p. 3
The New York Times, Vivian Raynor, March 15, p. C18
Village Voice, "Dennis Oppenheim: Project Drawings", G. Trebay, April 2, p. 35
Visitor, "Dream Factory", August–September, vol. 17, p. 23

1984

Anchorage Times, "University Sculpture Reflects Artist's Unconventional Flair", R. Gluckman, November 18, p. E5
Anchorage Times, "Artist Takes Offense at Fenced-in Sculpture", R. Gluckman, November 8, p. A1
Anchorage Times, "Swirling Sculpture", October 10, p. 7

Anchorage Times, "Sculpture Provokes Diverse Response", R.Gluckman, November 3, p. B5
Anchorage Daily News, "Metal Sculpture", D. Stabler, November 11, pp. 1–6
Artforum, Donald Kuspit, May, p. 85
Artforum, Donald Kuspit, December, p. 96
Artweek, "Dennis Oppenheim and the Eternal Machine", C. Simmons, May 19, p. 1
Arts Magazine, T. Liechtenstein, April, p. 71
Buffalo Evening News, "Works That Move You", R. Morgan, September 24, p. 13
Chicago Tribune, May 11, p. 32
Democrat and Chronicle, "Works That Move You", R. Morgan, July 14, p. D1
Flint Journal, J. Harvey, October, p. F1
High Performance, "Trunks of the Mind", M. Miffin, vol. 8, no. 4, p. 12
Jerusalem Post Magazine, "Machinations of the Mind", G. Goldfine, September 26, p. E2
Northwest Orient, "Frontiers of Culture", April, p. 11
Potsdam State University Newsletter, L.Cania, August 22, p. 5
San Francisco Examiner, "The Brainstorming Think-Pieces of Dennis Oppenheim", A. Morch, May 28, p. 7
San Francisco Chronicle, "Sculptor's Factories of Thought", K. Regan, May 31, p. 64
Syracuse Herald, "Oppenheim's 'Machine-Works' Give Structure to Concepts", S. Chayat, July 8, p. 2
Syracuse Herald, "And Just Marvelous", R. Hammond, July 13, p. D13
Syracuse Post Standard, "Artwork May Soon Go Over with a Bang", J. Barth, August 28, p. B2
Syracuse Daily News, "Machine as Metaphor", T. Tilton, September, p. 9
The Tribune, "Artist's Machines Mirror Human Foibles", C. Shore, June 1, p. D1
Visual Art, "Puer Aeternus: The Eternal Boy in Art", B. Brown, Summer, p. 45
West Art, "Experimenting with New Forms", May 25, p. 8
Watertown Daily Times, "Sculpture Explodes While 6,000 Watch", S. Billmyer, August 30, p. 1

1983

Anchorage Times, "Exploding House", J. Holloweel, September 25, p. 26
Art das Kunstmagazin, "Fattoria di Celle", August, p. 84

Art in America, Jonathan Crary, January, p. 87

Arte, "La Fabbrica dei Capolavori", Cabutti, February, p. 65

Artweek, "Mechanical Confrontations", K. Norklum, March, p. 26

Bomb, "Sculpture and Fiction", April, p. 33

Calgary Herald, "Installations", N. Tousley, August 4, p. F6

Express, "Dennis Oppenheim's Infinitely Ambiguous Objects", Don Wall, August–September, p. 8

Japan Times, B. Thoren, February 27, p. 7

Juliet, "Dennis Oppenheim", April–May, pp. 17–19

Studio International, "Interview with Dennis Oppenheim", Dorothy Walker, vol. 196, no. 999, pp. 39–41

Tableau, "Recent Works of Dennis Oppenheim", J. Robinson, Summer, pp. 406–10

1982

Artforum, T. Lawson, September, p. 78

Art Monthly, "Dennis Oppenheim", R. Ayers, May, pp. 17–19

Art News, "Art Between Mind and Matter", E. Schwartz, December, pp. 56–61

Artscribe, S. Morgan, June, pp. 60–62

Art World, "Rockets Red Glare", J. Tully, Summer, p. 7

Basler Zeitung, S. Gassert, June, p. 9

Express Newspaper, S. Falcon, Winter, p. 17

Flash Art, Summer, p. 82

Guardian, "A Sculptor Who Plays with Fire", I. McManus, May, p. 12

Kunstechos, "Kröller-Müller Beeldentuin", March–April, p. 11

La Tribune de Genève, "La Sculpture d'Oppenheim n'ira pas as Parc Bertrand", March, p. 27

La Suisse, "Alors, Oppenheim", March 27, p. 26

Life Magazine, "Sculpture with a Short Fuse", October, pp. 133–35

New York Magazine, "Apocalypse Now", K. Larson, June 14, pp. 50–54

New Art Examiner, "The Mechanical Obsession", A.J. Metaphor, February, pp. 10–11

Rampike, "Violence", K.E. Jirgens, vol.2, no. 3, pp. 9–13

Time Out, "Mutants, Machines, Make-Believe", S. Kent, May 7, p. 16

Vanguard, D. Jowlett, December–January, p. 23

1981

Art Express, K.S. Friedman, May–June, p. 77

Art in America, "American Quartet", R. Morris, December, p. 63

Art News, "Artist's Go On Record", P. Frank, December, p. 80

Artforum, S. Morgan, Summer, pp. 97–98

Artforum, "Labyrinths: Tradition and Contemporary Works", H. Kern, May, pp. 60–68

Arts, B.Cavaliere, May, p. 33

Arts, "Robert Smithson and Film: The Spiral Jetty Reconsidered", P. Childs, October, p. 56

Arts, "The Factories", E. Braun, June, pp. 138–41

Arts, "An Interview with Dennis Oppenheim", S.Wood, June, pp. 133–37

Artweek, "Metaphors of Esoteric Procedures", R. Glowen, October, p. 3

Benzene, "Image Processing Factories", R. Becker, Summer, p. 20

Cincinnati Inquirer, "Oppenheim Created Thinking Machines", O. Findsen, March 19, p. K771

Cincinnati Post, "Machine Sculptures Express Workings of the Artist's Mind", B.J. Friedman, March 26, p. 3C

Dialogue, J. Jordan, March–April, p. 8

Dialogue, "Constructions II: Dennis Oppenheim", N. Felshin, March–April, pp. 19–21

La Tribune de Genève, "L'Aventure Dennis Oppenheim à Genève", H. Teicher, January 18, p. 21

La Vie Protestante, L. Favre, January 9, p. 14

Miami Herald, H.L. Kohen, September 6, p. 2L

Seattle Times, S. Kendall, October 3, p. B6

Village Voice, K. Levin, February 18–24, p. 74

Rampike, "Wood", Dennis Oppenheim, Spring, p. 8

1980

Art in America, "Cost-Effective Earth Art", B. Noah, January, p. 6

Art News, M. Staniszewaski, September, pp. 248–49

Artes Visual, Carla Stellweg, May, p. 27

Artforum, I. Puliafite, February, p. 107

Artforum, "A Chronology of Video Activity in the United States: 1965–1980", B. London and L. Zippay, September, pp. 42–45

Artistes, J. Poi, February–March, p. 40

Arts, V. Tatransky, May, pp. 33–34

Arts, J. Herman, June, p. 33

Arts, "The Space of the Self: Robert Morris in the Realm of the Caraeral", S. Eisenman, September, pp. 104–09

Artspeak, "New Concepts in Environmental Sculpture", A. Zito, March 27, p. 6

Artweek, "Searching for Clues", B. Fahr and D. Hochofen, February, no. 2, p. 85

Artweek, "Images as Information and Experience", M. Johnstone, May, pp. 11–12

Artworld, M. Meyer, March–April, p. 7

Domus, "Dennis Oppenheim", B. Marcelis, March, no. 604, p. 56

Du, "In Jenen Ideen Geschiedet Werden", D. Hochofen, February, no. 2, p. 85

Eccentric Birmingham (Bloomfield Edition), "Sculpture Destined to Make Art History", C. Abatt, April 17, pp. B1–C

Flash Art, V. Tatransky, March, no. 96–97, p. 22

Landscape Architecture, "Earthworks Move Upstage", G. Clay, January, pp. 55–57

La Quinzaine littéraire, "Les Factories de Dennis Oppenheim", G. Raillard, January 1, p. 19

La Tribune de Genève, "Les Exposition a Paris. Les Usines de Dennis Oppenheim, D. Cornu, January 8, p. 25

Le Figaro, "Les Grandes Energies de Dennis Oppenheim", January 11, p. 26

Le Figaro, "Liberté Frande", M. Nuridsany, January 4, p. 28

Le Matin, "Dennis Oppenheim à l'Arc", M. Bouisset, January 7, p. 4

Le Monde, "Dennis Oppenheim à l'Arc", January 3, p. 11

Le Nouvel-Observateur, "À l'Arc – Dennis Oppenheim", F. Auser, January 5, p. 6

Los Angeles Herald, "A Sculptor's Mystical Machine", C. Synder, April 29

Opus International, "Petit Lexique en Forme de Puzzle", Spring, no. 76, p. 36

Paris-Hebde, D. Boone, January 9, p. 11

Soho Weekly News, "Keeping An Image", J. Perreault, January 3, p. 33

Southfield Eccentric, "Sizable Sculpture, Southfield Builder Aids Project", C. Abatt, April 17, p. 2

The New York Post, "The Week in Review-Art", J. Tallmera, January 15, p. 14

The New York Times, G. Glueck, January 11, p. C17

The New York Times, J. Russell, March 21, p. C21

Village Voice, "Metaphysical Attraction", K. Larson, March 17, p. 79

1979

American Artist, "Artist in Residence: Dennis Oppenheim", R. Fitzgibbons, January, pp. 60–63, 93–95

Artforum, H. Foster, May, p. 64

Artforum, "Monument-Sculpture-Earthwork", N. Foote, October, p. 32

Artforum, "Nothing / Not Nothing / Something", J. Masheck, November, pp. 42–49

Arts, V. Tatransky, May, p. 36

Arts Exchange, "Interview with Dennis Oppenheim", M. Bopp, January–February, p. 13

Artscribe, "Gut Reaction", S. Morgan, Spring, p. 34

Atlanta Art Papers, "Interview with Dennis Oppenheim", D. Talley, September–October, pp. 1–4

Basler Zeitung, "Dennis Oppenheim Inder Basler Kunsthalle", B. Cuiger, June 2, p. 13

Connaissance des Arts, "Ex-centrivites", December, no. 334, p. 55

Das Kunstwerk, J. Halder, October, pp. 81–82

Der Spiegel, "Wuste in Lieb", June 11, p. 183

Du, June, no.6, p. 27

Flash Art, "Dennis Oppenheim", P. Fend, January–February, p. 42

Flash Art, "Die Tottenstadt Eine Architektur Nach Dennis Oppenheim", P. Fend, June–July, p. 10

Flash Art, October–November, p. 52

Feuilleton, "Psycho-Installationen à la Duchamp and Hitchcock", H. Reuther, September, p. 10

Impulse, "I Shot the Sheriff", Dennis Oppenheim, Spring, p. 12

Journal de Genève, "Exposition a Bale", P. Mathonnet, June, p. 15

Kunst Magazin, "Neue Installationen 1978–1979", J.C. Ammann, June, pp. 24–33

Kunstforum International, A. Pohlen, no. 4, p. 240

L'Agina, "A New Aesthetic", B. Oldenburg, March 1, p. 17

Landscape Architecture, "Earthworks in Seattle: Reclamation as a Fine Art", G. Clay, May, p. 291

New Jersey Architecture, "Interview", D.

Wall, July–September, p. 1

Paletten, "Kontens Satellitresa och de Intuitiva Strategierna: Ett Samtal med Dennis Oppenheim", O. Hjourt, vol. 4, pp. 32–38

The Arts, "King County's Earthworks Symposium Breaking New Ground With Land Reclamation as Sculpture", G. Clay, July, pp. 1–2

The New York Times, "Custom-Made", J. Perreault, May 4, p. 46

The New York Times, "Artists of the Customs House", G. Glueck, May, p. C21

The New York Times, G. Glueck, March 16, p. C24

The New York Times, "Triple-Header in Newark", V. Raynor, October 14, p. B20

The Winnipeg Art Gallery Report, "Dennis Oppenheim: Works 1967–1977", July, p. 2

Vanguard, "Conjectural Imaging", W. Klepac, October, p. 12

Village Voice, "The Thought That Counts", P.G. Frank, March 13, p. 61

1978

Art International, "Teheran, The New Museum", E.H. Johnson, April–May, pp. 11–17

Art News, K. Larson, December, p. 144

Artforum, "Bodyworks and Porpoises", N. Calas, January, p. 33

Artforum, Edit de Ak, Summer, p. 76

Artforum, "Dennis Oppenheim's Delirious Operations", J. Crary, November, pp. 36–40

Arts, "Dennis Oppenheim: Post-Performance Works", K. Levin, September, pp. 122–25

Boston Phoenix, "Making Light of Heavy Art", K. Baker, January 16, p. 11

Domus, March, no. 580, p. 48

Domus, October, no. 587, pp. 45–46

Globe and Mail, "Art of Enquiry", P. White, September 16, p. 33

Macleans, "Modern Mystic, Witty Prophet", M. Weiler, October 23, p. 50

New York Arts Journal, "Dennis Oppenheim: An Interview", S. Morgan, November–December, pp. 29–30

The Review, "Returning Relevance", R. Rhodes, September 21, p. 6

Toronto Star, "Concrete Poet of the Contemporary World", G.M. Dault, September 21, p. 4

Vie des Arts, Summer, p. 6

Village Voice, "Dennis Oppenheim's Dilemma", R. Goldstein, January, p. 16

1977

Art in America, "The American Artist from Loner to Lobbyist", C. Ratcliff, March–April, pp. 10–12

Art News, E. Schwartz, September, p. 99

Artforum, "Madness in the Arena", N. Calas, September, pp. 51–53

Artforum, "I Shot the Sheriff", R.J. Onorato, November, pp. 71–72

Arts, V. Tatransky, September, p. 21

Arts, B. Cavaliere, May, p. 24

Arts, A. Ellenzweig, June, p. 33

Atlanta Journal, "Artists Saluting Carter to Discuss Work", W. Burnett, January, p. 2

Craft Horizons, August, p. 65

Cue, L. Harnett, November 25, p. 40

Domus, August, no. 573, p. 54

New York Magazine, "Ceremonies of Measurement", T.B. Hess, March 21, p. 60

Parachute, "It Ain't What You Make, It's What Makes You Do It", Winter, pp. 10–12

Studio International, "Art Outdoors – In and Out of the Public Domain", L. Lippard, pp. 83–90

The New York Times, "Far Out Art to Honor Jimmy Carter", G. Glueck, December 16, p. 11

The New York Times, "The New Museum Where Small is Beautiful", J. Russell, November 11, p. C17

1976

Art in America, P. Derfner, May–June, pp. 105–06

Art International, "The Modern Maze", D. Onorato, April–May, pp. 21–25

Art International, "Modern Maze Makers", J. Kardon, April, p. 66

Art International, "The 37th Venice Biennial", H.Marchtin, September–October, pp. 14–24, 59

Art News, E. Perlmutter, April, p. 67

Artforum, A. Kingsley, February, pp. 72–73

Artforum, N. Foote, April, pp. 54–57

Artforum, "Drawing the Line", N. Foote, May, pp. 54–57

Artforum, "The Anti-Photographers", N. Foote, September, pp. 46–54

Artforum, "The Size of Non-Size", D. Davis, December, pp. 46–51

Arts, L. Lorber, April, p. 19

Domus, July, no. 560, p. 53

Domus, "I Topi di Oppenheim", March, no. 556, p. 53

Domus, "La Biennale di Venezia", R. Barilli and G. Battcock, November, no. 564, pp. 1–20

Du, "Sport in der Zeitgenössischen Kunst", B. Braathen, pp. 62–63

Flash Art, May–June, no. 64–65, pp. 3, 21–28, 42–46

Museum Journal, "Kunstkritiek en de Veelzijde lijfelijkheid van Body Art", T. Zandee, February, pp. 97–106

Studio International, "Annihilating Reality", G.P. Orridge and P. Christopherson, July–August, pp. 44–48

Studio International, "Music of Signs in Space", November–December, pp. 284–85

Soho Weekly News, M. da Vinci, January, p. 29

The New York Times, J. Russell, February 15, p. B35

The New York Times, J. Russell, October 1, p. B30

The New York Times, "Far-our Art to Honor Carter Donated to a Museum", G. Glueck, December 6, p. 66

1975

Art and Artists, G. Battcock, June, p. 22

Art and Cinema, vol. 2, no. 1, p. 2

Artforum, "Pygmalion Reversed", M. Kosloff, November, p. 30

Artforum, M. Kosloff, November, p. 30

Artitudes International, "L'Art Corporal", F. Pluchart, January–March, no. 18–20, p. 10

Arts, "Dennis Oppenheim: An Art with Nothing to Lose", K. Baker, April, pp. 72–74

Arts, March, pp. 19–20

Arts in Ireland, "Dennis Oppenheim", June, p. 46-48

Arts in Society, "De-Architectuization", J.Wines, Fall–Winter, pp. 351–63

Arts International, September, p. 58

Domus, "Art in America", G. Battcock, May, p. 534

Goya, November, no. 129, pp. 178–79

Skånska Dagbladet, January, p. 24

Skira Annuel, "Dans le Courant de l'Art Conceptual", pp. 38–39

Soho Weekly News, "Soul Food for Thought at the Kitchen Table", M. da Vinci, October 2, p. 11

Soho Weekly News, M. da Vinci, January 9, p. 7

Studio International, "Space as Praxis", R. Goldberg, September, p. 132

Studio International, B. Baker, September, p. 164

Village Voice, "Far Out and Far In, Uptown and Down", D. Bourdon, January 20, p. 94

1974

Art and Artists, January, p. 42

Art News, "Back to Nature", E. Driscoll, Jr., September, pp. 80–81

Art Rite, "Rehearsal for Five Hour Slump", Dennis Oppenheim, Winter, no.7, p. 20

Artforum, S. Heinemann, September, p. 85

Artforum, R. Smith, May, p. 71

Artitudes, "Notes Sur l'Art Corporal", F. Pluchart, no. 12–14, p. 65

ArtsCanada, "Borderlines in Art and Experience", J. Bodolai, Spring, pp. 65–81

Avalanche, "Performance", May–June, p. 5

Cles Pour les Arts, "Bruxelles: Happening, Dennis Oppenheim", J.P. Tigem, October, p. 10

Chroniques de l'Art Vivant, "Projekt", I. Lebeer, July–September, p. 11

Dance, "The Arts in Fusion", P. Frank, April, pp. 56–57

Data, "Dennis Oppenheim", L. Venturi, Winter, no. 13, pp. 77–79

Feuilleton, "Die Unsichtbaren Tiefenschicheen der Energie", G. Jappe, April, p. 5

Magazin Kunst, "Interview with Dennis Oppenheim", W. Sharp, January, p. 114

Magazin Kunst, "Documentation # 19", G. Schwarzbauer, January, p. 64

Print Collector's Newsletter, "Words in Print", P. Larson, July–August, pp. 53–56

Studio International, R. Kennedy, December, p. 252

Studio International, E.Cameron, December, pp. 245–48

1973

Art and Artists, "Dennis Oppenheim: Myth and Ritual", Lenore Goldberg, August, pp. 22–27

Art in America, K. Baker, May, p. 103

Art News, February, pp. 72, 81

Artforum, R. Smith, April, pp. 85–86

Arts, "Renewal of Possibilities", L. Goldberg, November, pp. 42–43

Arts, "Open to Re-definition", J. Loring, November, pp. 42–43

Arts Review, October, pp. 20–21

Chroniques de l'Art Vivant, "Le Corps de l'Oeuvre du Corps", I. Lebeer, June, p. 7

Chroniques de l'Art Vivant, "Dennis Oppenheim", I. Lebeer, June, pp. 13–15

El Nacional Caracas, "Dennis Oppenheim: Arte Impossible", July, p. 8

Evening Standard, R.Cork, September, p. 20

Flash Art, February, pp. 20–21

Fuoricampo, "Paesaggio Ambiente e Gesto nella Land Art", Lea Vergine, July–August, pp. 20–22

Magazin Kunst, "Documentation # 15", M. Jochimse, January, p. 60

Studio International, "Interview with Dennis Oppenheim", Hershman, November, pp. 196–97

Studio International, S. Kent, November, pp. 197–98

XXe Siècle, "Cinema et Video", B. Borgeaud, December, no. 4, p. 154

1972

Art International, E. Schwartz, Summer, p. 128

Art News, "Education of the Un-Artist", A. Kaprow, May, pp. 34–39

Artforum, "Talking to Pomona", D. Antin, September, pp. 36–47

Arts, "Interactions: Form-Energy-Subject", Dennis Oppenheim, pp. 36–39

Arts, R. Matthias, Summer, p. 58

Arts, R. Mattias, November, p. 68

Craft Horizons, December, p. 61

Der Spiegel, "Nach Pop Ein Babylon der Kunst", March, p. 149

Interfunktional, June, p. 63

On Site, "Non-focality", A. Sky, p. 7

Opus International, June, p. 63

San Francisco Chronicle, "187 Hot Hub – Thievery for Art's Sake", January, p. 17

The New York Times, "Sculpturama", G. Glueck, June 11, p. B23

Times Union, "Art Without Limit", L. Hansen, April 7, p. 1

1971

Art, "Media/Art/Media", D. Davis, September, pp. 43–45

Art in America, "Epilogue: The Dead Letter Office", H. Kenner, July–August, pp. 104–11

Art in America, "Earthworks and Oz", D. Hickey, September, pp. 40–49

Art International, E. Schwartz, December 20, p. 80

Art News, "The Education of the Un-Artist", A. Kaprow, February, pp. 28–31, 66–68

Art News, "It Reaches a Desert in Which Nothing Can Be Perceived but Feeling", D. Antin, March, pp. 38–41, 66–71

Artforum, K. Stiles, January, p. 84

Artforum, J. Tarshis, February, p. 85

Artitudes International, "Le Corps, Materiel d'Art", October, p. 1

Arts, L. Venturi, March, p. 48

Arts, "Subject-Object: Body Art", C. Nemser, September, pp. 38–42

Avalanche, "A Discussion with Terry Fox, Vito Acconci and Dennis Oppenheim", Willoughby Sharp, Winter, no. 2, pp. 18–19

Christian Science Monitor, "And in Boston, a Child, a Parrot and Dog Join In", K. Baker, April 3, p. 4

De Groene, "Oppenheim in Galerie 20", C. Blok, November 6, p. 12

Flash Art, "Dennis Oppenheim", May, p. 12

Foto Visions, "Art Systems", August, p. 70

Haags Post, "Dennis Oppenheim Maakt Met Zijn Duim Een Hedere Piece", B. Van Garrel, October, p. 91

L'uomo e l'arte, Milan, no. 7, p. 5

Nuovo Indirizzo, "Dennis Oppenheim", p. 12

NRC Handelsblad, "Kunst meat Het Eigen Lichaam Als Material", L. Van Ginneken, p. 8

Opus International, "Land Art", B. Parent, March, no. 23, pp. 10–27, 65–71

Rolling Stone, "Conceptual Art, Media, Processed and Forced on a Bun – No Relish", T. Albright, June 24, pp. 40–41

San Francisco Art Chronicle, "Black Rock, Beams and Bones", A. Frankenstein, February 7, p. 11

San Francisco Art Chronicle, "The Urban Design Plan for San Francisco, A. Frankenstein, June 27, p. 15

Siete Dias, "Nadie Entiende me Obra Ni Yo Tampoco", V. Rabin, October, pp. 50–51

Studio International, "Interview with Dennis Oppenheim", W. Sharp, November, pp. 183–93

Village Voice, "Protection", October 21, p. 35

Woensdag, "Dennis Oppenheim: Houdt van Directe Emoties", L. Van Duinhoven, November 3, p. 6

1970

Art and Artists, November, p. 60

Art in America, "The Iceman Cometh. Symptoms of the 70s", J. Jacobs, January–February, pp. 62–67

Art in America, "Something for Every Appetite", G. Glueck, March–April, pp. 142–52

Art News, Summer, p. 66

Art News, "Lead Kindly Blight", D. Antin, November, pp. 87–90

Arts, "Documentizing", N. Calas, May, pp. 30–32

ArtsCanada, "Dennis Oppenheim: Catalyst 1967–1970", J. Burnham, August, pp. 42–49

ArtsCanada, "World Game: The Artist as Ecologist", G. Youngblood, August, pp. 42–49

Artweek, "Dennis Oppenheim: Conceptualist", C. McCann, November 21, p. 2

Aspen, "Art/Information/Science", no. 8, Winter, p. 12

Aspen, D.Graham, December–January, p. 7

Avalanche, "Discussions with Oppenheim, Heizer, Smithson", W. Sharp, no. 1, Winter, p. 3

Casabella, "Archives: Dennis Oppenheim", G. Celant, no. 346, March, pp. 42–44

Corrierre della Sera, "Land Art and Company", February 8, p. 7

Domus, "New York", no. 487, June, pp. 49–50

Flash Art, "Land Art", T. Catalano, May–June, p. 17

Horizon, "The Flight from Reason", T. Meeham, Spring, pp. 4–10

Interfunktionen, "Kunst als Kontext", November, pp. 1–41

Interfunktionen, "Dennis Oppenheim: Decompositions", no.4, March, p. 18–29

Magazin Kunst, "Concept Art", K. Honnef, September, pp. 1759–67

National Observer, "Latest in Museums: No Walls at All", B. Marchvel, August 10, p. 22

Newsweek, "Art Under Stress", D. Davis, May 2, p. 119

New York Times Magazine, "It's Called Earth Art – and Boulder-dash", R. Bongartz, February 1, pp. 16–17, 22–30

Robbo, "Quelques Aspects de l'Art Bourgeois", no. 5–6, p. 30

Sacramento Bee, "Conceptual Art", C. Johnson, July 19, p. 13

San Francisco Chronicle, "More Than One", T. Albright, December, p. 25

San Francisco Chronicle, "Return to Earthworks", A. Frankenstein, November 5, p. 11

Studio International, "Artists and Photographs", L. Alloway, April, pp. 162–64

The East Hampton Star, "Earth Art", July 30, p. 4

Time, "Back to Nature", June 29, pp. 62–65

Vogue, "A Sound Enclosed Land Area", J. Gruen, August 1, p. 38

1969

Art and Artists, "New York: Moving Out", R. Pomeroy, January, p. 56

Artforum, "Dennis Oppenheim: A Presence in the Countryside", J. Bourgeois, October, pp. 34–38

Art Gallery, "Exhibitions", February, p. 25

Art in America, "Impossible Art – What It Is", D. Shirey, May, pp. 30–31

Art News, "Sweet Mysteries of Life", A. Goldin, pp. 46–51

Art News, March, p. 54

Art News, "Scuba Sculpture at the Museum of Modern Art", W. Johnson, November, pp. 52–53, 81

Art News, "Dennis Oppenheim: Decomposition – Whitney Museum", January, p. 15

Artforum, "Place and Progress", W. Sharp, November, p. 46

Artforum, "Real Time Systems", J. Burnham, September, pp. 49–55

Arts, "Exercises in Anti-Style", D. Ashton, April, pp. 45–46

Arts, "Two Ocean Projects at the Museum of Modern Art", A. Robbin, pp. 24–25

ArtsCanada, "200 Yard Dash", October, pp. 38–39

Auction, "The Expanding and Disappearing Work of Art", L. Alloway, October, pp. 34–37

Casabella, "Nature Has Arisen", G. Celant, September, pp. 104–07

Casbella, "Towards a Critical Criticism", G. Celant, December, pp. 42–44

Combat, O. Nanteau, June 8, p. 12

Cornell Daily Sun, "Earth In", M. Goldman, p. 20

Domus, "Prodigal Creator's Trilogy", T. Trini, September, pp. 42–55

Emmer Courant, "Kunstboer Waalkens", September, pp. 80–86

Interfunktionen, "Land Art/Earth Works", F. Heubach, no. 3, p. 30

L'Express, O. Hohn, June 2, p. 8

L'Oeil, "Les Grandes Vacances de l'Art Moderne", May, pp. 11–19

Life, "Art You Can Bank On", September, pp. 80–86

Museumjournal, "Televisie Galerie", June, pp. 138–40

New York Times Magazine, "The New Art. Big Ideas for Sale", R. Constable, March, p. 10

Nieuwsblad, V.H. Noordan, April 9, p. 10

Pariscope, "Dennis Oppenheim", B. Borgeaud, June 4, p. 10

The New York Times, "Painting Icebergs, Decorating Dunes", H. Kramer, November 16, p. B25

The New York Times, "Modules for the Millions", G. Glueck, June 22, p. B32

The New York Times, "Snow Projects form Canadian Borders", G. Glueck, June 22, p. 24

Village Voice, "Down to Earth", J. Perrreault, February 13, pp. 18–20

Village Voice, "Earth Show", J. Perreault, February 27, pp. 16–20

Village Voice, "Off the Wall", J. Perreault, March 13, pp. 13–14

Winschoter Courant, J.H. Henssema, April, p. 7

1968

Art News, John Gibson Gallery, Summer, p. 17

Artforum, "A Sedimentation of the Mind", R. Smithson, September, pp. 44–50

Artforum, "Earthworks and the New Picturesque", S. Tillam, pp. 42–45

Arts, "Earth in Upheaval", P. Hutchinson, November, pp. 19–21

Connaissance des Arts, "Le Rêve Americain: Le Grand Canyon, Les Jeunes Artistes", October, no. 200, pp. 29–31

Madamoiselle, "Most Likely to Succeed", L. Lehrman, September, pp. 146–49

Newsweek, "The New Art. It's Way, Way Out", H. Junker, July 29, pp. 56–63

San Francisco Chronicle, "Tasteful Rendition of an Old Art", T. Albright, May 29, p. 23

San Francisco Examiner, J. Sanders, December 1, p. 10

San Francisco Examiner, "Art Out of Hand", S. Eichelbaum, December 1, p. 15

Saturday Evening Post, "Getting Down to the Nitty Gritty", H. Junker, November 2, pp. 42–47

The New York Post, "Art and the Artist", E. Genauer, December 21, p. 46

The New York Post, "Exhibitions not Exhibitionist", May 25, p. 37

The New York Times, "An Artful Summer", G. Glueck, May 18, p. D35

Time, "The Earth Movers", October 11, p. 84

Village Voice, "Illusions of Reality", J. Perrault, December 26, pp. 2–23

Photo Credits / Crediti fotografici

Dennis Oppenheim, New York
Luciano Carugo, Milano

Silvana Editoriale Spa

via Margherita De Vizzi, 86
20092 Cinisello Balsamo, Milano
tel. 02 61 83 63 37
fax 02 61 72 464
www.silvanaeditoriale.it

Le riproduzioni, la stampa e la rilegatura
sono state eseguite presso lo stabilimento
Arti Grafiche Amilcare Pizzi Spa
Cinisello Balsamo, Milano

Finito di stampare
nel mese di marzo 2007